POW! RIGHT IN THE EYE!

EDITED BY
LYNN GUMPERT

TRANSLATED FROM THE FRENCH BY
WILLIAM RODARMOR

WITH RESEARCH ASSISTANCE FROM
MARIANNE LE MORVAN

FOREWORD BY
JULIE SAUL AND LYNN GUMPERT

INTRODUCTION BY
MARIANNE LE MORVAN

*THE ABAKANOWICZ ARTS
AND CULTURE COLLECTION*

POW!

RIGHT IN THE EYE!

THIRTY YEARS
BEHIND THE SCENES
OF MODERN
FRENCH PAINTING

BERTHE WEILL

∽○─○∽

THE UNIVERSITY OF CHICAGO PRESS

CHICAGO AND LONDON

The University of Chicago Press, Chicago 60637
The University of Chicago Press, Ltd., London
© 2022 by The University of Chicago
"Wrestling with Weill" © 2022 by William Rodarmor
All rights reserved. No part of this book may be used or reproduced in any manner whatsoever without written permission, except in the case of brief quotations in critical articles and reviews. For more information, contact the University of Chicago Press, 1427 E. 60th St., Chicago, IL 60637.
Published 2022
Printed in the United States of America

31 30 29 28 27 26 25 24 23 22 1 2 3 4 5

ISBN-13: 978-0-226-81436-0 (cloth)
ISBN-13: 978-0-226-81453-7 (e-book)
DOI: https://doi.org/10.7208/chicago/9780226814537.001.0001

First published as Berthe Weill, *Pan !... dans l'œil !... ou trente ans dans les coulisses de la peinture contemporaine 1900–1930* (Paris: Librairie Lipschutz, 4 place de l'Odéon, 1933).

The publication of this edition has been generously supported by the Abakanowicz Arts and Culture Charitable Foundation.

ABAKANOWICZ
Arts and Culture Charitable Foundation

Library of Congress Cataloging-in-Publishing Data
Names: Weill, Berthe, 1865–1951, author. | Rodarmor, William, translator. | Gumpert, Lynn, editor, writer of foreword. | Le Morvan, Marianne, writer of introduction. | Saul, Julie, writer of foreword.
Title: Pow! Right in the eye! : thirty years behind the scenes of modern French painting / Berthe Weill ; edited by Lynn Gumpert ; translated from the French by William Rodarmor ; with research assistance from Marianne Le Morvan ; foreword by Julie Saul and Lynn Gumpert ; introduction by Marianne Le Morvan.
Other titles: Pan! Dans l'œil! English | Abakanowicz arts and culture collection.
Description: Chicago : The University of Chicago Press, 2022. | Series: Abakanowicz arts and culture collection | Includes bibliographical references and index.
Identifiers: LCCN 2021050467 | ISBN 9780226814360 (cloth) | ISBN 9780226814537 (ebook)
Subjects: LCSH: Weill, Berthe, 1865–1951. | Galerie B. Weill. | Painting, French—20th century. | Painters—France. | Women art dealers—France—Paris.
Classification: LCC ND548 .W3813 2022 | DDC 759.409/04—dc23/eng/20211208
LC record available at https://lccn.loc.gov/2021050467

♾ This paper meets the requirements of ANSI/NISO Z39.48-1992 (Permanence of Paper).

Contents

Foreword by Julie Saul and Lynn Gumpert, vii

Translator's Note: "Wrestling with Weill"
by William Rodarmor, x

Introduction: "The Marvel of Montmartre"
by Marianne Le Morvan, xv

Pow! Right in the Eye!

THIRTY YEARS BEHIND THE SCENES
OF MODERN FRENCH PAINTING, 1

APPENDIX A
"Preface: First a Few Words . . ."
BY PAUL REBOUX, 151

APPENDIX B
"Avant-propos"
BY BERTHE WEILL, 160

APPENDIX C
"Dolikhos's Beginnings"
BY BERTHE WEILL, 161

Acknowledgments, 172
Chronology, 173 Glossary of Names, 175 Notes, 199
List of Contributors, 219 Index, 221

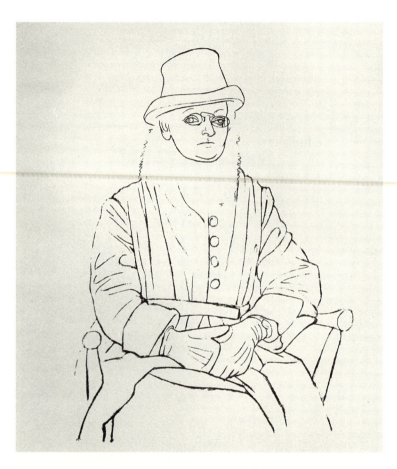

FIGURE F.1. Pablo Picasso, *Portrait of Berthe Weill*, 1920. Conté, pencil, and charcoal on paper, 62 x 47 cm. © 2021 Estate of Pablo Picasso / Artists Rights Society (ARS), New York. Used as frontispiece in the original edition of *Pan!*

Foreword

Julie Saul and Lynn Gumpert

"In the first years of the century, only one gallery specialized in twentieth-century art—the Galerie Berthe Weill." This unambiguous statement by Michael FitzGerald in his 1995 book on Picasso and the French art market intrigued Julie Saul. When Saul thought of modern art dealers, the names Bernheim-Jeune, Durand-Ruel, Rosenberg, Sagot, and Vollard all came much more readily to mind. Who was this Weill? As it turns out, Berthe Weill was both revered and celebrated in her time, as documented in Marianne Le Morvan's 2011 biography.[1] Le Morvan prominently cites Weill's 1933 memoir, *Pan! dans l'œil! . . . ou trente ans dans les coulisses de la peinture contemporaine 1900–1930*, the first autobiography of a modern dealer. Originally written in a chatty Parisian patois, *Pow! Right in the Eye! Thirty Years behind the Scenes of Modern French Painting* is an illuminating account of the first three decades of twentieth-century avant-garde art and appears here in its inaugural and, we are convinced, definitive English translation.

Wanting to learn more about this pioneering woman dealer, Saul spent more than two decades looking for a publisher who would translate and distribute Weill's memoir in English. In 2014, she found a co-conspirator in Lynn Gumpert, who partnered with Saul not only in her mission to make this obscure memoir available to non-Francophone audiences but also in the organization of an exhibition that highlights Weill's achievements. New York University's Grey Art Gallery is working with

the Montreal Museum of Fine Arts on an exhibition titled *Berthe Weill: Indomitable Art Dealer of the Parisian Avant-Garde*.

Reading *Pow!* today significantly expands our understanding of the modern art market that emerged well over a century ago. It reveals that the profession of selling art has changed little. Weill's narrative rings true to those familiar with the contemporary art world. *Pow!* is filled with tales of fraught relationships with artists, critics, and wealthy competitors; bungled deals; and worries about making the rent. Likewise, complaints of backstabbing maneuvers, bad business, high taxes, and lost commissions sound eerily familiar. Weill often took on side gigs and sold works on what we now call the secondary art market in order to pay the bills. Like many dealers today, she was an incorrigible collector of books and art that she could not afford. At the same time, she speaks fondly of summer vacations visiting artists' country homes and raucous, celebratory dinners following exhibition vernissages.

Weill's trajectory veers in a decidedly different direction from those of her better-known male counterparts. An outlier and a bold risk-taker, starting in 1901, she launched the careers of artists who later moved on to new galleries, remained loyal to the ones who didn't, and retained lifelong friendships with most. Weill's significance lies not in her business acumen or financial success but in her brave programming and commitment to those she dubbed *les Jeunes*, younger generations of emerging artists.

When Weill published *Pow!* in 1933, she commissioned Paul Reboux, a French writer and artist, to write a preface for the work. A strange text, it appears here at the end of Weill's memoir, followed by Weill's own avant-propos and her thinly disguised 1916 satirical broadside *Dolikhos's Beginnings* about Ambroise Vollard. This presentation allows readers to dive headfirst into not only Weill's lively saga of her career but also

the story of the Parisian art world. (Those preferring to read *Pow!* as it originally appeared should turn first to Reboux's text and then to Weill's avant-propos and the mysteriously titled *Dolikhos's Beginnings*, before tackling the memoir itself.) As an aid to contemporary readers, the book also includes a glossary of names with brief biographies of the many characters—nearly five hundred—cited by Weill, an inveterate name-dropper, along with explanatory annotations in the endnotes.

With her tenure of four decades, Berthe Weill provides a model for gallerists, demonstrating not only courage, determination, and perseverance but a powerful streak of independence. In her words, "I've had disappointments, but also many joys, and despite the obstacles, have created an occupation for myself that I thoroughly enjoy. On balance, I should consider myself lucky . . . and I do."

TRANSLATOR'S NOTE

Wrestling with Weill

William Rodarmor

So Picasso and Braque walk into an art gallery . . . Sounds like the setup for a joke, doesn't it? Except that it happened, and Braque got into an argument with the gallery owner, Berthe Weill. She tells the tale in chapter 12 of her invaluable 1933 memoir, *Pan! dans l'œil!*, published in English as *Pow! Right in the Eye!*

As a translator, I found tackling Weill's memoir to be a mix of pleasure and terror. The pleasure was in learning intimate details about an array of twentieth-century artists from a lively, sharp-eyed observer. The terror was in wrestling with Weill's rapid-fire prose, idiosyncratic style, and cryptic references while being haunted by the fear of getting something wrong.

What follows may sound like a lament, but it's been a treat to translate the memoir of an unsung heroine of modern art, and to stretch my translation muscles in the process.

Because I was working on a historical document, I was very careful when I encountered any mistakes by the author. I didn't hesitate to change the date of an exhibition from 1922 to 1921, when this was clearly what Weill had meant. But what to do when she says that Modigliani's 1917 solo exhibition opened on October 3? Any art historian would know that the correct date is December 3. Because of the date's prominence, I chose to correct it in the text, then explain the correction in an endnote, where people might otherwise miss it. I stand by these decisions but understand that someone might question them.

In that vein, I reluctantly set aside a favorite translator tool,

the "stealth gloss." This is the practice of discreetly inserting a word or two to clarify an otherwise obscure passage. For example, in chapter 15 I inserted the fact that a certain collector was German. Without this note, readers wouldn't understand why Edmond Renoir, an extreme French nationalist, threw him out of his apartment. I dutifully signaled the insertion with square brackets, unsightly though they are.

My loyalty as a translator is to both the author and the reader, but in a pinch, I try to help the reader. For example, if *Pow!* were a novel, I might silently expand "M." to "Marcel" in chapter 17 to clarify which of the two Kapferer brothers Weill worked with. (An outside source says it was Marcel.) But because *Pow!* is a primary source, I can't do that. Plus I could still get it wrong. Weill occasionally uses "M." as an abbreviation for "Monsieur." So what if it was actually Henri?

Did I mention that Weill almost never uses first names? This isn't usually a problem. After all, how many painters are named Barat-Levraux or Sabbagh-Sabert? (Both were Georges, by the way.) But sometimes ambiguity reigns. In chapter 21, Weill says that the Lombards visited Saint-Tropez and attended a dinner in her honor. Alas, there were two painters of that name around. Worse, they were nearly the same age: Alfred (1884–1973) and Jean (1895–1983). I have reason to suspect it was Alfred, but I'm no art historian.

When confronted with such uncertainty, the only solution is to write an endnote. I have written more endnotes to this one slim volume than to all my previous translations combined. I also created a glossary of names with some five hundred microbiographies as a reference, so readers can identify an artist or individual they're interested in. You're welcome.

When it comes to typographical style, Berthe Weill is happily inimitable. She doesn't waste time on line breaks, so passages with a lot of dialogue look like sheets of mud. And she

never met an ellipsis she didn't like. French writers use ellipses fairly often, but we avoid them in English because they . . . look vague. . . . In my early drafts, I eliminated most of the ellipses, but I restored many of them later. That's because Weill's prose rhythm is closer to Machine Gun Kelly than Marcel Proust, and I realized that the ellipses help smooth out her darting leaps from topic to topic.

Another challenge was not always knowing what Weill was talking about, even with help. In translating the memoir, I was assisted every step of the way by the wonderful French scholar Marianne Le Morvan, who wrote the principal introduction for this book. But even Le Morvan sometimes gave up in head-scratching dismay at passages so gnomic they read like cribs for Linear B. Weill is also extremely private about personal matters. In chapter 17, for example, she hints at a terrible event involving her brother that nearly tore two families apart, but she never says what it was.

Finally, there are the jokes, the bane of every translator's existence. When Weill says something funny about Montmartre in 1923, you had to be there. And she often cracks wise. In chapter 19, she describes an art exhibition called the "Folie dentaire," mixing jokes about teeth with an invented vocabulary about the artists in the show.

While I initially thought some of the five artists she names in this section were foreigners, they're all native to France. And you can't get more local than Utrillo, who was born in Montmartre. Here is just one sentence of Weill's original "French" (most of the words are distorted or made up): "Yougos, youdis, polachekas, polachekis, tchékos, tchékis, crottins, crottis." What to make of this linguistic stew? *Yougos* is almost certainly short for Yugoslavs; *youdis* might contain "Jew," like the French anti-Semitic slur *youpin*; *polachekas* and *polachekis* are our Polacks; *tchékos* is likely Czechs. I'm guessing *crottins, crot-*

tis both refer to Croatians; *crottin* is "dung," or "shit," so they could be dirty Croats. *Crottis* is probably a made-up word, or it refers to Jean-Joseph Crotti (1878–1958), a Swiss artist married to Marcel Duchamp's sister. Whew!

Then, before the reader (or translator) can pause for breath, Weill forges on in a second passage that inexplicably name-checks Jules Moy, a popular film actor in the 1920s. Moy's movie titles, however, hold no hints to the two lines in the excerpt: "Ah? laisse-moi plomper / Ta crosse tent du fond?" I also don't know why Weill writes here in a mock-Alsatian accent; "plomper" is the verb *plumber* (to fill with lead) and "ta crosse tent du fond" is *ta grosse dent du fond* (your big back tooth). In a situation like this, a translator can only bravely jump in and hope for the best. Some of my guesses may be wildly off base, but they were fun to make.

Weill and I both fared better with a comic set piece in chapter 19, when she pretends to eavesdrop on an interview with Maurice de Vlaminck by a credulous art critic. She gleefully takes the opportunity to puncture the artist, the interviewer, various art movements, Dada, pretentious poetry, and masturbation.

Berthe Weill is a marvel in the history of art, and translating her was a privilege and a challenge—I have the scars to prove it.

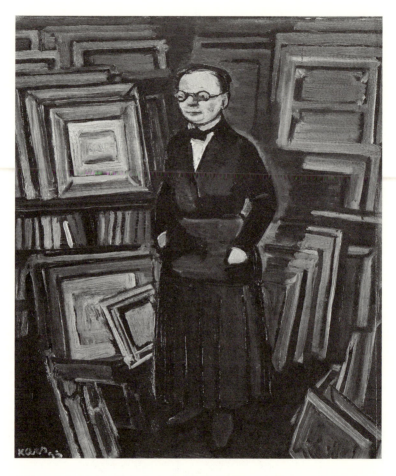

FIGURE I.1. Georges Kars, *Portrait of Berthe Weill*, 1933. Oil on canvas, 56 x 46 cm. Private collection © Maxime Champion: Delorme & Collin du Bocage.

INTRODUCTION

The Marvel of Montmartre

Marianne Le Morvan

In 1901, a miniscule art gallery debuted in lower Montmartre, then the heart of the Parisian art scene. Paintings covered the walls from floor to ceiling. Lacking space, the enterprising owner once stretched a rope across the room and used clothespins to hang still-wet canvases. In 1902, she displayed the first works by Henri Matisse and Pablo Picasso to be exhibited in Paris. Thus began the extraordinary journey of Berthe Weill (1865–1951), a remarkable art dealer who played an outsize role in identifying some of the most important artists of the first half of the twentieth century.

Standing barely five feet tall, with light blue eyes behind oval glasses, Weill deployed a keen wit, biting humor, and sharp eye for talent. She also cut a striking figure in an all-male guild, and her brash outspokenness clashed with the hushed, reserved murmurs of the commercial art world. Although Weill's significant accomplishments were recognized in her own time, she remains almost unknown today, never having achieved the notoriety of her male counterparts such as the Bernheim-Jeune brothers, Paul Durand-Ruel, Daniel-Henry Kahnweiler, and Ambroise Vollard.

Weill sets the record straight in her strikingly titled 1933 memoir *Pow! Right in the Eye!*[1] It is an engaging, raucous description of her career and the unstinting support she provided to emerging artists, whom she called *les Jeunes*.[2] Demystifying a romanticized view of bohemia, Weill creates a vivid

account of the challenges she faced in order to support artists whose reputations were yet to be established. At the same time, Weill skips over many details of her private life, leaving readers wanting more. She reveals little about her family origins or what led her to dedicate her life to art. Nor is her memory infallible: dates and names are at times approximate.

The memoir's provocative title mirrors the impact made by the artists and the artworks Weill championed and recalls Robert Hughes's *The Shock of the New*, his much later account of twentieth-century art.³ In *Pow!*, she forgoes polite conventions to tell it like it is, lifting the curtain to expose behind-the-scenes operations in the art world during the first three decades of the twentieth century.

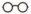

Esther Berthe Weill was born on November 20, 1865, into a large Jewish family of extremely modest means. Her father, Salomon Weill, was a ragpicker, and her mother, Jenny Levy, worked as a seamstress until she married. Berthe was the fifth of seven siblings and the older of two girls, all born in Paris's 1st arrondissement. Like her father, Weill's maternal grandfather had left the Alsace-Lorraine region for Paris in search of a better life. Though not religious herself, Weill descended from a long line of cantors.

Since the family was poor, all the siblings entered the workforce early. Berthe's beloved younger sister, Adrienne, for example, was placed in a sewing workshop. Berthe was a sickly child, so her parents found her a less physically challenging post. In her early teens, Berthe began an apprenticeship with Salvator Mayer, a distant cousin who dealt in antiques as well as prints and paintings. His shop was located in the epicenter of the Parisian art market, on 5 rue Laffitte, the so-called street of pictures, not far from the famed Drouot auction house.

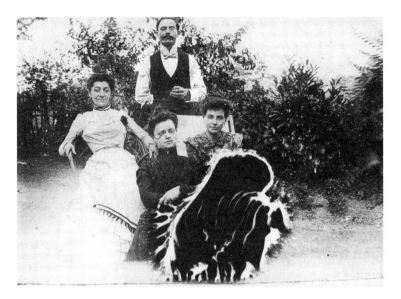

FIGURE I.2. Family photo, c. 1900. *From top:* standing at the back, Nephtali Weill (Berthe's oldest brother); seated on the left, his wife (also named Berthe); seated on the right, Adrienne Levy (Berthe's younger sister); and seated in the center, with glasses, Berthe Weill. Courtesy of Marianne Le Morvan, Archives Berthe Weill, Paris.

A genial, well-connected man, Mayer took to his curious young apprentice, serving as mentor and igniting her interest in art while teaching her the ins and outs of the business. She worked alongside him for two decades until his death in 1896. When Berthe was thirty-two, she and her brother Marcellin established a modest antique shop that, like Mayer's, sold drawings, caricatures, and collectibles. In 1901, Pedro Mañach, an enterprising Catalan businessman turned artists' agent, convinced her to transform the shop into an art gallery, which opened that year on December 1. He and Weill mounted six exhibitions together, until she took sole charge the following summer. This humble enterprise would develop into ground zero of a modern art revolution.

By the turn of the century, established Parisian art deal-

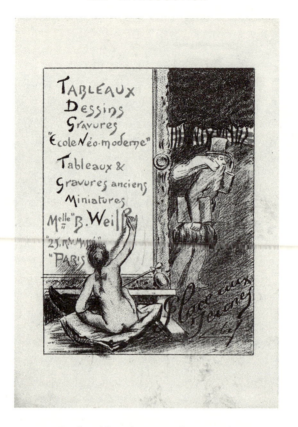

FIGURE I.3. Promotional card for Galerie B. Weill, designed by Alméry Lobel-Riche, 1900–1901. Courtesy of Marianne Le Morvan, Archives Berthe Weill, Paris.

ers had cornered the market for paintings by the Impressionists, Postimpressionists, and Nabis. Weill, however, devoted her meager resources to promoting the work of young, yet-unknown beginners, her coterie of Jeunes. She immediately demonstrated an unerring gift for spotting budding artists with a future. Among her first sales were three pastels on canvas by Picasso, who had moved to Paris in 1900. Her initial exhibition the following year featured a small ceramic figurine by Aristide Maillol and a sculpture by Meta Warrick Fuller, a Black American artist who had studied with Auguste Rodin. Weill included

works by Matisse and Francis Picabia in her next show. In April 1905, she exhibited the Fauves before they received their moniker later that year at the Salon d'Automne. She was the first to display works by André Derain, Othon Friesz, Henri Manguin, Albert Marquet, Jean Metzinger, Kees van Dongen, and Maurice de Vlaminck, among many others, in group exhibitions. In 1906, she mounted Raoul Dufy's first solo show. The list goes on.

By 1909, Weill was exhibiting Georges Braque's proto-Cubist works. In 1914, she presented three solo exhibitions of paintings by Cubist artists: the first shows in France by Diego Rivera and Alfred Reth, and the first in that style by Jean Metzinger. Among Cubist artists she supported were Albert Gleizes, Fernand Léger, André Lhote, and Marcel Mouillot. In 1917, she organized Amedeo Modigliani's first and only solo exhibition in his lifetime. This led to an incident that garnered the most notoriety for Weill up to that point. Among the thirty or so paintings and drawings in the show were four of the artist's now iconic nudes, which could be seen from the street. Their provocative poses with visible pubic hair attracted attention, including that of the district police commissioner, whose precinct offices were located across from the gallery. He promptly ordered the show's closure on charges of indecency. The scandal prevented sales of Modigliani's work; sadly he died two years later.

Weill named her enterprise "Galerie B. Weill," abbreviating her first name to disguise her gender at a time when art dealers were all men. The term *galerie* had only debuted a year earlier in the *Bottin du commerce*—the yellow pages of the day. In adopting this designation, she announced herself as a new kind of businesswoman. Referring to her "Galerie" with its capital letter underlines the high regard she held for the métier. Weill, moreover, didn't hesitate to make her political views known. Early on, she alternated exhibitions of prints and caricatures by Honoré Daumier, Henri Ibels, and Sem, among many others,

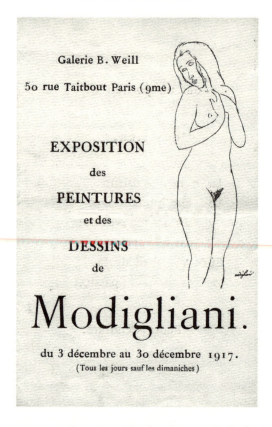

FIGURE I.4. Cover, *Exposition des peintures et des dessins de Modigliani*, exhibition catalog (Paris: Galerie B. Weill, 1917). Courtesy of Marianne Le Morvan, Archives Berthe Weill, Paris.

which sold more readily, albeit at very low prices, with painting shows. She also displayed artists' original illustrations that brazenly reflected her pro-Dreyfus sentiments. When subjected to anti-Semitic slurs, she unapologetically stood her ground. From the beginning, she promoted foreign artists, many of whom dared to break with conventions, before anyone else understood their bold experiments. With her adventurous programming, Weill changed prevailing opinions, shaped collectors' attitudes, and created a burgeoning new market for emerging artists.

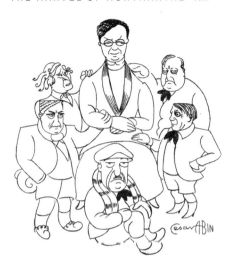

FIGURE I.5. César Abin, *"Leurs figures": 56 portraits d'artistes, critiques et marchands d'aujourd'hui avec un commentaire de Maurice Raynal* (Paris: Imprimerie Muller, 1932). Printed on vellum, edition of 250. *Clockwise from top:* Berthe Weill, Georges Braque, Pablo Picasso, Fernand Léger, André Derain, and Marc Chagall.

Weill also fought to be taken seriously as an entrepreneur who earned her own keep. Not only did she open the first art gallery devoted exclusively to contemporary art in Paris—one run by a woman, besides—but nearly a third of her exhibitions included at least one work by a female artist. One out of every five solo shows was devoted to women artists. Émilie Charmy in particular owes her a large debt of gratitude, as do Alice Halicka, Sonia Lewitska, Jacqueline Marval, and Suzanne Valadon.

Having learned business from a professional, Weill knew all about the bottom line but rarely focused on it. She was scrupulously honest, disapproved of exclusive contracts, and didn't charge her artists fees, as was then the norm. Selling works by emerging artists was risky as they couldn't command the prices of more established colleagues. Because she was often short of

money and unable to acquire inventory, Weill never achieved the financial stability and substantial earnings of her male counterparts, despite all the big names and important works that at some point hung from her picture rails.

In Weill's day, the best-known art dealer in Paris was Ambroise Vollard. A comparison of their careers illustrates the differences between their respective ambitions and underscores Weill's innovative approach to operating a gallery. Born a year after Weill, Vollard also learned the trade from a rue Laffitte dealer, but his bourgeois family supported him as he simultaneously pursued his university studies. Weill, however, was largely self-taught since public education for girls ended when they turned ten. She opened her gallery with a modest loan from Mme Mayer, her mentor's widow, who also convinced Weill's parents to give their daughter her dowry so that she could use it to support her fledgling business. Given the choice, Weill clearly preferred the freedom that came with independence over the shackles of a marriage.

What truly distinguishes Weill from Vollard is class. Weill never saw herself as part of *haute société*; her solidarity was with the paint-spattered journeymen in their studios. She never hid her modest origins and regularly heaved anarchistic brickbats at snobs and speculators. Unfortunately, her protégés soon left her for more prestigious and better-capitalized galleries. Lacking the means to retain them, she was constantly forced to renew herself. Ironically, this turned her limited means and constant struggle into the driving force behind a stellar roster of artistic discoveries.

Vollard is known as the inventor of the modern artist, but in fact, he was resolutely oriented toward the nineteenth cen-

tury: of sixty-six of his documented exhibitions, only thirteen, or 20 percent, were devoted to emerging artists.[4] During the same period, the figure for Weill was 100 percent. An equally sharp difference emerges from the two dealers' willingness to gamble on unknown talent. Weill showed artists who had never exhibited before, whereas Vollard would watch new painters for months or even years before investing in them. To limit his risk, he alternated new talents with older, established artists. These well-considered choices made Vollard by far the better strategist since he would concentrate resources on a few key painters. If an artist's work didn't sell, for example, like those by Vincent van Gogh between 1895 and 1897, Vollard stopped exhibiting it.

Weill opens her memoir by reprinting a 1916 satirical pamphlet she had self-published about Vollard, whom she dubs "Dolikhos," in response to his unsympathetic newspaper portrayal of a shared art patron, Count Isaac de Camondo. In it, she depicts Vollard as an unwitting bystander in the busy whirl of art and commerce in Salvator Mayer's shop, where Parisian luminaries came and went, searching for treasures.[5] Weill begins her own story only after Mayer's death, when she steps out into the world. In retaliation to her parody, Vollard deliberately omits any mention of Weill in his own memoir, published two years after hers, initiating the process by which her contributions were written out of the period's history.[6]

Berthe Weill's forty-year tenure of operating a gallery belies any charges of amateurism hurled at her. Moreover, she frequently produced small catalogs to accompany the shows she presented. In November 1923, she began publishing her *Bulletin de la Galerie B. Weill*. She commissioned contributions from renowned art critics and poets such as Blaise Cendrars, Roger Marx, and

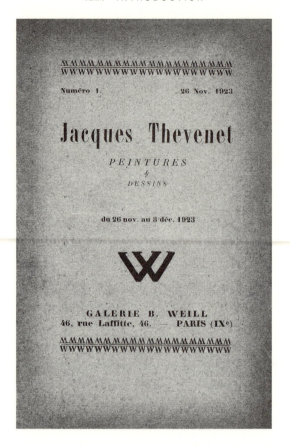

FIGURE I.6. *Bulletin de la Galerie B. Weill*, no. 1 (November 1923). Courtesy of Marianne Le Morvan, Archives Berthe Weill, Paris.

André Salmon, but she penned most of the columns herself. Many of her frank, pointed digs directed at competitors and art world denizens found their targets, and when she began writing her remembrances of her long career in the art trade, people took notice. In 1931, a journal announced:

> Mlle B. Weill, that extraordinary picture dealer through whose gallery most of the greatest artists passed, from Matisse to Derain and from Vlaminck to Dufy and Picasso, is spending her

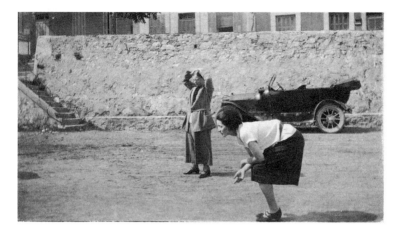

FIGURE I.7. Photograph of Berthe Weill (*left*) and unidentified woman (*right*) playing *pétanque* in Sanary, 1925. Gift of Hervé Bourdon. Courtesy of Marianne Le Morvan, Archives Berthe Weill, Paris.

vacation repainting her gallery and . . . writing her memoir: thirty years in art.

She had already turned to writing for the catalogs of the exhibitions she organized. On a few occasions, her sallies, jokes, and revelations have caused a bit of a scandal.

Mlle Weill has a long memory and doesn't suffer fools gladly. So gossip about the memoir by "the great and small" Mlle Weill is buzzing from Saint-Tropez to Sanary by way of the *terrasse* of the Dôme, and some people are feeling nervous.[7]

Weill finished writing her memoir in 1932, as her gallery marked its thirtieth anniversary with a large dinner, and *Pan!* appeared one year later. This banquet, like earlier celebrations of artists and momentous landmarks such as the gallery's one hundredth show and its twenty-fifth anniversary, engendered boisterous festivities with many art world figures in attendance.

The period following the stock market crash of 1929, however, was an especially challenging time in the art world.

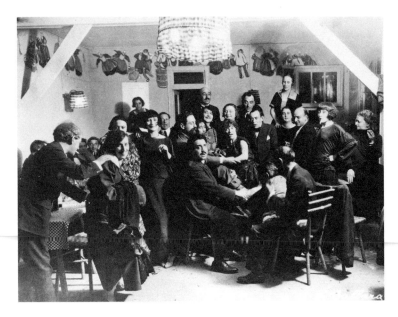

FIGURE I.8. Postcard of Suzanne Valadon's birthday dinner at a Montparnasse restaurant, photo by P. Ballara, n.d. Berthe Weill is at the far right and standing behind the artist Hermine David. Jules Pascin is standing at the far left smoking a cigarette. Additional guests reputedly included Georges Kars and his wife, Nora; André Derain and his wife, Alice; Georges Braque; Lucy Krogh, wife of Per Krogh and Pascin's mistress; and André Utter.

Between 1931 and 1937, half the galleries in Paris closed. Weill initially put her personal collection up for sale in the gallery, and she later consigned it to Salon Bollag in Switzerland in 1933.[8] She herself was forced to move from the 9th arrondissement to the 7th, where she opened her fourth and final location at 27 rue Saint Dominique. Her *Bulletin* ended around 1935, after twelve years and 123 issues, making her one of the most notable gallerist-publishers.

On the eve of the Second World War, Weill turned her attention to abstraction, exhibiting works by Étienne Beothy, Otto Freundlich, Julio González, and Alfred Reth, among others. She foresaw the looming disaster, writing these hauntingly pro-

phetic lines on the invitation for one of her shows in spring 1939: "While people prepare for the collective madness of destruction and death, only the artists, stoic and impassive, aware of their mission to create beauty, continue to work with love and self-lessness in accord with the rhythm of the eternal laws."[9] In a June 1939 letter to Picasso, she describes nearly being evicted for unpaid rent but miraculously coming up with the money, as she had done so often during her long career. Her last documented exhibition—paintings by Odette des Garets—was held in April 1940.

Not much is known about how Weill managed to escape deportation during the Nazi occupation—it seems that she just hunkered down in Paris. She had named a non-Jewish friend to head her business to avoid Aryanization, before finally closing in winter 1941. In 1943, she was the subject of a two-page profile in the anti-Semitic propaganda organ *Le Cahier jaune*. The article portrayed her as an opportunistic dealer who cared only about money, repeating all the usual prejudices and stereotypes. Among her artists, Sophie Blum-Lazarus and Otto Freundlich were deported and executed.[10]

Weill emerged from the war alive but penniless and in poor health. The Société des amateurs d'art et des collectionneurs organized a public auction to raise money for her. Eighty-four lots were donated by a number of the era's most prestigious artists and galleries in appreciation of her steadfast efforts and support when they were just starting out. A veritable roll call of modern art stars, the list included Marc Chagall, Raoul Dufy, André Lhote, Albert Marquet, Jean Metzinger, Jules Pascin, Francis Picabia, and Pablo Picasso. The sale took place on December 12, 1946, and raised about 1.5 million francs—roughly $130,000 today—enough to keep Weill for the rest of her days. On March 20, 1948, when she was eighty-two, she was named a chevalier of the Legion of Honor. Weill died at home

on April 17, 1951, at the age of eighty-five. She was infirm and, in one of fate's ironies, practically blind.

In 1923, André Warnod, a prominent art critic and one of Weill's most faithful allies observed: "Consider a gallery like Berthe Weill's. If you look at the catalogs of all the exhibitions she organized... it's amazing that she doesn't have a limo as big as a locomotive parked at her door. She welcomed all the painters who are famous today... when they were just starting out and weren't being supported by anyone. All of them."[1]

Berthe Weill's astute eye, radical exhibition program, and passion for contemporary art bear witness to her prescience in promoting key avant-garde figures. In *Pow! Right in the Eye!*, she reveals a vulnerable personality alongside a vivid account of the artistic community and the ups and downs of the art trade. She also lays claim to the significant role she played in the pictorial upheaval that she very early identified as a revolution. Her grateful protégés readily acknowledged her passion for them and her sustained efforts to promote their work, early on dubbing her "Mother Weill," a combination of *mère* (mother) and *Weill* pronounced as *merveille* or, simply and honorifically, a "marvel."

POW!

RIGHT IN THE EYE!

THIRTY YEARS
BEHIND THE SCENES
OF MODERN
FRENCH PAINTING

BERTHE WEILL

○─○

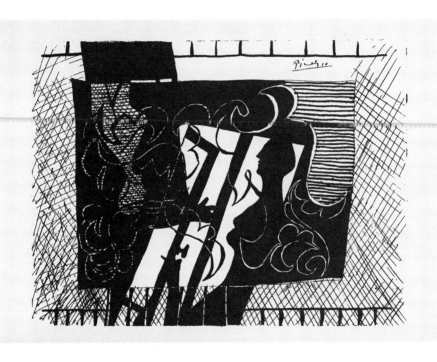

FIGURE 1. Pablo Picasso, *Composition*, n.d. © 2021 Estate of Pablo Picasso / Artists Rights Society (ARS), New York. The image appeared on page 44 of the original edition of *Pan!*

1

I LEAVE THE MAYER SHOP. — FREE AS A BIRD, I'M NICELY
SET UP ON RUE VICTOR MASSÉ. — MY WELL-STOCKED SHOP
SMELLS OF PROSPERITY. — COLLECTIBLES, ENGRAVINGS,
ILLUSTRATED NEWSPAPERS, POSTERS; KNICKKNACKS
GALORE. — THE HENRI PILLE BUSINESS.

Monsieur Mayer had died.[1] Without its guiding light, the shop lost all interest for me. That's when I got the idea of starting a business, so I would just be working for myself. When I told Mme Mayer about my plan, she was careful not to talk me out of it. She was counting instead on the fact that I didn't know anything about business to lead me to give up of my own accord.

But my determination was unshakable. We would see! So she very kindly offered to lend me the 375 francs I needed for six months advance rent on a shop. I immediately found one at 25 rue Victor Massé.

(For as far back as I can remember, I have noticed this striking fact: Whenever I express a desire, something fortuitous happens that helps me realize it or causes it to fail, even at the cost of painful trials if it turns out to be the opposite of what I expected. We will see this more than once later on.)

This is where my journal begins, which I am calling *Mémoires*.

○─○

I started out with just 50 francs in hand and went into debt to pay the costs involved in opening a shop. Obviously, the situa-

tion wasn't ideal, but I couldn't back out now. Besides, what was the worst that could happen? Not being able to hang on? I WILL HANG ON!!!

I couldn't count on any support from my parents, even moral support. Not only were they very poor, but they opposed my plan.

Mme Mayer and a few antique dealers in her family, who were distantly related to mine, become fellow pioneers in my enterprise, consigning various objects to me: old engravings and drawings, antique (or nearly antique) furniture and paintings, miniatures, silverware, etc., etc.

Ah, my friends! A sensational opening with all those objets d'art!

One of my brothers [Marcellin] went into the business with me. Given how difficult our early life was, what better compensation than independence? We'd never been spoiled by Fortune, so struggling struck us as perfectly normal.

Given how inexperienced we both were business-wise (and every otherwise!), we deserved to be encouraged for our boldness, but would merciless Lady Poverty find her way to our door in spite of our smiles?

Watch out!

Like anyone who never had any money, my brother loved to buy things. He would boldly venture forth, and I always felt anxious when he returned. His purchases might earn us a little profit if we could sell them, but they were a difficult problem to solve each time we had to pay for them.

Perseverance!

In those days, illustrated periodicals were everywhere, and lots of draftsmen contributed to them. *Le Courrier français*, edited by Jules Roques, was by far the most artistic. *L'Assiette au beurre* could be very interesting, and various others were more or less in demand. Their success was due to artists like Forain, Willette, Caran d'Ache, Henri Pille, Hermann-Paul, Sem, Cap-

piello, Abel Faivre, Roubille, Jean Véber, Helleu, Chéret, Steinlen, Bottini, Vallotton, Widhopff, etc.

There was a market for those artists' original drawings, and they sold pretty steadily.

Posters, which most of them illustrated, were also in demand. Pursued by collectors and merchants, billposters did a brisk business selling them. Some fanatics would go out into the streets at night to peel off posters by Grasset, Mucha, Chéret, Cappiello, and other artists in vogue and jealously take them home.

We were making money! How beautiful life seems when you find yourself in possession of the crazy sum of a hundred sous![2]

Probably excited by the tension over paying the bills, my brother enjoyed buying things more and more. One day he brought me some Henri Pille drawings. The artist had recently died, and we didn't know that a crooked bric-a-brac dealer was flooding the market with drawings he was making and signing himself. Their authenticity probably wouldn't survive careful scrutiny, but we were still new to the game (and off to a good start!), and our competence was certainly open to question. We felt confident, and proceeded accordingly.

I displayed the drawings in our store.

Almost immediately, as if she had been waiting for this moment, a buxom woman showed up, eyes bulging with rage . . . "I forbid you to sell those drawings!" Good gracious! I was taken aback by her bullying tone, but I recovered. "Only one person gives orders around here, and that's me!" I let her know that the door was open, and she was free to use it. Spluttering with rage and very threatening, the woman left. Turns out this was one of Henri Pille's women friends. I didn't know that, but it's so easy to be polite!

I told my brother about the intrusion, and he said it was true, that he'd heard rumors about forgeries.

Okay, that did it! The drawings were clearly fakes. I put them on a high shelf in a closet in the gallery's back room.

Integrity, honesty . . . I was becoming wary. If people were making forgeries for the sake of a few francs, where were we going? But I hadn't yet lost the last of my illusions. God, how nasty and ugly the world is!

Deceit exasperates me. I try to earn everyone's trust. So I would have to be prepared for some hard times.

(Mistrust is much harder on upright and conscientious people. It isn't in them to bluff or pretend they've had some great success. I've seen it time and again!)

Next day, the well-upholstered Pille woman came back, I wouldn't say smiling, but still under pressure, flanked by a suite of at least six gentlemen, all duly authorized. Like jacks-in-a-box, they popped out of no fewer than four hackney coaches and pushed their way into my tiny store. It got really crowded!

Thrilled to see such a throng, the neighbors envied our fate. "Those lucky ducks! All that business!" The police superintendent was there, along with his sergeant, his secretary, the artistic rights representative . . . and on and on.

"Do you have any forged Henri Pille drawings?" the superintendent asked. "Yes, sir. I do." "Where are they?" "I put them away in a closet. You can have them. I removed them from my shop, but not because of this woman's presumption," I said, pointing at the fat matron. "After asking around, I learned that my good faith had been taken advantage of. And since I won't sell forgeries . . ." This answer seemed to satisfy the superintendent. Just the same, he seized the drawings and told me to appear before the examining magistrate if I was summoned.

I was indeed summoned.

Ushered into the chambers of Monsieur Boucard (or Bourcart),[3] I saw that it was full of Pille drawings, both originals and fakes, that had been seized from merchants.[4] Questioned

by the judge, I told him about my situation, about starting out in business with my brother, who bought the drawings; about the Pille woman's rudeness (Monsieur Boucard seemed aware of that); about our decision to only deal in genuine works, and to buy more advisedly in the future.

Monsieur Boucard kindly asked if I could spot the forgeries among the drawings there. (Is this a trap? Too bad! I'm taking the leap!) I was pretty sure I didn't make any mistakes this time. (Touched by grace, I'd become an instant expert.) I was ushered out with, "I'll trouble you no further."

And that was that.

I'm pretty sure we never had any more forgeries, either of paintings, drawings, or engravings, ancient or modern. They were being churned out in basements and back offices, but we were careful.

HELLEU AND DE GROUX, THE STARS.—THE DREYFUS AFFAIR.—DEGAS IS AN ANTI-DREYFUSARD.—MY MOTHER GETS A SMALL INHERITANCE.—WE BLOW 4,000 FRANCS.—ODILON REDON DRAWINGS AND DAUMIER LITHOS ARE CHEAP.—THE GYPSY WOMAN.

Everyone was talking about Helleu's drypoint etchings, and his black-and-red chalk drawings. He was the international champion, the big star, especially in America.

Henry de Groux was also generating a lot of interest, but unlike Helleu, only among a small core of collectors. His *Christ Attacked by a Mob*, *Epic of Napoleon*, *Tetrology*, and *Divine Comedy* were huge successes, whether as paintings, pastels, or lithos.

Léon Bloy broke with his good friend de Groux over the Dreyfus affair.[1] Bloy couldn't forgive him for painting *Zola Attacked*

by a Mob as a response to his *Christ Attacked by a Mob*. I displayed the response in my gallery window, surrounded by original drawings by Ibels and Couturier (who died soon afterward) that had been published in the journal *Le Sifflet*, the opposition counterpart of *Psst . . . !* illustrated by Forain.

I must say, my courage was sorely tested in those troubled times.

Hatreds were raging out of control. France was split into two camps, one for Dreyfus, the other against him.

A mob threatened to shatter my shop window. "You dirty kike! We'll make you get rid of that garbage!" The screaming and collective insanity worried me, but I never back down from a threat. Though I was sure there would be trouble—in those sad times, you always expected the worst!—I stood up to the mob. First timidly, then resolutely, I walked to my door and said, "Just you try!" I must have looked pretty forbidding, because they moved away, furiously muttering but without smashing anything . . . Whew! A close call!

Degas shut his door to his close Jewish friends over this unfortunate affair. He was my neighbor down the street,[2] and if he saw me on my threshold, he would glare and ostentatiously turn his head away, spitting with contempt. Great men have their weaknesses. This didn't make me admire his talent any the less.

De Groux's success continued to grow. He worked in a huge, unheated atelier on boulevard du Port Royal. It was very cold, and to keep warm, he would walk back and forth reciting passages from the *Divine Comedy* while making the appropriate gestures, then capture them on canvas.

Such imagination! A poet! Maybe his personality would be recognized someday.

Well, well! My mother inherited a little money from an aunt whose death had been anticipated since she turned sixty. She

died at ninety-five, having buried a good number of family members who spent the last thirty-five years watching for her least sign of illness.

The money "put some butter on the spinach," as my mother used to say. My father was no longer the man he used to be, with a hundred sous in his pocket every day. "What can you possibly do with all that money?" Looking wise, he seemed to say, "Don't you worry, I know."

Business on rue Victor Massé was pretty slow. Mme Mayer approached my mother to persuade her to let me have the 4,000 francs that had been set aside for my trousseau against the fraught issue of my getting married.

We tried to get her to understand that the money would be much more useful in the business.

My mother's sister, her bad advisor, was well off and had no children. She criticized me for launching a business without any money.

"A fine thing, starting out with no money!"

"You should be dumb with admiration at such an accomplishment!" I replied.

She didn't understand that it was one way to avoid having to drop my drawers. I had no illusions where she was concerned. I knew what was in her heart.

Finally, my mother came through with the four thousand. Whee! France belongs to us, kids! Just see what we'll do with this! We all know what happens to people who've never had a sou who suddenly wind up with money.

We made idiotic purchases, bought theater and concert tickets, paid off debts, etc., etc. We impulsively stocked up on merchandise from all over that we'd be stuck with forever and that might never pay for itself. And then . . . no more money. And we were no wiser than we'd been before. Shhhh! Let's not talk about the *crazy* spending . . . We would start again. It wouldn't be easy.

The business was slowly chugging along, in its old familiar way.

We took a chance on a few modern works. We called it "playing hooky."

The Odilon Redon drawings that Mme Mayer owned weren't to her taste, so she sold them all to me. A new kind of artwork—that should appeal to us. We found ourselves gradually drawn to this much-talked-about modern art that would shape my life: a slippery slope.

Daumier lithos published in *Charivari* were being sold by the bundle. Even proofs before letters cost just a little more. Anybody want some? They went for 10 centimes, 25 centimes, a franc. Ah, modern art! What profits lie ahead!

An antique dealer was renting the shop next to mine, and the owner of the two stores wanted to tear down the common wall and make it one big space. He strongly urged me to take over the whole thing. I would become the biggest shopkeeper in the neighborhood! But I turned him down because I couldn't stand the idea of evicting a fellow tenant I got along with . . . What a fool I am!

So we stayed on in our little cubbyhole.

In life, sometimes little things happen that make an impression on you, and you wonder why.

One day a woman with masses of brown hair, piercing eyes, and big gold hoop earrings came into the shop. She wore a huge apron with two equally huge pockets around her waist. I couldn't believe the pockets! The woman was a handsome Gypsy type. She asked, "Do you have any chairs that need reweaving?" Negative. Then, in a low voice, "Do you want me to read your palm?" Whatever were those pockets for? I wondered. My curiosity led me to agree, and I held out my hands. "Put money in each one." I took five or six sous in each hand, but that wasn't enough for her. "Don't you have any silver coins?" Looking stupid—very stupid—I said, "Sorry, no."

She promptly made the sous disappear into the depths of her pockets and, to fully convince me of her power of divination (I must have seemed the ideal patsy), stared into my eyes and in a cavernous voice said, "I can tell if you have any, you know." My look of stupidity deepened, becoming trusting. She looked at my hand and started her spiel: "Someone is betraying you . . ." etc., etc. All right, that did it! I'd had my fun, and it only cost a few sous . . . But she wanted more. "For just a little more money, I'll tell you who is betraying you," she said confidentially. I said, "Oh, you know, I couldn't care less!"

She stormed out, threatening me with the worst calamities.

Despite its insignificance, the incident stuck in my memory, which is why I'm telling it. So there you have it.

3

THE 1900 EXPOSITION UNIVERSELLE.—LOUIS LEGRAND AND ROPS.—BARRÈRE'S FETUSES IN JARS.—WE LIVE IT UP.—MY BROTHER LEAVES, GETS MARRIED.—I BUY MY FIRST THREE PICASSOS, THEN GO TO HIS STUDIO.—I START SELLING THEM.—FOREIGN PAINTERS.

1900. Modern art was gradually making its way into our business, almost without our realizing it . . .

A young Spaniard named Mañach brought us works by Nonell, a talented Catalan painter who died quite young, and by Sunyer, who was also very gifted. This was the year of the Exposition Universelle, and a wave that grew bigger every day brought a flood of foreigners to the capital, including artists from all over, with Spain being especially prolific.

I'll have a chance to say more about that later.

Besides Daumier lithos, we also sold Lautrec drawings and

lithos, all of them genuine. People were forging works by Willette, Forain, and Pille, because those artists sold well, but it wasn't worth making fake Daumiers or Lautrecs, because those two weren't in demand . . .

Louis Legrand's etchings occupied a place of honor. Those by Rops were also sought after, especially the ones sold under the counter. Jossot, who made such oddly personal posters, suddenly died. Barrère, a young junkyard sculptor, portrayed the leading figures of the age as colored plaster fetuses sealed in pharmacy jars: Queen Victoria, Edward, prince of Wales, Déroulède, Reinach, Zola, Rochefort, Waldeck-Rousseau, etc., etc. Cheron, who would become a dealer, was a passionate collector of those jars. He hadn't yet turned his attention to modern art, and if someone had told him that he would soon be the most astute collector of modern painting, he would have been quite surprised.

Some well-known collectors followed my beginnings with interest: André Level; Olivier Sainsère, whom I met at Mayer's; Huc; Blot; Roger Marx; Joyant; Manzi; Armand Dayot; Georges Lecomte; Ellissen; Albert Sarraut, who took off his waistcoat when he went rummaging in corners; Delaroche of the *Progrès de Lyon*; and so many others, now dead.

One day we were given a wonderful marble Houdon sculpture on consignment, but a big antique dealer cheated us out of our commission. Then we bought a beautiful Sicardi miniature on very good terms, and made only a miserly profit . . .

This just wasn't cutting it! We weren't strong enough yet. We would never make it under those conditions. Plus, business was very bad, and we were starting to feel discouraged.

To change our luck a bit, we invited a dealer in antique

engravings to come pick though our bins. For 56 francs, he left with a significant batch of very high-quality prints.

Flush with all that money, we took in an opening-night performance by Réjane. That was always our family's way of warding off bad luck. Might as well keep up the tradition.[1] For my part, I've never focused on the tragic side of life. That optimism, which I almost never lose, has helped me get over many disappointments. My motto is, "It'll all work out!" And if you can't see the funny side of life, it isn't worth living.

My family was pressing me to get married, but I wasn't sure I wanted to. Out of pigheadedness, my parents tried to convince me. Why even bother? . . . Stinging rebukes flew. Furious, my mother yelled, "Then get out! You'll never be good for anything except selling your plates of spinach!" (meaning paintings).

My brother was less rebellious, and got married without demur in June 1900. Now I was fighting alone, and the struggle was tougher. But I had to hang in there, come what may. I started selling and selling, without letup. Everything had to move: drawings, engravings, paintings old and modern, miniatures, knickknacks, everything! I . . . had to hang on.

A lot of people from the provinces and abroad were coming for the big exposition. Mañach worked tirelessly to promote his compatriots—amazing, how many of them there were! (I'm speaking of artists, of course): Nonell, Canals, Casagemas, Gosé, Pichot, Evelio Torent, Iturrino, Sancha, Sunyer, and heaven knows who else.

Young Picasso had just arrived with Manolo, and the two of them shared a studio with Mañach, who was pounding the pavement, trying to sell their work. He was more successful with Picasso, who usually sketched in the evenings, in a café. The sales covered meals and tobacco for the three of them, plus rent on the studio they occupied on boulevard de Clichy.

From Mañach, I bought the first three canvases that Picasso

sold in Paris: a bullfighting series, 100 francs for all three. I immediately resold them for 150 francs to Adolphe Brisson, the publisher of *Annales politiques et littéraires*. I wonder what became of them.

Soon afterward, Mañach asked me to come see the paintings in Picasso's studio. I arrived at the appointed time and climbed the six flights of stairs. I rang and rang, but no one answered. As I stormed downstairs, I ran into Mañach. "Did you go up?" he asked. "Picasso's there." "No, there's nobody at home." We walked back upstairs and went in. I spotted a pair of pallets with two long shapes on them, hidden under blankets: it was Picasso and Manolo. The little rascals were laughing at my expense while I was hanging on the bell cord.

Paintings stood scattered around the studio, and I chose some of the more interesting ones.

Canals, Vogler, ten Cate, and many others also found their way to rue Victor Massé.

Canals signed a contract with Durand-Ruel, then left for Spain, where he became an official painter. Picasso began to sell. A little pastel, "Espagnoles," went for 50 francs! Then, even better, four paintings for 225 francs—a fortune! Sainsère was one of his first buyers. M. Kapferer missed the boat: he was buying color engravings by Manuel Robbe instead. In his defense, it must be said that color engravings by Müller, Robbe, Bottini, Ranft, Villon, etc., etc., were all the rage.

A new publication, *L'Estampe originale*, was making a big splash, and a number of promising artists were involved with it.

Abel Faivre's ship had come in, and he was selling like mad. What a craze! People were fighting over his paintings. His witty and more personal humorous drawings didn't sell as well. A painting looks better in the living room . . . Eugène Blot never forgave me for selling him one. But I hadn't pushed it; he wanted the painting, and was determined to have it.

Amazing, now Picasso was on a roll! Two paintings of heads sold for 110 francs. Sainsère bought a gorgeous painting—a child in a symphony of white—for 60 francs. Huc bought an important painting, *Le Moulin de la Galette*, for—wait for it—250 francs!

At least there were collectors (so few!) interested in emerging painters.

4

IN MOURNING.—I BREAK WITH MY MOTHER.—GALERIE B. WEILL IS BORN.—OUR FIRST EXHIBITION.— PERSEVERANCE.—ONE SHOW AFTER ANOTHER.—I SELL MY FIRST MATISSE.—THE FAUVES.—THE ACADÉMIE RANSON.—MAÑACH GOES BACK TO SPAIN.—I HAVE TO STRUGGLE ON ALONE.

November 1900—A family in mourning! My father got pneumonia, and died eight days later.

In addition, I was very worried about my sister's health. Since her marriage, [Adrienne] had been living in Saint-Germain-en-Laye,[1] where I visited her every week from Saturday to Monday. Boredom is an incurable illness, especially when it comes on the heels of a typical physical decline, and may even cause it. She was a frail flower from the Paris cobblestones, withering away in exile, and she awaited my weekly visit with feverish impatience. "You and she aren't made to live in the provinces," my older brother once said. "You need Paris." He was right. I once spent about a year in Nantes, living with some very kind relatives. I couldn't wait to get back. I don't mind being poor, but it has to be in Paris.

My sister's illness quickly took a turn for the worse . . . and then she died. I stayed by her side until the end, while my brother minded the store. It was so sad!

And what then? . . . What was the point of stirring up all the old bitterness? It wasn't of any interest to anyone. A confession? What would be the point of that?

With my mother still dead set against me, I left her for good, to go live on rue Victor Massé, on the sixth floor.

Business, fortunately, was picking up.

The sale of posters was slowing, which I thought was just as well. They took a lot of room in my little space and at this point were hardly bringing in any money.

What ambition! Am I developing delusions of grandeur?

Drawings and engravings were easier to display, and they sold for more . . . A real bonanza!

I hadn't lost touch with Mañach. Picasso was daily finding his way into more collections, which were interesting though few in number. Iturrino (Vollard's favorite), Pichot, and various other Spaniards were also reaching a few collectors. When you think of those paintings being bought in dribs and drabs because of their novelty, we seemed to be on the eve of an evolution (though revolution might be more accurate). What would emerge from this chaos? We would see.

I sold two Picasso paintings to André Level, who paid me 200 francs—a rare event in 1901, and well worth remembering.

In November of that year, Mañach came to see me and asked, "Would you be interested in mounting an exhibition of emerging painters?" "Am I interested? That's been a dream of mine." As it happens, I had mentioned that wish to Mme Mayer a few days earlier, but she had said, "You must be mad! Do you want to stagnate your whole life? Whatever you do, don't stop selling antiques." Could she be right? I was painfully disappointed, and didn't press the matter.

Now I could welcome the person who could help me realize my dream!

(And that was the fortuitous event! . . .)

Mañach and I agreed to start the initial preparations right away. I bought fabric for curtains, and Mañach became drape installer, carpenter, and locksmith . . . it was all hands on deck. As if with the wave of a magic wand, my shop suddenly started looking very impressive. I had "Galerie B. Weill" painted in big letters on the storefront. The first gallery for emerging artists was born.

Lobel-Riche engraved an amusing business card with the phrase *Place aux Jeunes!* [Make way for the young!]. Mañach curated the inaugural exhibition, which opened on December 1, 1901. An attractive little catalog with a preface by Gustave Coquiot went to all the movers and shakers in the arts.

Exhibitors: Bocquet brought a glass display case for his artistic jewelry; Paco Durio showed jewelry very much inspired by Gauguin, whom he admired tremendously; he owned several fine paintings by him. Girieud came to the vernissage in a jacket and top hat—what an image! He wanted to look elegant for his first exhibition. Launay was a gifted painter who died too young, before he was able to show what he could do. Mlle Warrick exhibited some promising sculptures . . . Whatever became of her?[2] Maillol showed some impressive terra-cotta figurines along with a few less interesting paintings.[3] We also showed Raoul de Mathan, a talented painter.

I won't surprise anyone when I say that nothing was sold. Nonetheless, that first exhibition made a big splash, which was very encouraging. A lot of people came.

Our second exhibition was held on January 2, 1902. We had decided to alternate shows of paintings and drawings. The latter sold better and allowed us to wait to exhibit the former.

Abel Faivre, Cappiello, Hermann-Paul, Gosé, Sancha, Sem, and Roubille were the exhibitors.

We made 600 francs in sales that month. So it was working; we could hang on.

In the exhibition that opened on February 10, 1902, we showed Matisse, Marquet, Flandrin, Mme Marval, and Mlle Kruglikova for the first time. Only Kruglikova complained at the smallness of the space. She sarcastically lay down on her stomach, claiming it was the ideal position to look at a painting that was hung very low. Marval, wearing an outfit only she could have thrown together, was much less pretentious, and doubted that her work would sell. "Price them any way you like. Four sous, if you like." Petitjean exhibited with the group, too. He was a very decent man, but you felt he was stuck.

Still no sales. Visitors weren't very interested in this kind of painting yet and came only out of curiosity.

Perseverance!

Frantz Jourdain bought a small Marquet snow scene for 50 francs . . .

The prices for Chéret's pastels were rising fast. By contrast, Odilon Redon's drawings didn't attract many collectors. Still, Maurice Denis paid 300 francs for two pastels and two drawings, which was wonderful for Redon, and also for me. To Denis's credit, he looked askance at what he felt was a ridiculously low price. When an infrequent collector wandered into my place, I didn't make them pay for the others.

Vollard complained about me to Redon, and tried to convince him that it wasn't in his interest to sell me his works. "She's giving them away for nothing," he said. Redon paid him no mind, thinking that giving advice is cheap and costs the giver nothing. I continued to buy and sell as many pastels and drawings by that charming artist as I could. I enjoyed Redon's company and often went to see him. He had the happy laugh of a child, and we would howl with laughter when we were together.

Vollard had earlier pulled the same trick with Maillol. When Vollard asked me the prices of the sculptor's figurines ("Tell me!"), he thought they were too cheap (especially as I was giving

him the dealer price). Given that, he should have bought them, but he didn't. Was he hoping to get them from Maillol at an even lower price? Or was this just so he could badmouth me to the artist? A charming character.

(Extraordinary, how much help and encouragement I get!)

Fight! Defend yourself! The story of my whole life!

On March 5, drawings and watercolors by Willette, Wély, Léandre, Depaquit, and Mirande. We're getting there! Willette's drawings were a big success. Wély, Léandre, and Mirande made sales, too. Depaquit was the most gifted of the lot, but he didn't much appeal to people; still, for a couple of francs, a few yielded to temptation.

What was wrong with these people? . . . Another Marquet sold: 40 francs . . .

The demanding Kruglikova found a less demanding collector for one of her canvases. She was so flabbergasted, she quit talking about flopping down on her stomach.

Then a Picasso painting sold for 160 francs: *On the Upper Deck.*

To show Picasso's paintings in a bigger space, Mañach persuaded Vollard to mount an exhibition at his gallery on rue Laffitte. The exhibition took place, but Vollard was so taken with the work that the collectors Mañach had invited found the door shut in their faces.

On April 1, we gave Picasso a new show along with Bernard-Lemaire, who painted figure studies in the style of Renoir. Except that Renoir does it better . . .

No sales.

Still, Picasso persisted.

May 1: drawings and watercolors by Braun, Câmara, Gottlob, Grün, Rouveyre, Villon, and Weiluc. Alternating shows benefited the painters because I used the profits I made on drawings to try to acquire paintings. Slim profits! Slim acquisitions!

In April 1902, I sold my first Matisse painting: 130 francs, of which he got 110.*

June 1902. This show recapitulated the six preceding ones. The mixture of drawings, watercolors, and paintings made the place look very lively.

A little Matisse study sold for 70 francs; a Flandrin went for 50. As with paintings, collectors still hesitated to buy emerging artists' drawings and watercolors. The art critics were just as hesitant, but they hedged their bets and stocked up . . .

Henri Matisse had started out working as a clerk for a *notaire*, but quit to paint, like Gauguin. It's a tough life, isn't it, Matisse?

His wife, who was so nice, ran a dress shop on rue Châteaudun. Their sixth-floor single room was just wide enough for the bed.

The day I went up there, we had to leave the door open so he could show me some paintings: first-rate still lifes and amazing figure studies. I took a few, to see if I could get people interested.

Matisse studied under Gustave Moreau, but easily evaded the *maître*'s influence. Actually, Moreau never tried to smother the students who showed personality.

Matisse was the senior student in the atelier, and doing distinctive work in plasticity, volumes, and light. This gave painting a new direction and created the school that Guillaume Apollinaire soon afterward dubbed the "école des Fauves."[4] Ignoring the jeers that greet every innovator, Matisse pursued his work, constantly renewing himself. But collectors gave his restless experimentation no credence, a fact made all too clear by his lack of sales.

And then there were Luce, Milcendeau, and Henry de Groux, who hadn't yet said his last word on the *Divine Comedy*. Also

*In a recent interview, Matisse bitterly said that I had sold some of his paintings for 20 francs, with great difficulty. He is mistaken; never less than 90 to 100 francs, except for unimportant sketches.

Ranson, a gifted writer and painter who wrote a satire for the Grand Guignol theater that was as clever as it was amusing. He founded a painting academy on rue Henri Monnier [in the 9th arrondissement] that became the gathering place for our young *hopefuls*.[5] After his premature death, his widow moved the academy to Montparnasse and continued to run it alone.

Also in the show were the painters and draftsmen Sunyer, Torent, Launay, Pichot, Wély, Léandre, Grün, Canals, Gottlob, Sancha, etc. They all got lucky and made sales. Just look at the cash register!

I wound up with a profit of 750 francs! Life can be pretty good, can't it?

For each painting, Mañach was paid a 25-franc finder's fee. Such profits! It was terrific!

Mañach was called back to Spain on family business. From then on, I had the heavy task of continuing the work that he had so well begun. Thanks to him, artists now knew the way to my gallery, which allowed me to regularly show paintings by these emerging artists, and their numbers continued to grow.

FOUR DAYS IN LE HAVRE.—THE ACCIDENT ON THE TRAIN.—
EXHIBITIONS RESUME.—ALCIDE LE BEAU, VAUXCELLES'S
DARLING . . . FOR A YEAR.—I BUY MY FIRST DUFY.—
MAX JACOB MEETS PICASSO.—BOTTINI, METZINGER.—
THE BIG PAYOFF.—THE CLOVIS SAGOT GALLERY.—RUE
RAVIGNAN.—MY WINDFALL . . . GONE!

June's enormous profits allowed me to spend four days in Le Havre for the July 14 festivities. I took my sister's eldest son along, who was seven at the time. We had wonderful weather, and

the short visit was a relaxing break for me and a dream for the boy, who had never been out of Saint-Germain. The trip home, unfortunately, ruined everything: An accident on the train almost killed him. If I hadn't just moved him to another seat, to get him out of the wind, he would have been killed instantly. I had taken his seat, so I was the one who was injured instead.

A badly loaded freight train was passing ours. The rattling of the train had shifted its cargo of huge wood beams, and they scraped the length of our train. When it got to our carriage, one of the beams came loose, smashed our door and window, and slammed down on the boy and on my right arm. Another beam jammed the wheels under the carriage, slowing the train.

Jerked awake, my nephew found himself buried under shards of glass and wood, and began to cry. Thinking he'd been hurt, I panicked and brushed the debris away, but . . . he didn't have a scratch!

Then I felt a sudden, sharp pain in my arm, and realized that I was the one who'd been hurt. I had a broken radius and ulna, and the pain was unbearable. I was the only person on the train to be injured, and eventually someone came to check on me. They wanted to put me off at Saint-Pierre-du-Vauvray, where the accident happened, but I refused because of the boy. So I gritted my teeth, trying not to faint, and we made it back to Paris. The conductor apologized and tried to sweet-talk me. We got in three hours late.

Pain! Surgery! X-rays! Three months in a cast! Plus bad faith from the Compagnie de l'Ouest, which denied any responsibility for the accident. They offered me 3,000 francs but without admitting negligence, and I turned them down . . . I won't go into detail about the case, except to say that I argued it myself and got 10,000 francs . . . but the negotiations and payment took nearly two years.

My store was closed for two months; luckily, it was during the summer.

Still, I wasn't about to spend the time napping, so I reopened on September 25, 1902.

While still denying responsibility, the company paid me a thousand francs, which gave me some breathing room. Also, I was able to cover my medical expenses.

The gallery dawdled along, selling a few things now and then. On October 5, I started exhibiting again, by myself this time. A group of four painters: Girieud, Launay, Picasso, and Pichot. For the artists who didn't sell, I waived the 25-franc per painting finder's fee they used to pay Mañach, for which they were very grateful.

But business was slow, and I only sold a few drawings.

Just the same, collectors took an interest in some of Ranson's pastels. And Alcide Le Beau scored a real coup: one of his canvases sold for 230 francs! (I apologize for all these numbers, but they are essential, and meaningful when compared to the figures reached later on.)

Vauxcelles, a friendly art critic, followed these young people with interest. But like anyone, he can be wrong. Like the day when he said to me, "I would buy Alcide Le Beau paintings, if I were you." "I'd like to, but I'd rather wait a while." "You're making a mistake." A year later, I asked Vauxcelles, "So what about Alcide Le Beau?" "No, no, no!" Was he wrong in the affirmative or the negative? . . .

A carefree-looking young fellow with curly blond hair offered me an attractive pastel he called *La Rue de Norvins* for 30 francs, and I bought it. This was November 1902, and my first meeting with Raoul Dufy.

Willette's girlfriend Christiane had inspired him to make his best drawings, yet he dropped her like a hot potato, leaving her so poor it was painful to see. The man she rescued from poverty had "chivalrously" ransacked the poor girl's home, so I bought all the surviving drawings she brought me . . .

I was occasionally able to sell some of Picasso's drawings and

paintings, but not enough to meet his needs. I felt bad about this because he resented me for it. He would look at me with those eyes of his, knowing they scared me. But if I wanted the gallery to survive, I had to buy work from everyone; I wouldn't make it if I handled just one artist. How could I make him understand that?

Max Jacob, who had become a regular visitor, asked me to introduce him to Picasso. That was easily done, and I made the introduction. Picasso spoke French pretty badly, and it was funny to hear our Max yelling at him in a kind of baby talk, trying to make himself understood. It was the way you might talk to a child or a foreigner, except that it only rattles them. Or, better yet, when you shout in a deaf person's ear, and they furiously snap, "Don't yell like that! I'm not deaf!" (Heard one day.)

December 18, 1902: an exhibition of drawings by Abel Faivre, Forain, Chéret, Helleu, Sem, Steinlen, and Jean Véber. We didn't strike it rich . . . at least not this time.

I thought my next-door neighbor might have to close up shop; I knew that his business was limping along. The woman who had financed it was demanding an accounting. Legal documents flew back and forth. What would be next? At one point this neighbor and I had talked about getting married. But since I was reluctant to give up my independence, he didn't follow through. (The fortuitous event . . .)

Christmas! New Year's 1903! Drawings, as usual!

I was able to get by without much, and I still think that's the best way to regain your balance. Bottini met a couple of good collectors. And Raoul Dufy sold a few canvases!

January 19, a new exhibition with a group of four emerging artists: Dufy, Metzinger, Torent, and Lejeune. The latter didn't hold my interest for long. Torent showed paintings that were pleasing at first and felt fresh, but when you saw them again, they seemed to go on repeating themselves. With Dufy, what came through was a distinct personality asserting itself. Metzinger was into Pointillism. "Division is the only thing that

matters," he said. He seemed to change his mind pretty often, but he was gifted. Though when he brought me his first canvases, I had my doubts: Did he do the painting, I wondered, or was it his mother? Why? I have no idea.

The three made some sales.

At long last, the Compagnie de l'Ouest paid me the settlement, 10,000 francs. Most of it went for expenses, covering various debts I'd incurred: I had paid small sums here and there for services rendered and made a few purchases, trying to invest my money . . . I should have put the rest aside for a rainy day. Except that whenever I have a little something, a terrific urge to buy stuff causes me to spend it all.

Can that be cured?

Lacking support, Picasso went back to Spain to make money. When he returned, around 1903 or 1904, he found that studio on rue Ravignan that would become historic. Clovis Sagot had opened a gallery at 46 rue Laffitte, having split from his brother, a seller of posters and prints.[1] The brother was all business, and Clovis was very much the artist. Such opposite personalities were bound to clash.

From then on, Picasso sold his paintings and drawings to Clovis Sagot. As for me, I bought them whenever I could, because he no longer gave me anything on consignment. It was always a struggle to make enough money, scraping by in Montmartre. He was tired of it . . . and I don't blame him!

The atelier on rue Ravignan, the place they called the Bateau-Lavoir, became the gathering place for these noisy young people, a whole artistic, literary, and pictorial army at battle stations, a revolutionary generation of outcasts from official painting and bourgeois literature. Their alarmingly frenzied get-togethers drew a cast of regulars: Apollinaire, André Salmon, Fernand Fleuret, Picasso, Manolo, Van Dongen, Max Jacob, Lesieutre, Albert-Birot, Casagemas, Mac Orlan, and many others I've forgotten . . .

A flood of new ideas and concepts was bursting out of Montmartre, a flowering that would blow away the pundits . . . and the world.

The jokes flew and money was scarce . . . but what the hell!

My god, my god . . . I was in such a state! I kept bumping into my furniture on the sixth floor on rue Victor Massé, high above my gallery!! The shop next to mine was going to be free. There was some friction involved, but I would get it.

This time, I had the Compagnie de l'Ouest settlement.

Meanwhile, I organized a March 10 show with Abel Faivre, Bottini, Helleu, Steinlen, Jean Véber, and Wély.

The sales covered expenses.

The day after I left my mother in despair, my friend V. had offered me hospitality until my place was ready. I was so distraught! This was when I got involved with the draftsman G., who had exhibited at my gallery. He seemed nice, and I let myself be taken in. It was a couple of months before I realized that I'd made a mistake . . . And my rainy day fund? Gone! Money that I set aside never lasts long, and like a fool, I was now down to my last sou. Kind of a habit with me, wouldn't you say?

DUFY INTRODUCES ME TO CLAUDINE.—DELCOURT, THE ULTIMATE BOHEMIAN.—I'M EXPANDING!—THE SALON D'AUTOMNE DEBUTS.—AT LAURENT TAILHADE'S.—LAUTREC AND DUFRÉNOY.—THE GUSTAVE MOREAU ATELIER GANG.—I SEARCH FOR A MATISSE.

Dufy became a regular visitor, and introduced me to Claudine [Brenot], his girlfriend. When money was tight, we often threw our leftovers together into a kind of hash called *frichti* . . .

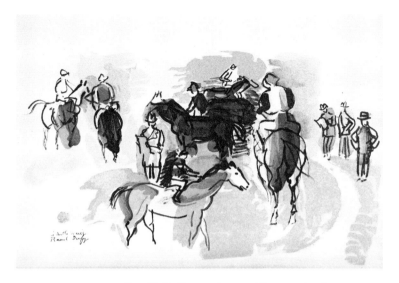

FIGURE 2. Raoul Dufy, *Chevaux de course* (Horse race), n.d. © 2021 Artists Rights Society (ARS), New York / ADAGP, Paris. The image appeared on page 90 of the original edition of *Pan!*

I found work for Claudine, so as to relieve Dufy of some of his worries (what worries?). Except that he just fooled around, and when he got bored, he took off for Le Havre. Friesz's girlfriend, who was friends with Claudine, took advantage of Dufy's being away to turn her against him, which wasn't hard . . . Gossip! Backbiting! It took so much work to settle everyone's frayed nerves. Having had his fun in Le Havre, Dufy waltzed back, fresh as a daisy.

As much of a bohemian as Dufy was, he wasn't in the same league as his friend Delcourt, whose woodcuts were in great demand and could teach Dufy a thing or two. This fellow Delcourt had been evicted from his place because he couldn't pay the back rent—he was on the rise, but not yet prized. Dufy offered him a room at his place, which only had two rooms, until he found another place to live. But once Delcourt and his

girlfriend settled in, they made no effort to leave. For the four of them, being poor together was unbearable. Dufy left for Le Havre, leaving a sick Claudine to be cared for by the couple. Delcourt did the shopping. One day Claudine gave him a hundred sous to buy something for lunch. He came back in triumph, having bought five lottery tickets at 1 franc apiece for a chance to win a lobster . . . They had to tighten their belts for the whole week.[1]

June brought the gallery's recapitulation show, paintings and drawings. Business was poor. The collectors stayed away.

At last! I was finally able to rent the shop next to mine, giving me two handsome spaces. All I had to do was to remove a partition and hang some fabric. My neighbor had long since cleared out, but the caretaker waited until the last minute to give me the keys, which kept me from doing the work sooner. She was a stage actress, and annoyed at having to clean up the place for me. I marched in at the stroke of noon, as was my right, and found her in a petticoat with a broom in hand, sweeping up some rags. Unconcerned by her somewhat ridiculous get-up, she was a little defensive. "I completely forgot to leave the keys," she said. "Why didn't you ask me for them?" I put on my most regal manner—you can imagine—and said, "My dear, you kept the keys, which was your privilege. But let's not play games. We're not on stage here!" Our diva tossed her head and said, "What a princess! There's no talking to her . . ." Okay, that would do for now. I left her hanging.

The workmen got busy right away so everything would be ready when the season started. By August, everything was done. I warned them that if they were hoping for a tip, we'd see about that later. I closed the shop for two weeks and went to Dinard to rest up.

The season got underway: engravings, drawings, antique miniatures—just look at the sales!

A juried show called the Salon d'Automne was launched . . . a sensational event![2]

The exhibitions resumed on September 2 with a group of five emerging artists: Auglay, Bétrix, Deltombe, Metzinger, and Müller. Of the five, I could see that only Deltombe and Metzinger had persevered. On October 10 of that year, 1903, another group, with drawings and watercolors: Abel Faivre, Chéret, Forain, Roubille, Vallotton, and Jean Véber. Once again, antiques paid the bills . . .

Lord, it's so hard!

Claudine was working and feeding herself. But you would think that she missed the times when she didn't eat every day.

The year 1904. Antiques, antiques, it's always antiques. But I can't stop putting on exhibitions, and on January 20 I again showed a group of four artists: Dufy, Duparque, René Juste, and Evelio Torent. Laurent Tailhade, who greatly admired Torent, wrote a catalog introduction that was so alarmingly laudatory of him that it put the other three artists in the shade. He was a fiery poet who didn't believe in half measures, and he jumped at any chance to make literature—but why Torent? To get the catalogs out in time, I went to Tailhade's house to pick up the preface, but it wasn't finished. Tailhade apologized and finished it in front of me, dictating to his wife. (They were both in their dressing gowns.) Words and more words, with gestures and exclamations! Inspiration was flowing. He strode back and forth in the room, stopping at times to watch himself walk, falling silent to hear himself declaim. I thanked him, and left. On the way out, I ran into Torent in a sitting room. He, too, was casually dressed, as if he were at home, and so were a couple of other young men . . . What was this . . . some sort of school?

When I saw Torent soon afterward, I asked him: "What

were you doing in that house? I don't think your mother would approve of such intimacies." (He had earlier introduced me to his mother, a very distinguished Spanish lady.)

I can't believe I was already playing mother roles!

Torent never went back to Tailhade's house.

Willette was still in vogue. His blue pencil sketches had a kind of brio. I bought a couple of them from a Monsieur Picon, a retired bailiff with a taste for the arts (bailiff and art, two opposite words!). He was a nice guy, and I did some business with him, quite happily.

May 3: drawings and watercolors by Abel Faivre, Chéret, Helleu, Steinlen, Lautrec, and Willette. Everybody made sales . . . except Lautrec. Picon, who owned the Lautrecs, let me keep them a little longer.

In a first, Dufrénoy brought me some paintings. I promptly sold two of them to Huc.

With some money in hand, I immediately got delusions of grandeur. I bought a really amusing pastel from Jean Véber . . . for 1,200 francs! But I couldn't find a buyer, and when I needed some cash, I let Mme Mayer have it at cost.

Wély's pastels were attractive and sold well (little women). His line wasn't as crisp as Helleu's, but he had fervent admirers.

If I wanted to go on showing emerging artists, I couldn't stop selling antiques. Their futures depended on it.

On April 2, 1904, an interesting group exhibited again: Camoin, Manguin, Marquet, Raoul de Mathan, Matisse, and Jean Puy. Camoin was the youngest of the group. Marquet was working with Matisse, and his scenes of Notre Dame and the Seine quays showed his grasp of the Paris atmosphere and the sharp eye of a true painter. He had met Matisse in Gustave Moreau's atelier and, like him, was able to slough off Moreau's influence. After lugging his canvases from dealer to dealer, Marquet finally had the satisfaction of people taking an interest in

his art. His work was both simple and sensitive, and was growing stronger by the day. Matisse was surrounded by a lot of young people in art and literature, friends from the Moreau atelier days. They were drawn to him as a creative innovator in painting whose new directions were amazing the establishment. His influence on these young revolutionaries was considerable.

I met Lebasque; what a nice young man! His painting was approachable and charming.

Lempereur, a talented painter, ignored his doctor's warnings and put his health at risk, defying illness as he downed one shot of Pernod after another. He lived in my building, and I was a doleful witness to his physical deterioration and pathetic death.

Marcel Fournier, who was more sailor than painter, exhibited as part of a group with Lebasque, Lempereur, Agard, Paviot, and Fernand Piet.

The wonderful Matisse still life I had sold for 180 francs was missing from his catalog, and we searched for it in vain. My own efforts didn't turn up anything. Did the collector keep it or sell it? I never managed to find out . . . ("Ooooh, such a saaaad story!" Damia might croon.[3])

I had an interesting series of signed original Ricardo Florès drawings from *L'Assiette au beurre*.

TRAVELING SALESWOMAN.—THE EXHIBITIONS RESUME.—
PICABIA AT DANTHON'S.—THE MITA MYTH.—A LAUTREC IS
SOLD . . . AND THAT'S NO MYTH.—BERNHEIM-JEUNE COMES
BY.—MY NEW NEIGHBORS.—THE GALERIE DRUET OPENS.—
GALERIE B. WEILL . . . IN THE DUST!

A pair of very distinguished-looking sisters moved into an apartment on my floor at rue Victor Massé. My new neighbors made an effort to get acquainted, but I felt intimidated; besides, I'm wary of people I don't know. They were both talented musicians. One was also a painter; the other taught piano . . . We would see.

Vacation time! What if I took a little loop trip? The Duchemin agency put together an itinerary for me, so let's go! To cover my expenses, I brought along a few collectibles on consignment to sell. They all went into a bag with a sturdy lock. I started in Rouen, where I sold two silver wine tasters. Then Tréport. In Dieppe, I sold an antique candy bowl. I reached Fécamp, whose casino was so cute I thought it was a rest-stop chalet. Saint-Valery-en-Caux. Étretat, charming; I was able to sell two antique knickknacks.

Sales in Le Havre were sensational! Lots of nice little deals. My expenses would soon be covered. Feeling quite satisfied with this initial result, I quit my tedious job as a sales rep.

Dufy happened to be in Le Havre, so I made a date to see him the next day. The weather was beautiful, and I walked up to Sainte-Adresse for dinner. It was getting late, and no one was visiting the lighthouses anymore, so the area was deserted. At the only cliffside restaurant, I settled into a big wicker chair facing the sea. The waiter probably hadn't expected extra work at

this late hour. I ordered an herb omelet that looked delicious, and was, followed by cheese and dessert. I gazed out at the sea, the twilit horizon, the sun brightening before setting in beauty. Its rays faded, and the darkness grew. I was alone, but I felt the need to talk, to share my feeling of wonder. "What a view! What a sunset!" I exclaimed, tempering my ecstasy. "Isn't it, though?" said the waiter evasively, as if he wanted to be somewhere else. And then it was fully night.

A quick walk back down to the [Hôtel] Normandy. Maybe the sight that had so transported me would give me beautiful dreams.

Dufy met me the next day, and we went walking, with a stop at the Hôtel Frascati. I then left for Trouville, as the weather worsened. I just wanted to take the train to Houlgate, where I would find my luggage and umbrella. In the meantime, a driving rainstorm left me dripping wet as I called on a few more antique shops, but made no sales. Réjane was in town, traveling in her two-mule carriage (this was 1904). She performed for a rapt Trouville audience, and was a sensation. I reached Houlgate in the evening. The weather was terrible and the sea stormy. I didn't try to do any business. Then Cabourg, with its charming beach. I spent two very enjoyable days in Caen. Bayeux was a pretty little town, and the women's costumes were gorgeous.

Lost out in the countryside, Isigny was hardly a town at all. You could walk a long way without meeting a living soul. Ah, a farm, at last! I went in and asked if there was a restaurant nearby. A woman kindly brought me a huge round loaf of bread and some delicious butter. I ate with relish, washing it down with some of her good milk as I underwent a lively interrogation. "Where are you from?" "Paris." "And what do you do in Paris?" (Inquisitive woman!) "Not much." "Oh, I know. You don't want to say, but you're in the theater, and you're on tour. Yes, yes, that's it! . . . I know the theater, (*sic*) and I could tell

right away by the way you talk." "I can't believe it! . . . How much do I owe you?" "Oh, nothing. I'm sure I'll see you perform someday . . ." "Really, you're too kind . . ." "How beautifully you speak!" She had made up her mind about me, and there was no way to set her straight. After thanking her, I went on my way.

I headed back down to Saint-Lô, but just to pass through. The countryside became more verdant and the vegetation more lush.

Then up to Cherbourg, where I spent two days. With the weather now fair again, the view of the Contentin Point and La Haye was magnificent.

In Upper Normandy, the sea isn't such an intense, brilliant green. This really is the Emerald Coast.

A wonderful outing on a sailboat. I found the old Cherbourg neighborhoods I visited very odd. I asked for permission to visit the naval base: granted! It set my French heart aflutter!!!

Return via Coutances where the landscape is so beautiful . . . and what good butter!

Seeing the sea at Granville made such a powerful impression on me that life suddenly seemed small and insignificant . . .

I was tempted to take a boat trip to Jersey and Guernsey, but my money was running low. The extra expense would shorten my trip too much. So I left for the cheerful little town of Dol.

Large-scale military maneuvers were underway, and the entire general staff had invaded the hotel. It was impossible to get any service, and the racket lasted until four in the morning. They finally left, and I could get some sleep!

A little train leads to Pontorson, and from there you walk along the causeway to Mont-Saint-Michel.

Touring the abbey dazzled me. The guide was remarkably intelligent, which rarely is the case.

I then left for Saint-Malo. I love that city with its ramparts, narrow streets, and picturesque, bustling old neighborhood.

From there you can go on outings in every direction, by boat and by tram. Saint-Servan by the train over the water. Paramé. At Cancale, a fishing port with oyster beds, you eat oysters right on the spot. I sent mail to friends and acquaintances. The weather was beautiful, and Mont-Saint-Michel could be seen in the distance. I visited the Rothéneuf carved rocks, which have become a pilgrimage destination. The hermit-sculptor was still working without a break. His task was far from finished.

By the ferry, you can go to Dinard and Saint-Enogat; by tram, to Saint-Lunaire and Saint-Briac. The trip from Saint-Malo to Dinan along the Rance River is wonderful.

It was time to think about going home. I headed to Fougères, and from there on to Rennes. What a depressing city! Made gloomier by a torrential downpour. What was keeping that train? I returned to Paris.

I was delighted by my trip. It did my morale and my body a world of good.

With the first days of September, it was time to get cracking!

I sold some antique knickknacks along with a few modern drawings. Also two sketches by Picasso, that lucky duck!

The exhibition season opened on October 24, 1904, with five painters: Raoul Dufy, Girieud, Picabia, Picasso, and Thiesson. Picasso and Dufy led the group.

Picabia was a fervent Impressionist. He was a little too taken with Sisley . . . but he was so young; give him time . . . His prices were high, though . . . 200 francs. He'd started talking with Danthon,[1] a dealer on rue la Boétie who was the first to use the procedure of raising prices through exclusivity. That meant he raised the price of paintings by a given artist (who went along with the scheme) in exchange for all they produced. I thought this was immoral when a painter already had something to say, but even worse when they were just starting out . . .

For Picabia, the maneuver ultimately led nowhere. But

young Mita, with whom Danthon launched this toxic system, got very full of himself. Later, he went out of his mind, and died.

Not long afterward, I happened to get hold of a painting by Mita. (I had never warmed to this artist, despite the public drumbeat around his name.) The painting cost me 100 francs, at a time when Danthon was selling them for 1,500 to 2,000. I offered it to Danthon for 150 francs. He counteroffered 10 francs! That was all I needed to know.[2]

So I warned Picabia against this mirage. But the next day he said, "I've made an arrangement with Danthon. From now on my canvases aren't 200 francs, but 1,500." "That's fine," I said. "Do you want more?"

I didn't even try to sell the Picabias, for good reason.

Thiesson, too, was steeped in Impressionism. I thought him charming, but a bit eccentric. At the Salon des Indépendants one day, I saw a retrospective of his work. It was a wide selection, and each painting bore a black crepe ribbon . . . He had died, apparently.

But a few months later, he showed up in the flesh. "What happened?" I asked, astonished. "So you aren't dead after all!" "Apparently not." "What was that nonsense all about?" "I wanted to know what people would say about me, about my painting." "You can't go around pulling stunts like that!" The poor guy looked so happy! As it happens, his "death" had gone quite unnoticed.

What do you know! Sainsère bought one of my friend Picon's Lautrecs for 350 francs. "You see, we'll manage to sell them yet," said Picon. "You think so?" One of those Lautrecs showed Granier and Guitry in the play *Les Amants*. I wrote to Maurice Donnay, the playwright, inviting him to come see it. When he came, he said, "You can't recognize either one of them, and besides, it isn't finished . . ."[3]

I also invited Monsieur Guérin of the Racahout Delangrenier company, who wanted me to alert him whenever I had a

Lautrec. His reaction: "Pfft!" (his usual tic). "Not quite what I was looking for." I apologize for giving all these names, but I want this memoir to be a truthful record, because many of these collectors might otherwise resent me for their belated perspicacity. Given the mistrust they always showed me, they have no one to blame but themselves.

My task was a tough one, as I was neither encouraged nor helped. But my reaction to people's indifference was to try all the harder.

Another Lautrec sold for 340 francs. What was going on? I invited the Bernheim brothers over to look at the Lautrecs.[4] One morning, when Odilon Redon's wife and I were chatting in the gallery, those gentlemen got out of their carriage and walked in, continuing their conversation. Motionless, I waited for them to deign to speak to me. "Those are the Bernheims!" Mme Redon whispered quietly, while frantically gesturing to me. "I know!" I answered, even more quietly. "I know them as well as I know you." Finally, one of them said, "You have some Lautrecs to show us?" "Right there on the floor," I answered. They took one look and immediately headed for the door, saying, "They're not for us." They left without any explanation. Later, I figured it out: they thought I had made them myself . . . And no, Mme Redon, I won't bow and scrape . . . That can hurt me, I know, but I just don't do it.

October 1, a show of drawings and watercolors by Roubille, Grass-Mick, Galanis, Léandre, and Ricardo Florès. Roubille sold a few watercolors. He draws with great humor, but is quite humorless about emerging painting. Galanis exhibited some sketches for illustrations, but was starting to cast sidelong glances at painting.

Picasso's drawings were definitely selling (again!).

Antiques, antiques! Our salvation in spite of everything.

I started taking German lessons.

My neighbors Mlles P. managed to overcome my unsociable ways, and we became friends. This would have been a good opportunity to take English lessons with one of them, but I didn't want to bring up the issue of payment. It was too delicate, and I didn't want to take advantage of their kindness. It wasn't the same thing with piano and singing, since we were all amateurs.

One of their friends, Mme G. had developed an unusual way to teach singing. Her demonstrations might have been useful in practice if she were a little more methodical, and used some judgment. Gargling words is a technique that's too often abused. In singing, as in medicine, you have to take each person's capacities and temperament into account. The way singing is often taught results in many people's voices being damaged instead of improved, when the same method is applied to very different vocal mechanisms.

It was now 1905. A new gallery was rumored to have opened in rue Faubourg Saint-Honoré: the Galerie Druet.[5] Competition? Heavens, no! My Montmartre gallery? In the dust! Maurice Denis and his group were helping the new gallery director with advice, not to mention money. The new outlet should give more status to *jeune peinture*.

Many artists would have gotten considerable benefit from me if they had given me similar help and support.

It always seems that one person winning has to depend on someone else losing, whereas it would be so easy to get along and progress together. Though when you come right down to it, I'm not flexible enough to do it. I'm stiff-necked, forbidding, and I have a difficult personality. (Nobody has ever put this to the test, so they've never had occasion to complain of it.) I'm haughty and proud, and everything about me deters and discourages anyone with a notion to ask for my collaboration.

But I'm not playing the victim, and I'm aware of the solitude

in which I have always lived. I made my life the way I did because I liked it that way. I've had disappointments, but also many joys, and despite the obstacles, have created an occupation for myself that I thoroughly enjoy. On balance, I should consider myself lucky . . . and I do.

There's a lot of truth to the saying that when you've made your bed you have to lie in it. People have often criticized me for not putting money aside. But how could I? It's not like me to save up so I could finally have a little steak every day when I no longer had teeth to chew it.

That's enough about me. From now on, I will only talk about myself to make a point.

VAN DONGEN.—POOR, POOR MANGUIN.—FRIENDLY FRIESZ.—SEURAT AND VAN GOGH AT THE INDÉPENDANTS.—PROUD CHARMY.—A HOLIDAY IN MARLOTTE.—PAVIOT, A NICE YOUNG MAN.—DERAIN AND VLAMINCK, TWO GIANTS.—MARQUET AT DRUET'S.—APOLLINAIRE, THE FAUVES' EULOGIST.—SARCASTIC SALLIES IN FRONT OF ROUAULTS.—CONSTANTIN GUYS, 2 FRANCS EACH.

January 16, 1905. Exhibition of a group of four artists: Raoul Carré, Deltombe, Torent, and Kees van Dongen. Ah, dear Van Dongen! Allow me to introduce him. A tall, lanky guy with a blond beard and a mocking expression, he was an unmistakable character, definitely one of a kind. Always in sandals, his toes sticking out through holes in his socks. You could find him everywhere, from slums to penthouses, flirting with girls of every background and milieu . . . He sometimes just seemed to be lounging around, but with a certain distinction.

A very good guy, and a real painter.

January was a pitiful month, and so was February. The year was off to a great start! On the twenty-fifth, a new group: Beau-frère, Boudin, Dufy, Lautrec, and Van Dongen (who was getting a taste for it). Three very handsome Boudin watercolors from Picon's collection sold for 500 francs; a Lautrec hunting scene went for 600. At last, the group was having some success, and March was making up for the first two months. A Dufy watercolor for 100 francs? Don't even think of it, it would go to his head. Actually, it wouldn't. Dufy always kept smiling, on bad days and good, trusting in life and in himself. Optimism suited him, and I liked that. Marquet, Matisse, and Manguin also had a few successes . . . Was the big day coming?

Manguin's outlook was very different from Dufy's: Manguin always felt he lacked for everything.

"Just think, mademoiselle, I have a wife, two kids, a maid, a model, and a house in the country." (He didn't really lack for anything, I thought.) "My rent here is 3,000 francs. How can I manage if I don't sell any paintings?" I was actually concerned: How could he afford all that, when this was the first painting he sold . . . poor baby, and he didn't have any money? . . . Still, give me a break!

Friesz, a student at the École des Beaux-Arts, was sure to keep evolving.

He was a childhood friend of Dufy's, who pressed me hard to buy one of his paintings. But I preferred to wait; I didn't like the way he painted. Dufy was furious. "What a bitch!" he said. (How I loved those salty compliments . . . !)

Camoin, the youngest, led the group in sales for a while; Marquet was second.

That year, the Salon des Indépendants was sure to launch a shift toward les Jeunes, emerging painters. Interesting retrospectives by Seurat and Van Gogh would silence the most recalcitrant. The work wasn't to collectors' taste yet, but the artists were very enthusiastic.

You could hear howls of laughter from one end of the glass-ceilinged halls to the other, and jibes sharp enough to earn a demand for satisfaction.

This was the year I first noticed paintings by an unknown young woman who hadn't yet brought me her work, which showed distinct personality. I wrote and asked her to bring me a couple of paintings. She did, and I sold one during the following exhibitions. After that, Charmy became my best friend.[1] My affection for her only increased when I saw that she faced almost hateful hostility from painters, especially women . . .

Because Charmy didn't belong to any particular movement, people mistook her reserve, which stemmed largely from shyness, for pride or disdain. If being proud means not shaping yourself to a pleasing, ready-made formula, if being proud means never deviating from your chosen line of conduct in art in order to fit your personality to fashion, then yes, she was very proud. And she had the kind of pride I greatly value.

That pride and reserve won the trust of Charmy's close friends, the ones who appreciated her and whom she could count on. I don't mean to say that she alone had a monopoly on dignity. I found that same contempt for publicity and the need to be esteemed only by the elite in all my friends, the artists who interested and surrounded me. But those friends didn't experience the latent hostility people showed Charmy.

She was sensitive, so did she suffer from this state of affairs? . . . Hardly!

That said, we continued to rank her among our good painters.

On April 2, we exhibited a likeable group: Camoin, Raoul Dufy, Mlle Gilliard, Marquet, and Van Dongen. I never saw Mlle Gilliard again; she was talented. The others had their usual modest successes.

The group on May 12: Bouche, Dufrénoy, Friesz, Minartz, and Ranson. Minartz painted appealing subjects: music-hall

scenes and women out on the town. Bouche, who was exhibiting with me for the first time, was less happy than his comrades in the group.

August and September, vacations. As usual, selling antiques allowed me to wait for emerging painting to see better days.

I went to Marlotte for a couple of days and stayed in a comfortable hotel, but the snobbish people I found there drove me up the wall.[2] I tried to keep to myself, but it wasn't easy.

What a delightful stay! Every conversation was about battling wasps and mosquitoes, which were everywhere. We had to protect ourselves night and day. We would meet at breakfast each morning, some with swollen noses, others with bumps on their foreheads, their necks, their arms, their hands, their . . . Yes, indeed, a delightful stay!

Paviot inaugurated an exhibition in October, and sold one painting. He was from Lyon, a charming young man, and a straight arrow. You could kill yourself trying to make him change his ways. It would be nice if you could get him to tell a joke. I tried . . . and it was a complete failure . . . After mulling over something I'd said at least three years earlier, he boldly spoke up: "You know that thing you once told me? It was a while ago. . . ." I no longer had any idea what I could have said, of course. But on balance, a very decent guy . . . very upright!

In late October, Matisse, Marquet, Camoin, and Dufy, exhibitors I've already mentioned several times, were joined by two impressive giants, Derain and Vlaminck.

Thus complete, the group suddenly became very popular. The wild Fauves were taming the collectors.

To help feed his five kids, Vlaminck played the violin in cafés. Life for this big joker was hard, but his cheerful personality and good humor shone through. Derain, though he was single, was struggling. I still have a letter he wrote me back then: "Send a few francs, I'm stuck in Le Havre."

Vlaminck was as blond as Derain was dark, and Derain's serious mien contrasted with Vlaminck's joviality.

Dufy expressed the desire to become part of the group. I agreed and told Matisse about it. He was furious, and shouted: "No! That boy just wants to infiltrate our group, and we don't want that! Stick him in the other room, if you like." A bit cranky, our great Fauve hope! So Dufy wound up *of* the group without being *in* it, and had a little one-man show in the other room. Friesz scored points with the gang by bringing a collector from Le Havre named Dussueil, who bought a painting from every member of the group . . . except Dufy, of course. (Did I mention that Friesz was his childhood friend?)

That was when Marquet signed a contract with Druet. Out of solidarity with his comrades, he continued to exhibit with the group in my gallery because the better-known galleries weren't yet open to emerging painters.

In November, the group was Charmy, Dufrénoy, Friesz, Girieud, and Metzinger. Only Charmy and Dufrénoy sold anything; one painting apiece.

Friesz's painting style was gradually changing as he got away from what he'd been taught at the École des Beaux-Arts. He was amazed and intrigued by the Fauves' approach, and was adapting. The change in the way he painted was a true evolution. From then on, he had to be reckoned among the most committed of emerging painters.

Apollinaire, who regularly visited my gallery, took a particular interest in works by these revolutionary artists, being an equally revolutionary poet. Those emerging painters were really stirring things up! But Matisse, the eldest, kept his distance. Picasso and Apollinaire became great friends, which made him distrustful . . . I wonder why? But he was reassured soon enough, and joined their clan.

Meanwhile, the poet Max Jacob had taken up drawing and

brought me a couple of sketches. He was so influenced by Picasso that I said I would wait before buying anything . . . He didn't understand, and resented me. All these young people were turning me into an altar server![3] Ah, 1906! It would bring all the happiness that I—we—hoped for. Like the year before, probably with some new painters, as usual.

On January 12, a group exhibition: Charles Guérin, Laprade, Marval, Ottmann, René Piot, and Rouault.

René Piot's brother Stéphane, who had earlier bought two or three Rouault watercolors (out of friendship for the painter, I think), came to see the show. Marval had some big nudes, and Piot got terrifically turned on by them. The cracks he made about them were so crude, I threw him out of the gallery. When I told Rouault about it, he promised to "wash his head." And he did.

When I ran into Piot at the Salon des Indépendants, he apologized. I didn't see much of him after that, but often enough to realize that his insanity had been only temporary.

At the Indépendants, people were making sarcastic remarks about the Rouaults. An Englishman lit a candle in front of the paintings and ran away, shouting "Bônnsoâr!" as people howled with approving laughter.

In his will, Gustave Moreau entrusted his museum to Rouault, naming him conservator. Rouault, a man with children whose works didn't appeal to collectors, was grateful for this valuable support. It would allow him to keep experimenting without worrying about public opinion, hewing to a path from which he would never deviate.

Lord, what a strange business this is! I sold a painting by Fantin-Latour for 2,700 francs (making a 150-franc profit) . . . So it goes, right? In the meantime, sepias by Constantin Guys— real ones—could be had for 2, 3, 5, or 10 francs!

9

THE JOY OF TAX (AS IT WERE).—MATISSE AND DOUANIER
ROUSSEAU'S HILARIOUS SUCCESS AT THE INDÉPENDANTS.—A
DEGAS FALLS INTO MY LAP, THEN OUT OF IT.—WITH DUFY
IN FALAISE.—PICON COMMITS SUICIDE.—COCO AND THE
TWO OLD MAIDS.—THE PRINT-COLLECTING COURT CLERK'S
COLLECTED PRINTS.—A SPLENDID LAUTREC.

The joy of tax: An inspector from the department of weights and measures walked into my shop with the friendly expression typical of all that organization's members. He had just been inspecting the dairy bar next door. "Your ruler!" he said. After checking to be sure he wasn't drunk, I said, "I am the mistress of the premises. What do you want?" "The ruler you use to take measurements." "What measurements?" "The measurements of frames and canvases." "I don't sell frames or canvases by the meter." "Well, you need a ruler, and you have to bring it in to be certified every year." "But I told you, I don't use one." "If you don't bring it in, you'll be subject to fines and penalties, etc. . . ."

It would be funny if it weren't so ridiculous. So I bought a secondhand folding ruler for 0.15 francs. Every year I got a bill for 7 or 8 centimes, and a summons to bring my ruler to the weights and measures certification service. There, you either waited in line or paid somebody to do it for you. The upshot of this rigmarole was that every year I paid a tax of 0.15 francs . . . Want any more? Later! . . .

The exhibitions followed their usual routine.

Antiques, antiques, forever antiques—my real silent business partners . . .

At the Salon des Indépendants this year, Matisse probably scored the most hilarious success of his career, when he showed

a large canvas, *The Joy of Life*. He shared the derision encountered by Henri Rousseau, who exhibited an equally important painting, *Liberty Inviting Artists to Take Part in the 22nd Exhibition of the Indépendants*. The two caused such a hubbub in the halls! Total strangers were exchanging opinions. I've noticed that in those situations, there's always some joker to make wisecracks and amuse the crowd. I've seen it in front of my own shop window. One day I even heard this admirable comment: "That one was obviously painted by a moron, but the real moron is whoever buys it!" Pow! Right in the child's eye!

The 1906 Salon des Indépendants sold a ton of tickets, and I only managed to see the Rousseau at the peril of my life. People had crowded onto a bench at the end of the hall, and I stood on it to see. I take up so little room . . . Suddenly there was a racket, and everybody ran off, causing the bench to tip over. I disappeared underneath it . . . This is what's called dying for the love of art (so to speak). Luckily, I extricated myself in good shape.

The sculptor Albert Marque joined the Matisse group, adding interest to a group that continued to be very popular and much talked about.

I was consigned a major Degas pastel at 500 francs (but only for two hours). That wasn't much time to sell it, and I didn't have the money to buy and hold it. A telegram brought M. Sainsère, who thought it very beautiful, but said, "The drawing of the leg is wrong." (Oh, Degas!) All that time wasted! Implacably, they took it back.

Durand-Ruel bought it, of course, and resold it for 7,000 francs soon afterward. (Oh, the eloquence of figures!)

I can already see the disbelieving smiles. "Couldn't she get the 500 francs? . . . Really, she's too much. Anybody would have loaned her the money." As a matter fact, no, they wouldn't have. (They might today, when I don't need it!)

Matisse asked me to do a show of watercolors by Jean Biette.

He put it together, and it was somewhat successful.

Lacoste and Roustan exhibited in my gallery for the first time. Lacoste had a strong personality.

The season was getting on. My friend Picon said he was going to a little place in Brittany he liked, and asked me to come join him. I promised I would.

I kept a record of the Lautrecs and other works that I'd sold for him or would sell in the future.

Dufy and Claudine left for Falaise, where they had rented a farm and its outbuildings for a song . . . Total comfort, in other words. They invited me to spend August there. Forgetting my promise to Picon, I set out for Falaise on a fine morning. Dufy was in Le Havre. Claudine met me at the train station with a wheelbarrow to carry my trunk . . . My trunk!

When we got to the house, I was given the grand tour. It was nearly three o'clock and I hadn't eaten anything since that morning, but I didn't see a fire in the stove, or anything . . . I looked at Claudine and she at me, stricken. "So there's nothing to eat?" "No, nothing." "What do you mean nothing? Is that why you invited me?" She must've been counting a little too much on me, because there actually was food: some potatoes and a few chickens. Luckily, I had anticipated the problem and brought subsidies. So we hurried out to go shopping, and eventually had lunch. "What about Raoul? Is he still in Le Havre?" "Yes, he went there to work." "Didn't he leave you any money?" "No, he didn't have any. He promised to send me some as soon as he could. Some coffee, too." "Oh, good! I'm interested in the coffee." But nothing came the next day, or the days after that . . . Then one morning Claudine walked in, glowing. "I got a postcard from Raoul! We'll have some coffee soon." She showed me the card, which informed her that he'd been working. He had sewn a 20-sou coin in the corner of the card. It was so funny I burst out laughing . . . She looked so sheepish.

Finally, we got good news! Dufy had sold two paintings in Le Havre. He was on his way!!

Lord, what feasts we had!! One night we all got so . . . mellow, I wonder how we managed to find our beds.

But all good things must end, and soon it was time to go home. I was excited by the paintings Dufy brought from Le Havre, so we agreed on a one-man show for October. Goodbye! See you soon! And I was off.

Back to Paris, back to business! Time to get serious.

Mlle du T., a relative of my friend V.'s, owned a magnificent eighteenth-century color engraving; a real beauty. She was asking 100 francs for it, so of course I bought it. Later, I sold it to Mme Mayer for 900 francs. V. and I took the profit and bought ourselves the finest Astrakhan [Persian lamb] jackets available, putting down a deposit, with a year to pay the balance . . . What about saving? Setting money aside? . . .

I then got some very bad news from Brittany. Picon, whom I'd completely forgotten about, had shot himself with a rifle. He must've been neurasthenic, but nothing in our daily conversations, which were very jokey, suggested he was in such a frame of mind. I was very sorry I hadn't gone to visit him. Who knows? It might have lifted his spirits.

That pained me . . .

Mlles P., my neighbors on the landing, had an atelier they were willing to share with a friend's daughter, a young painter who didn't have one. We only knew her as Coco, and she started coming every day.

Coco became very pretentious. To Mlles P., who were quite distinguished but somewhat old fashioned, she was constantly saying things like, "Those gentlemen think I'm amazingly gifted." ("Those gentlemen" were other painters.) "Those gentlemen like me. They pay me lots of compliments!" It was always "those gentlemen" here, and "those gentlemen" there.

Mlles P. could hardly believe her conceit . . .

Yes, yes, you guessed it! This was Marie Laurencin. Driven, as usual, by her hunger for extravagant sensations, she came down to my gallery one morning and told me point blank, "I want to meet a lesbian!" I didn't dare admit that I didn't know what that was, because she would've looked at me with contempt . . . She always struck me as a little unbalanced, though that didn't stop her from very skillfully making Chinese copies.[1] Soon afterward, she met the poet Apollinaire, who encouraged her to paint differently, and that was when she found her path: painting her head, over and over again, forever and ever. Still, she was something else!

She never came back to Mlles P.'s place . . .

When I worked in Mayer's shop, I learned a lot of interesting things about old and modern artworks, and I developed some expertise in eighteenth-century engravings, both color and black and white. They were currently very fashionable, which was doubling their prices.

Collectors would drop by my gallery hoping to do business, especially in old engravings, while trying to pull the wool over my eyes. The most frequent among them was the clerk of the 2nd arrondissement justice court. He had a very large collection of engravings, some two thousand items, of which at least a hundred were first rate. (How could he have collected all that?) One day, he showed them to me. They were in an indescribable jumble—closets and drawers so stuffed with engravings that it was hard to find the best ones. "I don't even know what I have," he told me. "I'd like to draw up a catalog, but I don't have the time. Would you be willing to take on the job? When it's finished, I'll entrust you with the sale of my collection." I accepted with joy,

not realizing the incredible amount of work I was undertaking. I soon did, but was determined to complete the project. And I was happy to do it. I started the very next day, and labored at the huge task every evening from seven o'clock to midnight or one in the morning. I'd like to say I enjoyed it, if it weren't for the constant presence of the clerk. Not only did that insipid man not help, he seemed to enjoy mixing everything up. He was suspicious and so self-centered that if I had worked all night long, he would have thought it perfectly natural . . . Once I got home, I often did work all night, organizing my index cards . . . I still wonder how he could have collected so much. For this, I was paid all of 300 francs! But I had agreed to that tiny fee because I expected he would give me the collection to sell. Unfortunately, I hadn't reckoned with my host!

A month later, my catalog was ready. But before delivering it, I had the idea of showing it to a couple of dealers first. (A stroke of luck, as will be seen.)

There was nothing wrong with that, since he was going to have me sell his engravings. To get things going, I even brought him a dealer who might make the purchase if the price were right. But the clerk kept putting off meeting him for the flimsiest of reasons: He couldn't see anyone right now, he didn't have the time to show his engravings, whatever . . . I had to face the fact that the clerk had just wanted me to create a catalog, organizing and filing his engravings—a job he could never have been able to do himself—and then to drop me.

Confronted with so much bad faith, and realizing that I would never get anything out of this person, I demanded my fee several times, but he ignored me. So I went ahead and sued him in the commerce court. There, he swore by all the gods that I had never created a catalog, and that therefore he owed me nothing. My witnesses were outraged by this pathetic loser's cynicism and lies. As one man, they swore that I had brought and shown

them the catalog. Naturally, I won my case, and he was ordered to pay my fee and costs . . . To think this was a clerk of the justice court!

October 1906. A handsome one-man show for Raoul Dufy was held, though his very strong personality made success problematic . . . Still, he went on waiting with a smile on his lips and great self-confidence.

Jeune painting still wasn't supporting its practitioners (or its dealer). We had to rely on our side jobs.

Academic painting sold so much better. Why persist in handling Jeunes? Shouldn't I consider switching? No! I would rather eat bricks than do something I disliked. So there!

A businesswoman who handled paintings by the likes of Henner, Vibert, and Bonnat, etc., etc., gave me on consignment a superb Lautrec that she wasn't able to sell. Its subject was a little risqué, but the drawing was so crisp and fine that no one would hesitate to hang it in their home. In the foreground, it showed a bare-breasted woman lying down with another woman behind her, gazing at her.

After a great deal of bargaining, I sold it for 1,200 francs to a Monsieur Libaude, an auctioneer turned dealer on avenue Trudaine [in the 9th arrondissement]. All he saw in the picture was a man and a woman lying down . . . So far, so good.

But when he showed the Lautrec to some collectors, they opened his eyes to the ambiguity of . . . "the subject"!

Very upset by this revelation, Libaude could think of nothing but ridding himself of this "compromising" item.

The beautiful picture was brought to the auction house at the Hôtel des Ventes. It was displayed the evening before the sale, and buyers could contemplate it at leisure. The next day, however, our auctioneer was seized by a somewhat belated attack of prudishness, and sold it under the table. With the result that the public, which had admired the picture without tittering on

the day it was displayed, now erupted with a flurry of tasteless jibes on the day of the sale ... This remarkable Lautrec went for just 1,500 francs.

10

A NEW ELEMENT: BOOKS.—METZINGER AND CHANGING TASTES.—THE DISGRUNTLED LAWYER.—A WOMAN ON MY HANDS.—A TRIP TO FRANKFURT AND ALSACE.— DUFY'S PROPHETIC LETTER.—A PRIX DE ROME WINNER GETS CARRIED AWAY.—CZÓBEL, MATISSE'S STUDENT.—CUBISM AROUSES PASSIONS.—MATISSE IN GERMANY.—DRUET PHOTOGRAPHS.—A VACATION IN BEAUFORT, DRÔME.— LÉON LEHMANN.

To wrap up the year 1906, we offered collectors a new quintet of painters in addition to our appealing Matisse group: Baignières, Desvallières, Charles Guérin, Laprade, and Rouault.

Amazing, how much money those shows bring in!

Those profits were so outrageous that I had to borrow my friend V.'s jewels ... and hock them!

Damn, damn, damn!

Help, you antiques! In an effort to boost my sales figures, I put my personal library up for sale.

Very impressive, a store window full of beautiful books! And the comings and goings of buyers gave the illusion that I was doing a colossal business.

Given the ups and downs of commerce, I had to rebuild my library several times.

In January 1907, I exhibited four painters, Charmy, Robert Delaunay, Halou, and Metzinger, and a sculptor, Ottmann. Metzinger had replaced Pointillism with "tiny squares." (Be kind, oh, my unknown beauty!) "Don't talk to me about division," he said. "It doesn't exist." (Third transformation.)

Poor Metzinger! I can still see him at the Indépendants, repainting the background of one of his paintings on the changing advice of his friends, who had conspired to alarm him.

"Oh no, old man. Your background doesn't work with the figure. I would paint it red."

Metzinger scraped the paint off and painted it red.

"What the hell did you do?" asked another. "Blue is what it needs!"

He scraped it off again and painted it blue.

"Is this your painting?" asked a third. "You completely messed it up down below!"

This went on until Metzinger finally realized they'd been pulling his leg. Stoically, he repainted it the way it had been at the outset. He then picked up his ever-present cane, and with great dignity walked out without saying a word.

Matisse was beginning to make his mark; Dufy was slowly coming along; Marquet was the top seller; Derain and Vlaminck, mere crumbs; Friesz did what he could, kept himself busy; Camoin had highs and lows.

From then on, that group exhibited in my gallery twice a year; Vallotton joined his comrades this time.

The fierce partisans of a movement I didn't like once burst into my shop in a rage and showered me with insults and sarcastic remarks. "Aren't you ashamed to be selling such garbage?" they shouted, waving their fists . . . My martyrdom went on and on . . . Poor innocent woman! Poor victim! Actually, I was secretly proud. I wasn't going unnoticed . . . I laughed and laughed.

One day a pathetic-looking painter brought me a couple of his canvases. I couldn't honestly muster any interest in them. "Goddammit," he exclaimed, pointing at the paintings around me. "It kills me to see trash like this being sold!" He stormed out, slamming the door. His irritation was evidence of something in art that can't be helped: it's legitimate to push aside whatever stands in the way of the truly talented.

At least our young hopefuls were causing a lot of talk; they were unsettling people. That was good! Patience!

○─○

My friend V. was doing odd jobs for a woman friend who was married to a lawyer. Attorney M. had had his wife's portrait done by a painter I didn't know and didn't care to know, though the household considered him a genius. M. was confident of his artistic knowledge (and given his profession, what he said was law), but still wanted my opinion. So I hurried over to see this masterpiece. Uh-oh! Hold me up, before I keel over. "So what you think of it?" asked M., in a way both friendly and triumphant. "It's actually not all that bad." (Compared to what? What did I know?) "A little academic, maybe . . ." (In reality, the "opinion" he sought was a flattering appreciation of his taste, while I hid my own pictorial predilections.) My words clanged like the tolling of a bell. His smile froze. I felt embarrassed, and didn't know what to say . . . I had blundered. "Thank you . . . Goodbye, mademoiselle." I got out of there—whew! The mood lightened . . . It's hard, not being able to hide one's thoughts! . . . But it's a privilege, and a wide-open field for psychological discoveries. Do your odd jobs, dear V., and don't ask me to appraise any more artwork for these rare birds! (Not that rare, actually . . .)

Claudine became so grouchy that Dufy left to go work in Le Havre. I helped the rash creature rent a room, and found her some sewing work, so she could manage alone; you never know. She used the first money she made to travel to Le Havre to confront Dufy and make a scene . . . Crazy woman!

I'm only describing these things because I was involved in them.

Now sick and tired of Claudine, Dufy turned her over to me, and dumped her. So now I had a woman on my hands! . . . What a situation for a *marchande de tableaux*!

For my having tried to help her, this lady's gratitude knew no bounds. She cursed me as the author of all her misfortunes (me!). I had caused all those scenes . . . Her thoughtlessness was too much, and I kicked her out. My nerves! Tears!

My friend V. continued to see her, which annoyed me. Eventually, Claudine offered her apologies and I accepted them . . . but from then on, we each kept to ourselves. Dufy, who had been taking it easy in the meantime, left for Marseille.

Vacation. I left on a two-week trip to Frankfurt am Main, and came back through Alsace, seeing family.

September. Business! . . . One should never go away; coming back is always depressing.

Modern painting was selling so poorly, it was discouraging . . . Result: the shows happened less regularly . . . So much effort for so little result, because I couldn't set items aside and create a reserve. Then I could buy pieces that were in demand and wait until les Jeunes came into their own. But where could I find the money? Nobody had confidence in me. I should just give up. At least with antiques I could keep going; there's always turnover . . .

Just as this crisis of self-confidence reached its peak, I got a letter from Dufy in Marseille. So as not to spoil it, I'm going to quote it in full. I'm sure Dufy wouldn't mind, because this very surprising letter was prophetically inspired, and came from a real artist.

MARSEILLE, OCTOBER 20, 1907

Dear friend:

I left Paris without seeing you . . . I would have liked to talk, but I was in a hurry to get here. I didn't want to spend money in Paris, and I wanted to see if my funds would allow me to live here.

. . . Friesz is returning to Paris, which is too bad! He'll come

back in a few months. I am working here. I've had more beautiful weather in two days than the whole summer in Le Havre. I have a room near the port, with a splendid view. I can work down by the harbor. Life isn't expensive. I'm full of energy and as soon as I have a few canvases, I'll send them to you. I'm counting on you, etc.

I especially would have liked to talk with you before I left, to cheer you up, and cheer you about your business. When I came back from Le Havre, I saw that your window, which used to be reserved for paintings, was full of antiques. Why? You seem to have dropped painting, which is a terrible mistake. Support us, the way you have always supported us, the gang. But do it with real commitment, or don't do it all, otherwise someone will take your place, and that mustn't happen. *You must know that in Matisse, Vlaminck, Derain, Friesz, and a few others, you have the painters of tomorrow, and for a long time to come. After all, wasn't that clear enough at the Salon? Compare the intensity of life and thought in their canvases with the boredom and futility in most other canvases, even those by young people who grow old in a couple of years! Look at Matisse and Friesz, who get younger every year. They are increasingly fresh and vigorous. Come on, for god's sake! Courage! You're clearly annoying plenty of people already; if possible, try to annoy more of them. For heaven's sake, find a little cash, and go for it! Keep your shop looking the way it always has; put the antiques aside, and above all, don't abandon painting. I'm sure it's in your best interest, and in fact it's your only interest.*

Answer me quickly.

YOUR FRIEND,
Raoul Dufy

It was only later that I realized how much comfort that beautiful letter gave me . . .

But reading it revived my taste for the business. My crisis passed, and I was grateful to Dufy for that.

After a four-month break, I finally started exhibitions again, and on November 2, 1907, I brought together the usual group I mentioned earlier, of Camoin, Derain, etc.

My rent, which was 1,500 francs for the two shops, was raised to 1,600 francs. This was my New Year's present for 1908. The previous year, 1907, hadn't been great. Let's see what this one had in store for us!

The January 6 group: Marie Laurencin, Marval, Flandrin, Léon Lehmann, and de Mathan. A few new artists in the group. Absolutely nothing to report.

Buoyed by Dufy, my courage certainly wasn't flagging . . . but I couldn't give up antiques; the success of the modern depended on them . . .

What's this I was hearing? What was I seeing? Could this be the savior? A painter, a Prix de Rome winner, was fascinated by emerging painting. He lived in the avenue Frochot [apartment] complex across the street from my gallery, and came every day to gape and express the weirdest ideas about this kind of painting.[1] I listened very patiently . . . One day he said, "I've got it! Come and see!" I went over and he showed me a self-portrait: red eyes, green eyebrows, yellow hair, purple nose, blue lips . . . basically, a set of paint chip samples. Whaa? It was, it was . . . (Oh, yes, it was a piece of . . .) "I wonder if I should exhibit it at the Cercle Volney.[2] They would make such a stink!" I couldn't believe it! He wanted to shut me up. I exulted, and laughed. He took that at face value and a few days later asked me, with the chumminess of a man who felt sure the deal was in the bag, "So, how much would it cost to take over your gallery?" "Gee, I don't know. I've never thought about it. Fifty thousand francs, maybe." I expected to see him jump . . . Not at all, he just left. Maybe he thought he could screw me over for two or three thou-

sand francs . . . I only saw him a few months later. With a mocking, satanic laugh (his enthusiasm had waned), he said, "You should try to sell your emerging painters in Carpentras.[3] Shops there rent for nothing." "Right! And while I'm there, I could check out retreat homes for the feeble-minded!" His laughter went from satanic to forced . . . his face started to look like the sample portrait he once showed me.

This same guy was still trying to impress me when he said this to his very young son: "Son, you'll find that there's only one thing in life that matters: money!" How awful! What a thing to teach a child! . . . Ugh.

Ugh, ugh! What could I do? I didn't have the money to pay my rent! My friend V. loaned it to me; I was still lucky that way.

Ah, Dufy, my friend! I have a lot of courage, but those shows weren't earning me anything . . . How could I get out of this fix?

Béla Czóbel's one-man show in March 1908 had a real succès d'estime . . . but that was all. He was very inspired by Matisse, whose teaching he followed at his academy. I thought Czóbel very gifted.

Princet set out Cubism's first markers, which Picasso developed in profound experiments, and Braque skillfully used. Metzinger's tiny squares became cubes. "Cubism, that's real life!" he said. "Everything else is crap!" (Fourth stage.) Herbin wasn't there yet. Each of them was anxious, and each showed it in a different way . . . For a change of pace, Matisse went off to Germany, to be crowned with laurel wreaths. We met two Americans, the Stein brothers, and their sister Gertrude . . . They hesitated . . . and went on hesitating. They showed up at the Indépendants wearing truly individual get-ups. They were trying to get comfortable with this style of painting, which appealed to them. They often came to my gallery . . . Matisse interested them . . . But they didn't dare. "Trust me, you should buy Matisses," I told them . . . They weren't ready yet.[4]

They made up their minds soon enough, however, and started buying hand over fist (not from me).

At the Druet sale at the Hôtel Drouot,[5] I bought two beautiful Matisse paintings with 950 francs I'd been loaned. A big event! . . . "She's gone crazy!" I heard people say.

Every year at the Hôtel des Ventes, Druet would get rid of the paintings he hadn't been able to sell, thus earning some much-needed cash. Despite all the support he got, he, too, had some hard times.

Druet's photography technique was quite successful, and largely contributed to his gallery's success.[6]

I had no time to waste with my Matisses because I was under pressure to quickly return the money I'd borrowed for the purchase and share the profit . . . I was in too much of a hurry, and I sold them! Anyway, what mattered was making an impact . . . Besides, I always like having something new . . .

In June, the group show brought in no more than the earlier ones.

At 200 or 300 francs apiece, Odilon Redon's pastels had fervent collectors. Some made friends with this wonderful artist, and followed his career . . .

August. Vacation. With my friends Mlles P., I spent three weeks in Beaufort, a delightful little burg in Drôme.[7]

The painter Léon Lehmann spent part of the year there, and he made arrangements for us with his hostess. It wasn't expensive. We had a nice, restful stay, and the weather was beautiful.

I came back alone to reopen my gallery . . . Business!

Before leaving Paris, I had sent a crate of paintings, mainly by Picasso, to Frankfurt, with very modest prices.[8] While at Beaufort, I got a series of telegrams asking me to reduce my prices by at least three quarters. Annoyed by all the bargaining, I didn't answer until I was back in Paris. Then I wrote: "Please return everything!"

They kept it all.

Lehmann had benefited by his long stay in Beaufort and made a lot of progress. We agreed on a one-man show in October. His friend Rouault wanted to exhibit with him, but Lehmann hoped to show a large body of work, and pointed out that since their approaches were so different, neither would benefit by the arrangement.

Rouault insisted, daily using his powers of persuasion. Lehmann gave him some hope, then shrank back. I hoped he would be able to get free . . .

A sensational event: I had the gallery wired for electricity! This kind of lighting didn't exist in rue Victor Massé, so the current had to be brought from god knows where, which meant more expenses. I'm telling you, I'll never have a sou to call my own! . . .

The Lehmann show inaugurated this "innovation." An honorable success.

It may have been noticed that I haven't had any exhibitions of watercolors or drawings in the last two or three years. I still sold a few, but stopped holding the alternating exhibitions.

The artist Wély, who'd had some success, died young, leaving a widow.

This widow, who knew very little about the business her husband and I had done, demanded settlements that I had already paid, and sued me. In the justice court, she produced a letter I had written to Wély, after changing or ignoring the date to suit her cause. She lost her case because of the evidence I presented to the judge, but I was still ordered to pay half the costs . . . Justice!

She was wrong to have acted improperly that way, however painful her struggle as a woman prematurely left on her own. I was heartsick at having to defend myself against her.

Then I was in a bind again! I borrowed 1,800 francs from my mother, to whom I had to pay 20 francs a month interest.

I bought a batch of antique weapons and china . . . Purchases!
. . . Purchases! . . . Madness!

11

MALPEL DOES ME PROUD.—ROYBET, MEISSONIER, AND THE
REST OF YOU BIG SHOTS: HELP!—BRACKETING BRAQUE.—
DIRIKS THE NORWEGIAN.—TO BEAUFORT AGAIN THIS YEAR.—
PASCIN EXHIBITS FOR THE FIRST TIME.—HENRI LE DOUANIER
ROUSSEAU DIES.—"IT'S LITTLE ANDRÉ LHOTE!"

A magnificent (if I may say so) watercolor by Rouault sold for . . .
30 francs . . . Antiques, it's always antiques.

December. I sold a few paintings by the regular Matisse
group.

The first time Charles Malpel came to my gallery, he ran
away in panic. A collector from Toulouse, he certainly evolved
after that, becoming more avant-garde even than . . . the Jeunes.
He traded barrels of wine for paintings, which was fine for some
artists; others preferred cash on the barrelhead. In any case, it
took Malpel a lot of guts to stand up to the jeers of Toulouse's
upper crust.

1909. The years followed each other, each alike . . . The num-
ber of collectors didn't increase, while dealers swooned over
works by Roybet, Caro-Delvaille, Carolus-Duran, Joseph Bail,
Detaille, and Meissonier, all academic painters in the official
salons. Meanwhile our young emerging painters were shaking
everything up but not enjoying much success.

I found an attractive little Van Gogh for 40 francs. Whatever
happened to it? Oh, yes! I sold it for 60 francs.

Another new artist to add to the friendly group: Braque. The
gang consisted of Camoin, Derain, Dufy, Marquet, and Ver-
hoeven, whom Odilon Redon strongly supported.

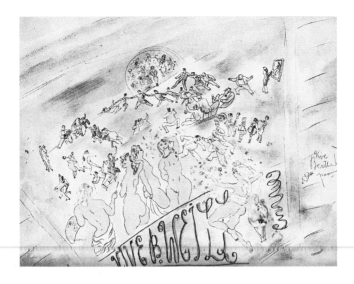

FIGURE 3. Jules Pascin, *Le Jubilé de Berthe Weill*, 1926.
Ink and watercolor on paper, 50 x 60 cm. Current location unknown.
The image appeared on page 152 of the original edition of *Pan!*

Rouault offered me three watercolors, which I bought without haggling: 90 francs for all three. How brave of me!

March. The Charmy, Czóbel, Girieud, Metzinger, and Tarkhoff group.

That month worked out wonderfully: Dufy, Friesz, Marquet, Picasso, Girieud, Odilon Redon, and Puy all sold pictures, and everybody was happy. If only that could continue . . . Well, it didn't. April was pathetic.

May. Diriks, the Norwegian giant, exhibited in the first room (that's right, dah-ling, I have two rooms!), Evelio Torent in the second. Only Diriks made any sales.

Odilon Redons were selling slowly but surely, for between 300 and 400 francs . . .

Poor Vlaminck, who was struggling, spotted an attractive Odilon Redon study in my gallery.

"Oh, how I'd love to own that study! I won't rest until it's mine. Would you consider doing a trade?"

In the face of so much enthusiasm, I couldn't say no. Next day I spotted the Redon at a dealer's! Don't you think that's funny? And so friendly!

I bought two boxes of antique engravings for 400 francs. That should help me hang on . . . maybe until October. And have some pocket money for vacation . . .

My friends Mlles P. and I returned to Beaufort. Once again, Lehmann made the arrangements for our stay there.

I took one of my nieces along, who was fourteen. She was so unbearable I swore I would never again take on that kind of responsibility. I returned home alone, leaving her in my friends' care. Mlles P. had much cause to complain about her. That was so thoughtless of me!

People who are too weak to teach their children tact and manners shouldn't have any . . .

The antique engravings I bought were selling in dribs and drabs, and I spent the money as I went along. When a good *marchand* buys a batch of goods, he repays himself the money he laid out as soon as he sells some, and the rest is profit. It's the only way to make a transaction worthwhile . . . I know that, but I don't do it. What a businesswoman!

In November, a strange group: de Groux, Lehmann, and Verhoeven . . . Books! And antiques, always . . . Mme Mayer was right. I shouldn't quit selling antiques. It was what allowed me to stick with Jeune painting . . .

Books, books! I love books. If I hadn't sold paintings, I would have been a bookseller . . .

Nothing worthy of note at year's end.

January 1910. Pascin, whom I met for the first time, exhibited along with Bern-Klene, Van Rees, and Schnerb. I had to put Pascin off in a corner by himself because his somewhat daring

drawings shocked collectors. When I pointed this out to him, he stopped coming by. He was afraid of me. For all his cocky ways, he was quite shy.

Still, Lugné-Poe bought a pretty watercolor of his.

February. Another group that didn't bring in any money.

What a month! Not a single sale . . . Bolliger, who was part of that group, blamed me . . . Ribemont-Dessaignes, also in the group, was struggling desperately. He wound up becoming a writer without losing any of his charming personality. Finkelstein, the third member of the group, landed a decorating job with Lugné-Poe; all very well, but kind of boring!

In March, a new group: Burgsthal, whom Odilon Redon recommended to me, [Jacques] van Coppenolle, Deville, and Tarkhoff. The latter had already exhibited with me several times. His recent success in Germany had gone to his head . . . It's not like he was the emperor's cousin . . . Burgsthal, who wasn't known as a painter, made a name for himself in stained glass.

In April, a show of Derain, Girieud, de Mathan, Rouault, and Van Dongen. Misery, misery! It takes so much courage to keep doing this job . . . That's it, I'm quitting! . . . No, not yet! . . .

Henri Rousseau, so celebrated by Picasso, Apollinaire, and the whole gang, died . . . The poor man had had many difficulties. People took advantage of his naiveté, and made him sign papers without his understanding the fine print. Shortly before his death, he and I had agreed to do a show of his work . . . but his friends talked him out of it . . . Maybe they had reasons I wasn't aware of.

He's missing from my list of exhibitors! . . .

So what's happening, Derain? Are you in trouble again? . . . I got another note from him: "Send money. Stuck in Le Havre . . ."

And who was that cute, curly-haired young man who looked so pleased with himself? He took an interest in each of my shows, discussed them, looked around, asked questions . . .

He intrigued me. "So who is that?" "Don't you know? It's little André Lhote!" "No, but he's been coming around for a while now." And that's how I met André Lhote. He joined a group with Lacoste, Plumet, Paviot, and Van Rees shortly thereafter.

Same old, same old, I'm telling you. I sold just *one* canvas, by Lacoste. These shows are so lucrative!

12

ODILON REDON LIKES MY MONTICELLI.—THE AMIABLE MAXIMILIEN LUCE.—A HEARTWARMING ENCOUNTER IN BEAUFORT.—LÉON LEHMANN IS CANONIZED.—I'M SHRINKING: I SUBLET HALF MY SHOP.—CHARMY EXHIBITS AT DRUET'S.— HENRY SOMM AND GRASS-MICK EXHIBITIONS.—I VISIT CHARRETON, THE PAINTER.—ACQUISITIONS BY THE MUSÉE DE LYON.—CHARMY AND I GO TO DINARD.—OUR ANXIETIES.— THE H. SISTERS ON RUE LA BOÉTIE.

Whatever was I thinking when I considered subletting one of my two shops? . . . And yet I'd begun negotiations with my neighbor, a woman who sold knickknacks and wanted to expand . . . My own business was doing so poorly . . . Maybe I would do it . . . We would see.

Odilon Redon liked a Monticelli I'd found so much that when he suggested a trade, I couldn't refuse. We agreed that he would give me a painting and two pastels for it.

Maximilien Luce, an appealing painter and very independent man, was buying Daumier lithographs, building a beautiful collection at little expense. He also owned an extremely rare Daumier bas-relief. As with many artists, Luce's talent was very uneven, but he had the great merit of sincerity.

Vacation time. Lehmann made the arrangements with our

hostess, and my friends Mlles P. and I headed for Beaufort, in Drôme, for the third time.

As I said, Beaufort is a hamlet of four or five hundred people, evenly divided between Catholics and Protestants, who all got along perfectly well . . .

The town had two churches. Lehmann, who was a fervent Catholic, went to one; my devout Protestant friends P. went to the other. To keep them happy, I went to both. No other religion was represented in Beaufort.

The area was very pretty, and I liked to wander in its meandering valleys.

Before setting out one day, I warned my friends that I wouldn't be back until dinner, and headed for the town of X, about a half-hour walk away. But an hour passed without my seeing it, or any other living soul. I must have made a mistake; so where was I? I finally saw some scattered farms, but everybody was at work in the fields. Dogs barked as I passed . . . The farmhouses were all deserted . . . I started getting worried.

Ah! I spotted a woman in the distance bringing her animals in. I walked up to her and said:

"Excuse me, madame, I'm lost. Is this the town of X?"

"Oh, no! That's in the other direction. Where are you coming from?"

"From Beaufort. Can I make it to X by nightfall?"

"No, you would get there too late . . . But wait for my daughter; she'll be home any moment now . . . Ah, there she is."

A friendly looking young woman joined us.

"Mademoiselle is lost," said the mother. "She is staying at Beaufort."

"Oh, yes, I know you. You're at Beaufort with your friends. My husband is the leader of the brass band."

This man had gotten all the local farmers interested in music, and made them into perfectly decent instrumentalists.

They practiced every evening, at some cost to our eardrums . . .
The band was good for morale, the locals loved it, and it endured.

"Come inside and rest," said the friendly woman. "And have
some of these fruits," she said, bringing a basket full . . . "We'll
fix up a bed for you, and you can set out tomorrow morning."
"I'm very grateful for your hospitality, madame, but I can't do
that. My friends would be too worried. I'm going to start back
right away, because I promised to be home by dinnertime." "All
right, but at least wait until the storm passes. Then I'll set you
on the right road. In the meantime, we can chat." The woman's
face was lit with friendly curiosity, and with a desire to talk, to
meet people—in short, to live! The storm burst. The two of us
sat in front of the window, and the questioning began. "Do you
like Beaufort?" "Very much. This is the third time we've come."
After a pause: "Are you Catholic?" "No." With a confident smile,
she said, "Then you must be Protestant, right?" "No, not that
either . . ." At a loss, almost fearfully, she said, "Well, then . . .
what are you?" Should I tell her? What impression would my
answer make? But I had to tell the truth, it would be unthink-
able not to. So as not to frighten her, I quietly said, "I'm Jewish."[1]

She started. Should I leave . . . ? But she recovered quickly,
and took my hands in hers. "Jewish! What are Jews like? I never
knew . . . I thought . . ." "Tell me what you thought . . . That they
had horns? How were they?" "Oh, how happy this makes me!"
she exclaimed, giving me a hug. "So many nasty things were said
about them during the Dreyfus affair. I had no idea they were so
nice . . . !" (That was for my benefit!) "Like a lot of people during
that sorry affair, you might have read up and weighed the pros
and cons. Then you could have easily decided for yourself, unless
you had already up your mind, as too many people had, unfor-
tunately . . ." "Have some more fruit, and here's some cream.
Really, we're happy to make up a bed for you." It took me a long
time to persuade her to let me leave.

I would hold on to that happy memory forever.

Meanwhile, Lehmann and my friends were worried about my being late, and wondered if I'd found shelter from the storm. Lehmann set out on the road I should have taken, describing me and asking everyone if they'd seen me. Finally, as I was getting back, I spotted him in the distance. I whistled, and he saw me. My friends found me safe and sound except for my disheveled hair, and were angry for causing them so much concern. So I said nothing about my adventure, and went to bed without telling them. I was afraid that the fervently Catholic Lehmann and my devoutly Protestant friends wouldn't understand the warm feeling that enveloped me. It was the only time I hadn't been afraid of a thunderstorm!

As it happens, I had other complaints where they were concerned . . .

Friendship is a feeling that is impossible to obtain. I see friendship as all about honesty and unselfconsciousness. We always have friends, but I still haven't found true friendship. Distrust, jealousy, exclusivity . . . certainly. But real, true friendship . . . not yet. It seems to be easier between men.

A couple of times, I overheard (not deliberately, believe me) Mlles P. and Lehmann in colloquies about religion that I wouldn't care to join even if they had invited me. I should say that they were careful not to include me in their discussions.

My friends Mlles P. were wonderful women, but a little too focused on such matters and also on occultism, which ruins everything. Less from a philosophical vantage than as . . . hocus-pocus, to the point that they couldn't grasp how contrary it was to their religious spirit.

When I first met them, I had been able to shift our conversation away from that tiresome inclination to painting, music, and literature, and we had some very pleasant evenings.

But then Lehmann showed up, and all my efforts were

undone. That was when the colloquies began, often interrupted by my involuntary intrusion.

I was dismayed at Lehmann's ill-considered effect. To the women, he was a god. Cloaked in his divinity, he took those two creatures in completely and gradually annihilated them. He played on what I dare call their remaining humanity. He could have stopped everything with a word, but he didn't, and left them shattered instead. They are nothing more than poor wrecks today. An evil piece of work!

<p style="text-align:center">∞</p>

Well, the deed was done: I sublet one of my shops to my neighbor. She assured me that she was completely straightforward and perfectly honest. "You'll never have any problems with me," she said. Why all these preambles? One should always beware of people who, like drunkards, shout from the rooftops, "Me, I'm an honest man!" I'm very trusting, up until the slightest thing gives me pause, and then I've had it with all these *honest* people . . .

The door connecting the two shops was sealed, and I was relegated to the smaller one. A few essential connections had to be made. I didn't put on any exhibitions for a few months; the space was too small. It wasn't any bigger than this when I was starting out, but shrinking feels a bit humiliating.

That's right, Dufy, I'm increasingly going back to antiques!

Charmy showed me a group of very interesting paintings she wanted to exhibit. Using my place was out of the question, so I mentioned it to Druet, who said he would be happy to give her a show . . . Success!

Passing by one day, Braque and Picasso entered my quarters. "Hey, did you shrink your gallery?" asked Picasso. "Yes, the Jeunes were giving me too many headaches." "You'll soon wind up with a sidewalk stand," Braque said sarcastically, and

laughed. (Talk about tact!) The son of a painter-decorator, Braque was in the chips, as we say. Buoyed by his own wit, he went on: "What about my 90 francs?" (I had sold one of his canvases for 100 francs, and was waiting to be paid.) "You'll get them; I expect to be paid this week." He started pounding on my desk. "I want my 90 francs, goddammit!" "There's no point in pounding my table and my eardrums. You won't fill your belly with anything you get today." The two of them left, with Braque furious and Picasso chuckling to himself . . . Braque got his "90 francs, goddammit!" a few days later.

1911. First payment due from my oh-so-honest subtenant . . . She was already complaining about how many doors and windows the place had, as if that money were going into my pocket.[2] We shared a standpipe and were splitting the cost of gas and electricity, so I could foresee happy days ahead.

In February, André Level suggested an exhibition of drawings and watercolors by Henry Somm; the narrowness of my store wasn't a problem . . . Only two or three sold . . . Misery!

In March, again at Level's suggestion, I exhibited Grass-Mick's paintings . . . and sold two . . . What would have become of me if I had quit selling antiques, I wonder?

A collector named H., who trusted me implicitly (and still does), said he had noticed Charreton's work at the Indépendants show. He found the artist's address in the catalog and asked me to borrow some paintings from him so he could make a selection.

I explained H.'s desiderata to Charreton, whose huge, sumptuous atelier was completely unlike those of the emerging artists I was accustomed to seeing. He was very friendly (he knew my Galerie) . . . and persuaded me that it would be better if the collector came to his place. "I'm not like the others," he said. "I'll make sure to take you into account." I agreed with him, and with some difficulty managed to persuade H. to make his

choices in the studio. H. selected a few canvases and asked the artist to have them brought to my place . . . which was done. That purchase was followed by others . . . and then still others. Charreton was in seventh heaven. But it wasn't enough. He came to see me and said, "You're close to H. Could you persuade him to name me to the Legion?" "I don't know. I'll ask him." What can I say? I thought the whole thing was quite funny. So I talked to H., who said, "Certainly. It's the easiest thing in the world, and he's as deserving as any number of other people. Tell him to send me his documents, and so forth." I carried out the errand, and Charreton got his medal.[3] In a display of fine manners, he sent Madame H. a big basket of flowers and a painting. For my part, I waited patiently . . . My turn would come . . .

Sometime in July, buyers from the Musée de Lyon led by Jacques Martin, the well-known Lyonnais painter, came to my shop and bought a superb Jongkind watercolor and a large, beautiful painting by Odilon Redon. Shipping the pieces and having the museum board meet to approve the purchase took a while, and it was vacation time. The summer of 1911 was particularly beautiful and hot. Charmy's atelier on place Clichy was like a greenhouse; there was no way to work there in the heat. After paying my rent, I was down to about 15 francs. From then until August 12 I sold a few more collectibles, and managed to scrape 26 francs together . . . But I was feeling rich, since I would get the Lyon payment. So I asked Charmy, "Can you pay for your ticket to Dinard? I'll take care of the rest." "You bet!" I knew a woman who ran a family-style boarding house in Dinard. So off we went! After paying for our two tickets, we had just a dozen francs left . . . In Dinard, I negotiated with the woman, who agreed to wait to be paid . . . But two weeks went by, and . . . nothing! We started getting desperate. We used our small change to send telegrams to Lyon . . . We finally learned that the money would be coming, but we first had to send 35 francs for expenses

and documentation . . . ! Damn! I didn't have the money. Our last sous went for another telegram. By now, the woman running the boarding house was giving us the evil eye.

Lyon finally came through, showering us with gold! (I strongly suspect that Jacques Martin advanced the money.) We paid our bill and, to punish the manager for her distrust, told her we were leaving.

You should have seen her face!

We found a beautiful, brand-new hotel right on the departure pier for Saint-Malo. Life is so wonderful once the storm is past. But what a pickle we'd been in! It was a near thing, and we were quaking in our boots. But my motto remains, "It'll all work out."

Back to town. Everything may work out, but my *honest* neighbor was trying to work me over . . . What wasp's nest did I blunder into by subletting to that virago? If at least I were making a profit, but I wasn't. She paid exactly half the rent during the whole term of the lease . . . I'm just a born fool!

Here's another of her dirty tricks. My devoted Alsatian housekeeper was passing one evening around nine and came into the gallery in a fury. "Mat'moizel, your neighbor's shop is closed, but all ze lights are on, and she blocked ze transom with a curtain so you can't see ze light from outside." That shrew had come up with the bizarre and idiotic idea of making me pay as much as possible, even though she'd also have to pay much more than she had to, since we were splitting the bill. "That's okay," I said. "Don't say anything. But first thing tomorrow, find an electrician to cut the wires." That was done. To the woman's great surprise, her shop stayed dark that evening. I turned the gas off, too, so all she had left to quibble about was the rent.

1912. My young brother got married in Versailles.

Nothing transcendent as the New Year began. The last one was bad, so let's hope for something better.

My friends, the two H. sisters, went into the antique business, opening a beautiful shop on rue la Boétie.[4]

The sisters had big plans, but I feared they didn't have the staying power to carry them out.

13

CHARLES MORICE, ART CRITIC.—A BEAUTIFUL RENOIR FOR SALE.—MISCHIEVOUS *MARCHANDS*.—GARROS'S FLIGHTS AT LE CROTOY.—JEAN MARCHAND, THE SCRUPULOUS.— THE MARSEILLE-VILDRAC PARTNERSHIP IS DISSOLVED.— ATELIERS ON THE BOULEVARD DES INVALIDES.—PROFESSION OF FAITH.—MY BREACH OF TRUST.—UHDE AND THE "YOUNG MAN."—CRAVEN CRAVAN.—THE SECTION D'OR.—AT FURSY'S.—TABARANT BRINGS ME LOUISE HERVIEU.

The art critic Charles Morice suggested exhibiting the work of a young artist he had discovered. A true independent of unquestioned talent, Morice was a friend of Gauguin's and part of the Symbolist pleiad. We arranged to meet at the Closerie des Lilas[1] at ten in the morning, and then go to meet the artist, Jean Berger. When I got to the Closerie, I found Morice with a glass of absinthe in front of him. I had a feeling it wasn't his first . . .

Eventually, we went to see young Berger. I couldn't refuse to put on the exhibition. Morice wrote an impressive preface, and . . . two paintings sold.

Ah, poor Camoin! What a trio you, Charmy, and I make! When it comes to poverty, our cup runneth over!

An aunt of Camoin's had once wanted to buy a painting by Renoir, so he traveled to Cagnes[2] with her to see the *maître*. She bought a magnificent painting of a nude reclining in a landscape. She now wanted to sell it, and he consigned it to me. The

asking price was 12,000 francs, and we could only hold it for three or four days. I wrote Eugène Blot to come take a look. "How beautiful it is!" he exclaimed. (But he claimed his artistic competence was no guarantee . . . What if it were fake?) Then he said, "I own a lot of Renoirs, you know!" He continued, laying it on pretty thick. "How many do you think I have?" I couldn't have cared less, but he forged ahead. "I sold eight of them just in the last two weeks . . . at 30,000 francs apiece! And a Diéterle portrait for 100,000." So I shyly said, "In that case, this one is perfect. It will replace the ones you sold." "Oh, I still have plenty more! Find me some Van Goghs instead." So I asked Georges Bernheim to come over. "How much is she asking?" "She wants 15,000 francs," I said. "Offer her 3,000." There was no point in continuing, and I gave the beautiful Renoir back. Poor Camoin! There may be a deal out there that would earn us a few louis and put us back on our feet, but this wasn't it.

I did find a pretty little Van Gogh, and decided to have some fun. I asked Blot to come to the gallery. "You asked me for Van Goghs. Here's one that I think isn't too bad." "How beautiful it is!" (And then the same old story, his competence, etc.) "Do you know how many I sold this week?" . . . Eight. "For 30,000 francs apiece." . . . "Oh, let me look at you! I've never seen such a titan of business!"

Someone reading these lines might object that I'm making this all up. But it's the gospel truth, and I defy anyone to prove me wrong.

(Later on, and more than once, I would hear this sentence: "Ah, Mademoiselle Weill! You must be rich, seeing all the things that have passed through your hands"—and all the help I was given . . . !—But let's not anticipate.)

Poor Charmy suffered an attack of appendicitis, and had to be rushed to Dr. Dubois's clinic for immediate surgery.

The operation was quite successful. She was on her feet ten

days later and preparing to move to rue de Bourgogne. After that, she planned to go to Lyon to rest.

I myself went to spend a few days in Le Crotoy,[3] where my brother and his family were on vacation.

The rain didn't let up once during the eight days of my visit. I became fascinated by the airfield (a novelty for me), and spent all my time there, in spite of the rain. The daring flights were impressive, and I was especially thrilled by one by Garros.[4]

Back to town. Books were selling, but they weren't bringing in much, and I had to constantly renew the stock. My personal library would probably go again. I had a pretty 1830 crystal jam jar that the painter Jean Marchand liked a great deal. He offered to trade it for a small painting. I agreed, of course.

I had met Marchand some time earlier through my singing teacher, Mme Ghist, and even sold a few of his paintings. Then he was offered a contract by Marseille,[5] who had just dissolved his partnership with Charles Vildrac, the well-known writer. With Marseille, artists like Marchand, Segonzac, Louis-Auguste Moreau, Boussingault, and others found an energetic and loyal champion.

Marchand was the soul of propriety, and pushed his scruples to the point of mania. If he ran into me while he was with Marseille, for example, he acted very embarrassed and barely said hello. Amazing! As if Marseille imagined that he was secretly selling me paintings, a thought that never occurred to him.

Eventually, Marchand brought me his little painting, and exchanged it for the jam jar. But he asked me not to mention it to Marseille, even though it would have been so much simpler just to tell him.

Next day, in walked Armand Parent, the violinist and collector. Not a collector of violins, that is, but a collector of les Jeunes. He bought the little Marchand landscape for 50 francs. I told him about the artist's scruples, and asked him not to tell

Marseille about the sale. "Of course," he said. "If you think I'm in the habit of talking about my acquisitions, you don't know me."

Marseille got wind of the purchase that very evening, and was infuriated by the sale price. (As you see, no detail was omitted.) Marchand's wife Sonia Lewitska showed up at the gallery in a tizzy. "What did you do? Marseille is angry." "Can I help it if collectors are asses?" I said. "And you can tell Marseille to go jump in the lake for me." I don't know if she ever did . . .

Lewitska was almost motherly in her care for Marchand. I had met her when she first arrived from Kiev and was living in the former Hôtel Biron—it's the Rodin Museum now—where a couple of artists had beautiful, inexpensive studios. Matisse also lived there for a while. At her request, I went to see her and saw a couple of paintings that showed a sense of decoration that she went on to develop intelligently later.

I did some business with my friends the H. sisters in their beautiful shop on rue la Boétie. But times were tough, and I didn't think they were cut out for struggle and perseverance.

An old-fashioned lady I had bought some trinkets from was leading a difficult, joyless existence. To help out, I hired her to give me piano lessons. I worked hard at it and wanted to play decently, but it didn't come easily, and I began to get annoyed. This in turn made me somewhat . . . sudoriferous. The lady had become rather plump, but she still considered herself a great beauty. Seeing me perspire during our very first lesson, she said, "Is it me that is putting you in such a state?" I was flabbergasted! She was so impoverished that I couldn't bring myself to fire her on the spot, but I did after the second or third lesson. Funny how stupidity and pretentiousness go hand in hand—or hand in glove!

It's true that I love pretty women, but especially intelligent, lively ones who are both elegant and a bit zany. (Don't look at me like that, it's not at all what you're thinking.) I love and admire

them, the way you might enjoy looking at and playing with a pretty bauble. Where's the harm in that? I like to be surrounded by young people and basically everything that makes life bearable.

I found all that in Charmy, and loved her for those reasons. Far from hiding it, it did me honor . . . Stuck-up women who are full of themselves, I flee like the plague.

All right! On to serious matters!

Georges Bernheim gave me a ravishing Odilon Redon painting to sell on consignment for 300 francs. I sold it for 350 francs to Léon Hodebert, a colleague whose little shop on Faubourg Saint-Honoré was across from the Barbazanges.[6] A few days later, Bernheim drove over to my place in his magnificent automobile (a Rolls-Royce or a Mercedes; I don't know about cars). He'd probably gotten wind of this lucrative deal, or maybe someone had asked for the painting. "I'm here to get my Redon," he said. "It's been sold. I'll bring you the money this week." "What? Don't you have the money on hand?" (Rolls-Royce or Mercedes?) "I'm going to the police to proceed with a breach of trust complaint." "In that case, you should take your car," I said, "because just 'proceeding' won't get you there fast enough."

("Ah, Mademoiselle Weill, you must be rich . . .")

I often used to be visited by a modest young German named Wilhelm Uhde, a collector with fairly advanced tastes who wrote a well-documented monograph on Douanier Rousseau. One day this amiable man said, "I got married!" Well, well, and who's the lucky girl? Robert Delaunay was a frequent guest of their household . . . Sometime later, Uhde told me, "My wife isn't my wife anymore, you know. She married a young man." The "young man" was Delaunay![7]

1913. Thirteen! I like that number, along with seven. Maybe this year would be better . . . It had to be!

Who was the mysterious young man who talked on and on,

dizzying us both with his words? In Russia, he had danced in black tights; in Paris, he was a regular at men's shelters (supposedly), ate beggar stew at Les Halles (he claimed), spent time at the local precinct (likely), and traveled in Germany, Italy, everywhere! At the time, he was working with Utter and Valadon; I'd lost touch with them, and we reconnected. The guy had really knocked around; and he talked, and talked! A hodgepodge of lies and misquotations, a language salmagundi... When he was pushing paintings, what a gift of gab! But he hadn't yet shown me his own masterpieces. "One of these days," he said confidently. "Oh, you know, I really don't give a damn." This was Edmond Heuzé.[8]

Like every year, the Indépendants were harshly criticized. A boxer named Arthur Cravan founded and edited a little review called *Maintenant*. In its pages, he insulted painters and viciously attacked women, and especially Valadon and Marie Laurencin. He also targeted Robert Delauney, raking him over the coals. Up in arms, the artists marched en masse to the Salle Champollion, where Cravan was to give a boxing exhibition. But the craven provocateur was too scared to show up ...

I wondered why Malpel ever spent time with this bird, whom he once brought to the gallery. Next to those towering highboys—they were both over six feet tall—I looked like a footstool.

"First of all, sit down," I said. "That'll bring you closer to my level."

The introductions were made.

"Ah, so you're Mister Cravan, the man who insults women? You're plying a pretty ugly trade."

"Oh, come on," he said, laughing. "You're a feminist, I suppose."

"I certainly am!"

"Well, in that case, since men and women are equal, there's no reason for me to speak differently about women than I do about men."

"You're setting that up to protect yourself, because when you're challenged to face your responsibilities, you slink away. It's a question of good manners, monsieur. In France, we respect women and each person's individuality. I'll say it again: you're playing an ugly game."

He gave a forced laugh, and they left. When war broke out soon afterward, Cravan fled. When André Level learned he had deserted, he brought me his copies of *Maintenant*. "I can't keep anything connected with that person at my place." It's true, they were compromising . . . and such a nice gift!

But I'm anticipating.

I had a major Henri Rousseau painting, which I sold to Louis Libaude. Books, books! The number thirteen sometimes brings me luck, but the year 1913 was the pits!

There was a major exhibition of the Section d'Or on rue la Boétie.[9] Everyone was there, the Cubists, the sub-Cubists, and the . . . subcutaneous. The group certainly had a lot of energy. So much life! So much youth! A few visitors were alarmed, but the snobs "got the message."

I just wasn't buying all the sub-thises and sub-thats. "You'll come around, you'll see," Marie Laurencin kept saying. I've always been interested in everything new, and still am, but I don't show slack-jawed admiration for flim-flam artists, even when the flim is well flammed. Robert Delaunay exhibited a very impressive Eiffel Tower. Apollinaire was ecstatic.

In Montparnasse, all of Paris's first-nighters gathered at the Théâtre Bobino to see Molière.[10] André Antoine was a regular at the performances. Major success.

In Montmartre, Henri Fursy's place was packing them in.[11] It was the rendezvous for every country's highest aristocracy, which is why I had an entrée there . . . sort of.

"You comin' tonight?" asked Méphisto in passing. He was the one they called the Old Man, and he was pretty casual, like all

theater people. "Sure," I said. "Then come early!" So I brought my friend V. and her aunt. At the box office, Fursy was quite curt. "Oh, great! It's Mademoiselle Weill and her tribe!" If I'd been alone, I would've turned around and left, but I had guests. Fursy grumbled, but found us seats anyway. When I entered the hall, I understood why he was on edge: the place was jammed, with every box full of people decked out in diamonds and jewels of every size and shape. A dazzling roomful of French and cosmopolitan aristocracy. We gawked, let me tell you, trying to put names to faces in the glittering crowd.

It was "Mossieu' Fourrsy" here and "Mossieu' Fourrsy" there. Fursy didn't know which way to turn, bowing and scraping, scraping and bowing while the audience got increasingly restless, until the play started . . . It was a hit!

"What the heck was that last night?" I asked Méphisto next day. "That was an amazing audience!" "Shut up, I had no idea! We had the Archdukes Vladimir and Alexis and company; Archduchess Vladimir and her suite; the whole Carnot family; plus high muckety-mucks from various oriental countries . . ." "Oh, too bad I didn't know. Tossing a nice little bomb into that bunch would have made a hullabaloo, wouldn't it? Make 'em sit up and take notice! And the next time Fursy treats me like dirt, I'll strangle him." We cracked up over that, because Méphisto knows my bark is worse than my bite.

The exhibitions started up again.

My friend Tabarant, the well-known art critic, brought me an artist he warmly recommended, Louise Hervieu.[12] She struck me as very excitable, rebellious, vaguely suicidal. Times were so damned tough! What misery. She was young and husky, with big biceps. Brrr! When Tabarant came by a few days later, I told him, "Give that colossus a show? You've got to be kidding! She scares me. If I don't sell her stuff, she'll smash her paintings over my head!" . . . He laughed, but he didn't disagree.

14

GLEIZES AND METZINGER EXPLAIN CUBISM; APOLLINAIRE
DOES, TOO.—TWENTY FEET OF PICTURE RAILS FOR
TWENTY ARTISTS, ALL WORTHY.—LEWITSKA, LHOTE,
AND CHARMY EXHIBIT, THEN SELL EVERYTHING.—THE
BOOKSELLER CHEATS ME.—HOLIDAY IN AUVERGNE.—*LES
SOIRÉES DE PARIS*.—JEAN DUFY, WATERCOLORIST.—1914
BEGINS PROMISINGLY.—THE PEAU DE L'OURS SALE.—
GRANDISSIMO DIEGO H. RIVERA.—SARAJEVO!—JAURÈS
IS ASSASSINATED.—WAR!—MY SISTER-IN-LAW DIES AT
TWENTY.—MY OLDER BROTHER IS KILLED IN ARTOIS.

Three well-known Cubist painters, Gleizes, Léger, and Metzinger, exhibited a group of works that should have made an impact, but . . . a fiasco!

Two of them, Gleizes and Metzinger, laid out their thoughts about Cubism and the arcana of that plastic art in a much sought-after book. Apollinaire, that erudite and enthusiastic poet, brought clear language and his usual conviction to discussing that art in a (very rare) volume called *Cubisme*. Would the profane allow themselves to be persuaded? They wavered, but ultimately wound up befuddled. To them, anything that wasn't official art was Cubism . . .

My twenty feet of picture rails offered collectors works by Charmy, Lucie Cousturier, Marval, Camoin, Raoul Dufy, Girieud, Gleizes, Lacoste, Laprade, Lebasque, Léger, Lhote, Luce, Matisse, Metzinger, Picasso, Odilon Redon, Rouault, and Van Dongen—plenty to feast one's eyes on.

The pits! . . . Books, books!

Lewitska had a show, and everything sold! At low prices, but a real encouragement for the artist.

An André Lhote exhibition had the same outcome.

Charmy sold about fifteen paintings along the same lines. I took a very small commission on these shows, because what mattered was that they allowed the three artists to work and renew themselves. It also allowed Charmy to go work in Auvergne, at Bouche's invitation.

I remember a comical event that showed just how strapped Charmy and I were. One morning when there was a visitor in the gallery she arrived looking chic and smart, as usual, and driven by car, no less! When she came in, Charmy said, "Do you have any change? I don't have any, and neither does the driver." I gave her a hundred sous. When she returned, she handed me the change for the hundred sous with comic ostentation. I took it, chuckling to myself. The moment the visitor left, Charmy said, "Give me back that change, I'm flat broke!" Ah, lord! We had a good laugh about that one . . .

My own situation wasn't much better. Just imagine, with all those lucrative exhibitions! I invited a bookseller from rue de Douai to come over. Why did I choose the very man who once tried to fob some fake Lautrecs on me—without success, of course? I should have been more careful.

He had once told me, "When I like books, I pay good money for them." I knew that he sold them at a good price, because I'd had occasion to buy some. This time I offered him a batch of very, very good books. He offered me a third of what they had cost me . . . and I accepted. I didn't have a sou. Having scored such a good deal, he came back a few times to try and take advantage of me again. In exasperation, I kicked him out, even though I was in dire straits.

I bought books, and more books!

Vacation time! Invited in my turn by Bouche, I went to Auvergne, only to find myself in a select group of depressed stiffs. Bouche's intelligent, very lively mother stood out amid those joyless young people. The Marius-Ary Leblond brothers

didn't laugh much.¹ While painting out of doors, Lacoste didn't laugh at all; his wife sang Duparc.² When Bianchini, a talented musician, sat down at a table, it was no laughing matter. Add the celebrated owner of the Galerie B. Weill . . . *brrr!* There was no fooling around in a setting like that. Just the same, I had a very pleasant time.

Back to town. Books, always books! October was a bad month. How was I going to make it? Still, November was better . . .

Apollinaire became the editor-in-chief of a very interesting publication, *Les Soirées de Paris*. Number eighteen, the first one he edited, was devoted to Picasso. Despite being the top editor, he handled chores like delivering copies of the magazine; it was all very appealing.

A group show in December: Charmy, Lewitska, Valadon, Lacoste, Lhote, Ribemont-Dessaignes, Utter, Czóbel—what a mishmash!

Nothing sold . . . I worked at this and that, making barely enough money to buy stamps.

Poor year! Poor me! If I didn't add a little sugar, life would be bitter indeed!

The year 1914. Well, well, what do you know? January got off to a very good start. What was happening? Was I finally going to be able to make it?

Young Jean Dufy, Raoul's younger brother, had his first exhibition, of watercolors. Nothing sold, of course.

In February, a young Hungarian named Alfred Reth exhibited a body of work that was somewhat successful. He wasn't without talent.

The first sale of Jeunes at the Hôtel Drouot auction house took place in March. This was the sale by the Peau de l'ours group, under whose auspices a dozen collectors had gotten

together to buy emerging painting. André Level was the group's advisor and buyer.[3] The sale's success was a major event. The big Picasso painting *Family of Saltimbanques* sold to some Germans for 11,600 francs, a record. (When I say record, I mean for emerging painters up to then. The prices didn't compare with those for Meisonnier, Detaille, Carolus-Duran, or other official painters.)

At the sale, I paid 130 francs to buy back a gorgeous little Pointillist Luce painting of rue Mouffetard that I had sold to Level for 30 francs. In fact, three quarters of the paintings at that sale came from my place, which brought me a few new collectors . . . a source of *incredible* profits for me . . .

Bolliger was still mad at me, whom he considered the cause of all his problems. Nonetheless, he was part of a group with Jean Buhot, who was the son of Felix the engraver; Reth's very promising friend Esmein; Léon Lehmann; and Van Rees. Bolliger wound up selling a couple of studies; Buhot sold three canvases.

April saw the exhibition of the *grandissimo* Mexican, Diego H. Rivera. He was like Gulliver among the Lilliputians; I could easily imagine him putting out a fire by pissing on it. I wrote the preface to the catalog myself, teasing Picasso a little.[4] Rivera didn't like it. "Picasso is my best friend, and I won't stand for this . . ." A little later, the two of them were at knife point.

Rivera sold a few "roundist" paintings, which inflated his ego. His "rounds" became "cubes." He then claimed the title of *maître*, but got into a fight with Picasso, whose friends saw him as the uncontested holder of the title. Rivera left in disgust.

In May, the joint show by the Galimberti couple sparked widespread indifference.

In June, a dozen of Metzinger's colorful Cubist studies, among the prettiest I'd had, were exhibited without much success.

A tragedy: Sarajevo! . . . Astonishment! . . . Life went on.

Charmy left for Auvergne to work.

July 14 festivities . . . the usual celebration.

Jaurès murdered! Shock! Upheaval . . . We felt sick at heart. Were the rumors of mobilization true? As one man, all the Germans disappeared . . . War was declared. My young sister-in-law gave birth that very day . . .

Ah, the enthusiasm of those first days! But for those of us left behind, what anxiety! My oldest brother, a captain, left on the second day. There weren't any more vehicles, so he rode out triumphantly on a garbage wagon! And we asked, "A good augury?"

"No, no, it can't be! That would be too awful!"

But it happened. I couldn't bring myself to open the gallery and instead wandered the streets, looking for news . . . After two weeks of inactivity and alarm, I finally opened my store. I still had 150 francs, so I bought maps and little flags to follow the operations. Also some illustrated postcards, which were being sold in bulk on the street and in shops . . . I made 1 franc, 1.50, or 2 francs a day. It kept me busy.

I was getting panicky letters from Charmy in Auvergne. She didn't learn about the mobilization until the church bells started tolling, or the declaration of war until the men left. She had no idea what was going on. Although delayed, her letters were reaching me, but she wasn't getting any of mine, which increased her distress. I sent her telegram after telegram, but none reached her. I so wanted to reassure her, or at least keep her up to date.

My sister-in-law [Andrée], the new mother, was left alone in this chaos and felt abandoned, even by her mother. Fortunately, a very devoted little eighteen-year-old maid was there to help with the baby. I went every day to give her the basic care she needed. The doctor—the *butcher* who helped deliver her, I should say—came by from time to time, but her fever persisted.

After a month he allowed her to get up. She felt a pain in her groin, passed out, and died! . . . At twenty!

This left the baby boy. With some difficulty we found a wet nurse in Champagne, three quarters of an hour from Paris, but the enemy army was advancing, and the whole countryside was being evacuated. The poor infant was brought back to us after twenty-four hours on the train.

The baby's maternal grandmother, who had already let her daughter die, didn't want to take him. However, since she had a property near Versailles, she agreed to have him placed in Le Chesnay. There the poor baby was as badly cared for as his mother had been, and died a few months later . . . Pathetic!

For several days, an endless parade of evacuees from the north streamed through a deserted Paris; women, children, and pets in vehicles of every sort carrying not only their bizarrely outfitted owners but piles of even more bizarre possessions. Paris was expecting a desperate resistance; the fewer mouths it would have to feed, the better.

Our ministers, deputies, and so on departed for Bordeaux, leaving us masters of the pavements, pillars of the city. I had read Clemenceau's newspaper *L'Homme libre* ever since its founding, and it was now being edited and printed in Bordeaux. Since I couldn't get any news until the following day, I quit reading Clemenceau's paper to punish him for ditching the Parisians. It would serve him right for getting himself "chained" in Bordeaux, because the newspaper resumed publication as *L'Homme enchaîné.*

"There's no way Germans are entering Paris!" we said. And they didn't . . .

Gallieni came up with a crazy, ingenious idea, and the taxis all drove off.[5] . . . "They aren't coming in!"

The Marne on the eleventh! Paris was saved! Long live Gallieni! If only this were the end of the war!

I was selling post cards for 10 centimes. In two months, I made 16 francs, as much as our brave *poilus*.[6]

Then we got more terrible news: my older brother was killed on October 10 in Artois at Monchy-au-Bois. Before leaving, he had told his wife and daughters, "When I'm facing the Germans, I'll write, 'I'm putting on my white gloves.'" We had just received his card. Would these horrors never end? Damned war!

They had asked to surrender: "Kamarad!" Marching at the head of his company to become prisoners of war, as the Germans had demanded, he was shot at point-blank range.[7] He was beloved of his men, who wreaked bloody vengeance . . . What carnage! What an awful war!

15

POSTCARDS.—LITTLE FLAGS.—I SERVE LUNCHES FOR 1.25 FRANCS.—MAX JACOB WEEPS.—UTRILLO AND MODIGLIANI COME TO SEE ME.—OZENFANT PRODUCES PATRIOTIC PUBLICATIONS.—MY POVERTY FAILS TO MOVE A COLLECTOR WHO WAS "SO INTERESTED" (?) IN ME.—THE GALERIE MALPEL HAD SEEN IT ALL.—YOU NEUTRALS, KEEP QUIET!— *THE BREASTS OF TIRESIAS.*—MALPEL INTRODUCES ME TO CHARLOTTE GARDELLE.—FAVORY.—MME MAYER DIES.— CANNONS AND MUNITIONS.—BASLER AND RENOIR'S BROTHER.—HESSEL WON'T COMPROMISE.

It was postcard madness! Postcards were selling like hotcakes on the streets and at every intersection. The wholesalers were making money hand over fist. "What if I published some cards myself, instead of buying those awful things?" I wondered. Artistic cards would surely sell better. The wholesalers would snap them up . . . So I had Raoul Dufy, Depaquit, and Luce make some drawings. Then I had to find a printer. André Level thought

it was a good idea, gave me helpful advice, and also ordered some drawings, from Grass-Mick. As a trial run, we printed five hundred postcards and a few engravings of current events . . . I fully expected the wholesalers to place a big order. But when I showed them my samples, they said, "That's not at all what we want. Here's what sells." And they showed me rotogravures with images like "Germans drooling over a sandwich," "*Poilus* strolling with their girlfriends," "Little women handing Joffre flowers,"[1] and so on. I couldn't sell even twenty-five of my cards, and I'd just placed an order to print two thousand, including the patriotic engravings. What a disaster! The printer demanded to be paid, and was threatening me . . . And I didn't have a sou!

Then, as the last straw, selling postcards on the street was forbidden, just when my supply was ready. If only I had found an artist-wholesaler!

Seeing that I was in a jam, Level loaned me the money to pay the printer. All I could do with the cards I received on account was to sell them for their weight in paper.

Disgusted by the maps hanging on my walls, I took them down to make room for paintings . . . Whew, that was better! It felt like being at home again.

A few soldiers on leave visited my gallery. What a break for them!

My women friends H. didn't dare open their shop on rue la Boétie (like I said, no staying power!) and were talking about dropping everything . . . "Don't quit," I said shyly. "That would be too bad. Maybe we could do something together." I watched as their faces tightened. Dead silence! (And these were my friends!) Such trust in me! What a pity; it was such a beautiful store!

1915. The horrible carnage went on.

Verhoeven had been very successful in Switzerland before the war. Now he was starting to lose heart . . . It was lean years for all of us, alas.

To get by, I cooked lunch every day for four or five people at 1.25 francs apiece. It worked out for everyone (war profits!). I ate at my mother's from time to time. More often than I would've liked, I also bartered a few drawings or paintings that I had kept for myself.

Max Jacob came by one day, moaning. "My brothers are being killed, it's dreadful!" he lamented, tears flowing. What a pitiful weakling! When your heart is broken, do you whimper at a tragedy?

A new, beautifully designed publication appeared, *Le Mot*.[2] It only cost 0.50 francs, but people fought over copies, bidding them up to 10 or 20 francs. A welcome diversion!

Utrillo brought me a lovely painting on cardboard: *Snow Scene*. He wanted just 10 francs for it. I hesitated, reluctant to take advantage of the somewhat excited state he was in . . . I bought it, though. He came back the next day and this time was so sloshed that I refused to buy anything from him. "Just a hundred sous!" he pleaded. Pathetic! Someone probably took advantage of the situation, but I couldn't. What a terrible businesswoman I am! Doomed to stagnate my whole life.

I also had a visit from Modigliani, who asked me to come see his sculptures. (Not long after that, he met Zborowski and gave up sculpture for painting.) He, too, was plastered, practically falling on top of me . . . No! No! Impossible! Let someone else do it. How sad! Such a fine, refined mind, and a superb head! Was he really such a drunk?

Ozenfant's new publication, *L'Élan*,[3] was in very good taste and quite successful. People desperately seized the slightest distraction from the nightmare gripping us to escape this infernal atmosphere, this collective madness of carnage we hopelessly struggled against . . .

A couple of artists on leave came to the gallery, to feel the old mood again. Utter had just enlisted, and Suzanne Valadon

asked me to put on an exhibition of his work. I was more than happy to. Sales were almost nil, but a lot of people came.

Libaude was buying up Utrillos, undeterred by their low prices. Dufy made some pretty silk pocket squares portraying the Allies. Then he did an amusing panorama showing soldiers from all the allied nations, in the naive style of an Épinal image. Very successful. Low prices.

Lewitska invited me to spend two days with her in Saint-Nom-la-Bretèche, outside Paris.

October. November. December. The carnage continued, a series of dark disasters. Charmy was sick . . . Misery, misery!

Olivier Sainsère was the secretary of the president of the republic at the time. I was so desperate for money that I offered him a very beautiful painting at whatever price he chose. I got this response: "Dear mademoiselle, I greatly regret that I cannot accept your offer." It was my first and definitely my last attempt along those lines. I later found out that others had had more success . . . Instead of "B. Weill" on my gallery, I bet I would have had better luck with a sign that said "Weillèchekopf."[4]

I knew some of the prisoners of war in German camps, and they were pretty depressed. We had to try to cheer them up and let them know what was happening in France, because they didn't have any news. Using dialect only they could understand, I wrote them long, funny, and informative letters that were shared around the whole camp . . . It wasn't much, but what else could we do?

In 1913, Charles Malpel had opened a gallery of Jeunes on rue Montaigne. This was the Toulouse collector who took to his heels the first time he saw emerging artists when he came to my shop, and had since become the most advanced collector I knew. He was the first to buy and exhibit Chagall and, in the face of quodlibets and imprecations, to offer him a contract.

Malpel was called up when war broke out, and had to close

his gallery and ship all his paintings to Toulouse. The Galerie Malpel will have seen it all.

Yet he still continued to buy art, and kept moving ahead.

The hostilities didn't stop artists from neutral countries from blowing their own horns and pushing for exhibitions of their work. Not at my place, though! Several of them came and asked. I said, "Have a little tact, please! Do you really expect me to show your work while our people are being killed? After the victory, maybe." I had to rein in their exuberance more than once.

Among them was the Spanish painter Sánchez-Solá, from whom I'd bought a few paintings, and who was now bringing me new ones. "No thanks, nothing right now." "But Rivera just bought two of them from me," he said insolently. "Well, in that case, take him those." He left in a fury, slamming the door.

1916. My little personal art collection was gradually melting away. I was still selling a few postcards, but I couldn't live on so little business . . . Selling books also helped with minor expenses . . . When I thought that our *poilus* were risking their lives for five sous a day, I had no right to complain.

André Lhote was finding and selling 1830s collectibles for the time being. He was hanging on while waiting to be able to get back to painting.

Deemed crazy, Metzinger was mustered out of the army and sent home.

The money started to flow. A Charmy painting of flowers sold for 300 francs, a little Bonnard for 400. It was crazy! A Derain sketch, 6 francs. Could business be picking up in spite of the turmoil?

Would I have to trudge across ruins to become solvent again? That would be too awful. I would prefer to vegetate my whole life . . . When, oh when, will peace come?

This was the moment that Heuzé chose to show me his paintings! They displayed more skill than character.

Charmy dropped by the gallery, and I introduced her to that protean man, who knew her painting and complimented her on it. After she left, Heuzé remarked, "Mademoiselle Charmy is wonderful, but I can't stand a woman who has more talent than I do!" . . . Careful, there!

Two pretty little Utrillo pastels sold for 25 francs—a windfall!

Albert-Birot, an avant-avant-garde poet and friend of Apollinaire, launched a review, *Sic*,[5] that cost four sous, practically nothing. It flourished, and Birot made money, and so did I, of course.

Sic was the organ of Apollinaire's *The Breasts of Tiresias*, a crazy burlesque that had a memorable premiere at the Conservatoire Maubel. The place was jammed. It was a huge hit!

Diaghilev's famous Ballets Russes were also generating a lot of talk. Stravinsky's music sparked shouts, noise, catcalls, and furious arguments. Picasso, Matisse, and Derain did sets and costumes. The evening started with *Parade*, for which Picasso had designed the sets . . . Spectators yelled at each other, the young carried the day, and it was a striking success.[6]

What a curious era this was, its ferment foretelling an artistic, literary, pictorial, and musical renaissance.

Rouché managed to renovate the décor at the Théâtre des Arts. Several of the artists he enlisted did the job with such intense vitality that it would be too bad not to continue on that path.

In November 1916, Malpel introduced me to an elegant young artist, and I scheduled an exhibition of her work. From a decorative point of view, Charlotte Gardelle's painting was tasteful and assured.

Why is it that talented decorators don't like to be put in that

artistic category? It's because painters consider themselves on a much higher plane than decorators, even though they are very often both.

The Gardelle show took place, and two paintings were sold.

I met Favory, a very talented young painter who came by while on leave, and I bought a pretty little Cubist study from him.

My mind was in such a whirl, I went to spend four days in Auvergne to catch up with Charmy, who was hard at work there. It calmed me down a bit.

Mme Mayer had been ill for some time, and died. She was deeply affected by the war and could not endure the anxieties. Her loss was a great sadness for me. November 1916.

The hellish war continued: cannon fodder, youth cut down, innocents massacred, profiteers' cynicism and cowardice!

One of those hyenas came to visit my gallery and said, "Oh, I don't give a damn if it goes on. I'm clearing 10,000 francs a day!" (With misery all around, go ahead and shrug your shoulders and pat your wallet . . .) My legs were too short to kick him, but I threw him out and said what I thought of him. I know that he was later forced to disgorge his money, but that wasn't enough. We should make a bonfire of all those vultures.

A few soldiers on leave came to see me, happy to reconnect with the artistic life, and life itself! Sergeants who managed to save some of their pay bought a few things, reviving the business. I made a trade with Basler, a dealer I'd recently met. I gave him an Utrillo sketch and two Cubist Metzinger studies in exchange for a drawing by Marie Laurencin and one by Pascin.

I remember the "big deal" that brought me the pleasure of his acquaintance. It was in 1915, I think, after Basler returned from America. He came to see me and said, "If you hear of any really big pieces" (by which I don't think I meant pork; we're talking painting), "let me know. I have a [German] collector

who might be interested." By complete coincidence, Renoir's brother [Edmond], who lived on rue Saint Georges, came to the gallery and introduced himself. As we chatted, he asked if I would be interested in buying some of his brother's paintings.

"Of course!" I said, though I didn't have a sou to my name.

"Then come see what I have."

I came at the appointed time and went upstairs to his place . . . My stars! It was stunning! He showed me everything he had . . . on the walls, in every corner, in every chest of drawers: a collection of masterpieces!

As I waited for him in the living room (this was less enjoyable), I noticed that he had pinned up a map with little flags to follow the operations, all with their patriotic attributes. He said that things were a little tight and that he would be happy to sell one or two items.

From a drawer, he took out a little painting, about 24 x 12 inches. It was a full-length portrait of a woman, a real marvel. "How much would you sell this painting for me?" "Three thousand francs." Then I had the daring to say, "I'll take it! Put it aside for me." (I figured I could raise that amount quickly.) "And I'll send you a collector for a bigger painting." "Agreed." I told Basler about this and gave him the address (how trusting!). He wanted to see for himself before bringing the collector. Renoir's brother showed him the little figure that he'd supposedly reserved for me. "What do you think of this?" "That? It's priceless!" said Basler. When I came back to see the figure I'd been dreaming about, Renoir said, "I want 12,000 francs for it now."

Basler himself told me about his gaffe. His enthusiasm was understandable, but what a bungler! I obviously wouldn't have been able to profit by this windfall, but what did that matter? I could have felt *glorious* for a moment. In any case, Renoir's brother's word clearly wasn't worth much.

Basler returned with his German collector. Renoir, a rabid nationalist and ill-tempered to boot, threw them both out, and came to upbraid me.

"What you mean, sending me Boches?"

"What are you talking about? I don't know any Boches! If you like, I'll send you another buyer." (I don't hold grudges; besides, there was money to be made . . .)

So I went to find the dealer Jos Hessel, told him what I had seen at Renoir's, and warned him not to annoy the bulldog. He went to see for himself, and when he came back, said, "Try to get it all for 100,000 francs." So I returned to Renoir's—a bit shamefaced, I admit—and put the offer to him.

"A hundred thousand francs? What the hell am I supposed to do with a hundred thousand francs? I never said I wanted to sell everything, just a few paintings to tide me over. What is it with these people you keep sending me?"

In short, I got yelled at, and that's all I got, because Hessel never wanted to take less than "everything." So that was that.

I never get upset about deals that fall through (especially during the war). But in this case, my detachment came close to an attitude I cherish: not giving a damn.

16

IT'S FREEZING, FIFTEEN DEGREES CELSIUS.—GUSTAVE COQUIOT, PICTURE DEALER.—HE SQUABBLES WITH SUZANNE VALADON.—COQUIOT'S BODYGUARDS.—I MOVE FROM RUE VICTOR MASSÉ TO RUE TAITBOUT.—RAYMOND CASSE,[1] A YOUNG ARTIST WITH A BRIGHT FUTURE.—MME BONGARD (HIGH FASHION).—MORGAN RUSSELL'S SYNCHRONICITY.—THE FUTURISTS.—MODIGLIANI WITH ZBOROWSKI.—A MODIGLIANI EXHIBITION.—THE PRUDISH POLICEMAN.—LUCKY LIBAUDE.— LES VEILLEURS ASSOCIATION.

A new publication called *Soi-même* appeared, and its first issue was a paean to me that felt so over the top, I wanted its distribution stopped. My unhappiness dismayed the editor, who didn't understand it, since the article was written to benefit me. By way of thanks, I told him, "I just want to be left the hell alone!"

Well, well, Charmys were selling. And a Marquet went for 2,300 francs, meaning a 200-franc profit! For shame!

Brrr! It was very cold—twelve to fifteen degrees Celsius—and there is no coal! We would stand in line at the coal sellers, and most of the time didn't get any. "What the heck," I said to myself, "I'll just use my gas heater." But my heater froze, and the boiling water poured on it froze as well . . . I was now chilled to the bone, and had to take refuge with the concierge, who had a little coal stove. The plumber who came to thaw my heater asked for some big pans of boiling water. My concierge gaped at him: "Huh, what?" How in the world could we boil water? Still, she managed. But even after lots of pouring, he had to take the heater away, afraid it might explode . . . My shop was like a skating rink. Yet this "sad" adventure delighted us; why?

We were so on edge!

The temperature became milder, and I returned to my summer quarters.

A little exhibition got things going, so to speak.

I visited Borgeaud, the Swiss painter, to see what he was up to (pictorially speaking, you understand).

Utter's painting *The Harlequin* was a fine piece of work, and caught a collector's eye.

Gustave Coquiot had been working as a picture dealer for the past year, and was prospering; the war produced a fair number of such anomalies. His apartment was crammed with paintings, and collectors were very well treated there: port wine, the best brands of liquor, cigars. A painting would be shown without being shown, but actually shown. "Here's one I bought from a poor guy who was starving to death." A refrain repeated daily amid cigar smoke and the clinking of crystal.

Coquiot was very close to Utter and Valadon, and owned a great number of canvases by them, and also by Utrillo.

Silly fights would erupt between him and Valadon, and they got into arguments in a swirl of gossip and chit-chat. "I gave her shelter!" "He deceived me!"

Pesson, Heuzé, Giran-Max, and many others were regulars at Coquiot's, who also gave them shelter, as he liked to say. Giran-Max would often spot fakes he was proud to have executed being sold by dealers (to his amusement).

At one point I got interested in paintings by [Marthe Laurens,] the very gifted wife of [Henri] Laurens, the Cubist sculptor.

During the hostilities, tenants with no income who couldn't pay their rent were granted a moratorium. My subtenant, who actually earned a scandalous amount, used this as an excuse not to pay me a sou. My landlord tried to intimidate me, and since I didn't know that evictions had been suspended, was able to force me out: I had eight days to vacate the premises. But since this

was the only means I had to get rid of my horrible subtenant, I cheerfully took it, and signed a statement acknowledging my back rent. By a stroke of luck, I found a beautiful store at 50 rue Taitbout that had been closed since the start of the war. I asked to come see it. "I must have it," I said to myself. "But I only have 250 francs. What am I going to do?"

"The lease is 6,000 francs," said the concierge.

"Is the owner around?"

"He lives in the building."

I went upstairs and told him, "Monsieur, I just saw the shop and I like it. But I can only pay 3,000 francs." (How?)

"That's not very much! What about 3,500?"

"Done! If it's okay with you, we'll sign the lease this week."

"Agreed."

I needed 1,750 francs for the six months advance rent; I had 250, so I was short 1,500. This was no time to hesitate; I went to see my youngest brother at the grain market and put my case to him. The welcome was rather cool . . . I knew he wasn't rich, but I couldn't let such considerations stop me. Putting my dignity aside, I pressed him, and got the 1,500 francs.

I signed the lease, and presto! I made the move.

(The fortuitous event!)

I was certainly happy to move, but often choked up when I recalled that little shop on rue Victor Massé. It was the cradle of our dear hopeful painters, welcoming all that noisy youth, hungry for independence and renewal, that gave shape to pictorial experiments whose blossoming impacted the whole world.

I had to carry on that task, though it was now harder because of persistent obstacles, and with fewer possibilities as expenses had soared.

The space hadn't been used for three years, and was indescribably filthy. Also, I had to get rid of an enormous machine that filled the entire center of the store. I quickly requisitioned

painters, electricians, and carpenters and said, "Here's what has to be done, and here's what I want. Can you do all that right away?"

"Of course!"

"And one other thing: I don't have any money. Can you wait to be paid?"

"Just as you like."

They fixed the whole place up. Between antique paintings and antique furniture, I started doing some business . . . It was a good start. But I had trouble getting used to so much vastness. The space intimidated me. I felt tiny, as if I were going to get lost in it . . . I should hang a bell around my neck . . . What a change! I felt completely discombobulated. Once, when I got to my mother's house in Batignolles for dinner, she said, "Did you take off your hat?" I felt my head. It was true. I had forgotten it, and hadn't noticed during the whole trip . . .

Finally! What a pleasure to be away from my Victor Massé environment. And my new neighbors were excited! We hung a big canvas with my new address on the store. Twenty years! Twenty years spent assiduously following the evolution of the new pictorial movement!

A prospectus went out with a change of address notice, and it was full speed ahead!

I inaugurated the new gallery with a big group show of paintings by all the artists who had exhibited with me before. Many people came, but the show was only a moral success.

Suzanne Valadon brought me some of her and Utrillo's paintings. Conscious that the war was still raging, we had to set the prices low.

The butchery was continuing: we spent evenings in the basement, never spared a night without the cruel aerial bombs and torpedoes falling at random. And to think that amid this chaos, I was able to feel hopeful again, expand, and take on new debt.

Hope! Hope!

I got very interested in a young artist named Raymond Casse who had a lot to say, pictorially speaking. For now, he was doing decoration work to get by. He'd been unable to enlist for health reasons.

Yet another new journal came out, called *Nord-Sud*, published by Delmée and Reverdy.[2]

Clovis Sagot had died about a year earlier, and his widow was trying to carry on the way her husband had, with the help of his assistant, Charles Villette. An exhibition of Herbin, a new convert to Cubism who used striking colors, made something of an impact. Villette picked up a brush himself, becoming a Sunday painter. With a perfectly straight face, that rascal Picasso dubbed him a "great painter" (not a very mean joke, fortunately). But Villette missed the sarcasm completely and began to deliver unexpected, addlebrained insights into art and his own person . . . But he was a good and honest young man.

When war was declared, Mme Sagot panicked and closed her gallery. Also, Villette was called up. So she gradually sold off her stock, including boxes of drawings by Picasso and others . . . What a shame! I didn't have any money, as usual, so I couldn't take advantage of it.

Young Casse had talent; his work was selling quite well . . .

For some time now, very interesting exhibitions were being held at the fashion house run by Germaine Bongard. The salon attracted a lot of people, especially artists drawn by their hostess's striking good looks.

Ozenfant was a frequent visitor to the house, which is where he got so interested in fashion that he launched the Amédée company on rue Blanche. But let's not anticipate.

In 1912, the American painter Morgan Russell and one of his compatriots had put on a show called "Synchronism" at the Galerie Bernheim-Jeune.

Around that time, Bernheim-Jeune also held an exhibition of Futurists that drew crowds, made ink spill, dismayed many celebrities, and enchanted the great unwashed. I confess to being among the latter. I enjoyed the impetuous movement and color. Since then, I've lost my illusions about many things, but the fact remains that the art was very lively stuff . . . In this case, stagnation seemed the greatest danger. (Remember, "If you're not moving forward, you're falling back.")

To return to Morgan Russell, his current work was stuck. He would have trouble breaking out unless he opened his thinking to more freedom and more life. Would he manage to do that? I wondered . . .

Demobilized because of an injury to his right hand, Charles Villette was painting with his left, and fairly skillfully. I exhibited a body of his work with some success.

Modigliani was causing a lot of trouble for Zborowski, who was now handling him. It was very hard to sell his work, and he himself wasn't easy to get along with . . . To give it a shot, I bought three of his canvases.

Malpel consigned a very handsome Lautrec to me and—surprise!—I sold it. This proved helpful because he was in a fix: he had a bachelor apartment that he had to vacate quickly. To help him, I took care of everything while promising discretion. The move-out was accomplished in a morning. I then took charge of selling the paintings by Marquet, Matisse, Rouault, Raoul Dufy, and Van Dongen that had decorated the little place.

Zborowski asked me to put on an exhibition of paintings and drawings by Modigliani. I agreed, of course.

We hung the show on a Sunday, and held a preview for a gathering of the elect on Monday, December 3, 1917.[3] Sumptuous nudes, angular figures, ravishing portraits. When the daylight faded, we turned on the spotlights. Intrigued to see so many people in the shop, a passerby stopped and stared. He was joined

by a second, then a third; eventually, a crowd gathered. The division police *commissaire*, whose precinct was across the street, got upset. "What's that? A nude?" (His window directly faced a nude.) He sent over a plainclothes cop with a friendly manner.

"The commissaire orders you to remove that nude."

"Really, why?"

Louder, and with more emphasis: "The commissaire orders you to remove this one as well." (My god! He hadn't seen everything yet. But none of them were in my shop window!) The nude was removed. The assembled elect laughed without quite knowing what was going on, any more than I did. Outside, the crowd was growing, and getting restless: danger!

The cop came back, as friendly as ever. "The commissaire requests that you come to the station." ("Requests"—that was better.)

"But I'm busy, as you can see."

Louder, and even more emphatically: "The commissaire requests that you come over." Amid catcalls and jibes from the crowd, I walked across the street to the precinct, which was full of customers.

"You requested that I come see you?"

"Yes, and I'm ordering you to remove all that filth!" This, in a tone of rare insolence that brooked no reply.

I tried, just the same. "Fortunately, some connoisseurs don't share that opinion. Besides, what's wrong with those nudes, anyway?"

"Those nudes!" (Eyes bulging, and in a voice you could hear as far as La Courneuve.) "Those disgus—... they ... they ... h-h-h-have *hairs!*" His self-regard bolstered by approving laughter from the poor saps crowding the precinct, he went on triumphantly: "And if my orders aren't obeyed immediately, I'll send a squad to confiscate the lot of them."

A pastoral image ... each cop in the squad carrying a Modigliani nude in his arms ... cinema.

I immediately closed the gallery, and my trapped guests took the canvases down. Henri Simon, the minister for the colonies, Marcel Sembat, Georgette Agutte, and various other notable personalities had just left.

The commissaire, one Rousselot, should have taken a few grains of hellebore.[4] He was typical of the kind of cranks who laid down the law for us during the war. What was the point of complaining, and to whom? We had too many other fish to fry. His shrieks of outraged prudishness clearly revealed a sick mind, which the sight of nudes inflamed.

Speaking of La Courneuve, I now remember that after the explosion there,[5] which was heard all over Paris, Rousselot loudly revealed his feelings when he was terrified. He just ran through the streets screaming at people not to spread panic. "If anybody spreads panic, I'll arrest them!" What was he waiting for to arrest himself?

With all the paintings taken down, the exhibition continued; only two drawings sold . . . for 30 francs each. To compensate Zborowski, I bought eight of the paintings myself.

Two years later,[6] we learned of Modigliani's pathetic death at about the same time as his wife's tragic suicide.

A few days beforehand, having heard that the poor man was at death's door, Libaude spent the day pounding the Paris pavements, snapping up everything he could find, like a hyena on a carcass (up to then he hadn't bought any Modigliani paintings). When the artist's death was announced, Libaude skipped about like a madman, saying, "I'm so lucky! I was still getting Modiglianis for practically nothing the day before he died. I was just in time!"

An association had recently been formed called Les Veilleurs (Why "The Watchers"? Someone once explained it to me, but I never understood.), whose members, recruited by the poet

Carlos Larronde, came in from the provinces.[7] The aim of the association was to help artists, which was all very well, except that to be helped you had to be a member of the association and blindly obey the orders of your superiors, however whimsical they might be. The penalties were very severe! The leaders, psychologists and bons vivants who were never seen, traded on the naiveté of their subordinates. A year later, the Italian painter Elmiro Celli was able to have a show at my gallery under their auspices. (He was a clever one!)

My friends the de La Rochas made a short stay in Bièvre, also under the association's auspices, because Bièvre was where the Veilleurs group lived.[8] They prepared an exhibition of decorative art to be held at my place. Marcel Hiver also visited Bièvre, using and abusing what profit he could extract from it. For some people, the association was helpful, as long as it lasted.

Big businessmen from Le Havre—they were called "scouts"—were underwriting Les Veilleurs (its leaders, that is).

Each member who agreed was given a special suit to wear. Women were admitted, but only as a lesser evil. The leaders disapproved of committed couples, and they condemned marriage. Carlos Larronde asked me to put on a Veilleurs exhibition later.

17

ZÁRRAGA.—BERGON'S "SPIRITS."—ANOTHER CRUSHING BLOW: BIG BERTHA.—I GO TO LA BAULE WITH MY MOTHER.—ARMISTICE!—THE SPANISH FLU.—A BAD DREAM!—MY SISTER-IN-LAW'S BEAUTIFUL GESTURE.—HEUZÉ WANTS MY GALLERY!—THE GALERIE PESSON OPENS ITS DOORS.—SADNESS.—I MEET BAUCHY FOR THE FIRST TIME.—AN ART BOOKSTORE.—A NERVOUS PARTNER.—LAUGHING LOOKY-LOOKS.—COUBINE AND GIMMI EXHIBIT.—PAUL GUILLAUME MOVES FROM FAUBOURG SAINT-HONORÉ TO RUE LA BOÉTIE.

The painter [Ángel] Zárraga was a charming man who lived alone, saw no one, and surrounded himself only with real friends (Fénéon was one of them[1]). "You must join us," he told me. I was glad to. I bought a small, pretty Cubist painting from him. But he was evolving both too fast and too little for my taste, so I stopped following him . . . I didn't see him anymore . . . I was no longer a "real" friend!

I still couldn't give up selling antiques, since that was what had allowed me to make it this far. Not that this stopped me from buying Picasso drawings and watercolors from Mme Sagot . . . I bought everything, everything I could!

1918. If I could pay my debts and get out from under, I would be saved! But there are always hiccups, and I find myself starting over again and again.

What a horrible vision! The trenches, bombardments, all that beautiful youth cut down! The nightmare went on, but we had to continue to love and struggle in spite of everything.

If all the weapons of war were requisitioned from all the countries, the killing wouldn't last a month! Utopia! But oh, the profiteers!

January. The Marthe Laurens show had few sales . . . So antiques would still be our salvation.

Charmy, who was always reckless, got very sick and needed nursing. Help!

I put on an exhibition for François Bergon, the painter who wrote that ridiculously laudatory article about me in *Soi-même*.[2] He believed that genius "came to him from Spirits." He made tables turn and sideboards dance; when he called to a chair . . . it came running. Best to avoid such overheated spirits . . . No sales.

Derain was mobilized, and his wife was forced to sell drawings he'd done. I bought a few, then a pretty watercolor by Laprade and a few watercolors from Asselin . . . Given the times, I seemed to be on a roll.

The Hensel show; a few pieces sold.

March. A crushing blow: Big Bertha![3] We were stunned, panic-stricken. Everything ground to a halt. Then the exodus started again. The toll of that infernal device's victims climbed relentlessly. Paris emptied out, as if a savage horde were approaching.

My mother kept walking around heedless of the danger, so my brothers pressed me to take her to La Baule, which we reached on June 15.[4]

What torture! We gathered at the train station every evening, feverishly waiting for newspapers and news. In spite of my fear—that big gun scared me, I'll admit it—I was sorry not to be in Paris. The social life in La Baule created by the refugees from the capital did nothing to cheer me up. Besides that, I wasn't used to living with my mother anymore, and her despotism made the stay unbearable. Our nerves were frayed, we got irritated over trifles, and news didn't come fast enough. We returned to Paris around August 20 . . . Our troops were advancing at a terrific rate; this was the great offensive.

I had left Charles Villette in charge of my store, and he opened it every other day or so, even though it was pointless.

I asked my landlord if I could postpone my lease payment, and he very kindly agreed.

Our troops continued to advance. In disarray, the German army asked for an armistice.

At long last! The bells all rang, the cannon boomed. The war was over! The killing had stopped! We wept with joy, embracing each other in the streets. Armistice! Armistice! Delirious crowds gathered. People were dancing at every crossroad. Just describing it now, I feel overcome, my eyes moist . . .

Next day, the joy was a little more forced, less intense. Still, people everywhere were singing "La Marseillaise" with every chorus imaginable.

I would have been heartbroken not to have lived through those two days in Paris!

Life began to pick up again, stores opened. Everyone wanted to get back to business and pleasure, but we had lost so many.

To end this chapter of the horrible carnage, a new calamity robbed us of still more friends: the Spanish flu. Yet another reminder that even brief joys come at a price.

Many who had escaped the shooting were now dying, among them Guillaume Apollinaire. The young painter Raymond Casse died at twenty-five, leaving a widow and a child. Artists donated canvases, and I put on an exhibition to raise money for the widow and the orphan.

Communal joy was distinctly contained, and ours especially so. My brother was intelligent, but almost painfully shy, which caused him to fall into an indescribable moral distress beyond all human power. His wife, who was totally devoted to him, stood by him against her own right-thinking family . . . The clash only sharpened his pain. But thanks to her courage, the obstacle was overcome. Let's draw the curtain, and forget that bad dream![5]

Business was quiet. The year 1918 ended, leaving some hope in our hearts.

1919. Gradually, our *poilus* started coming back. The poor guys had to make up a lot of lost time, and they threw themselves into it with a passion! They were home, which was all that

mattered. The country's gratitude (?) would accomplish a lot . . .

Meanwhile, the ever-resourceful Heuzé had stayed behind, even though he was perfectly healthy. No point in wondering why: mystery and discretion . . . He looked out for himself . . .

Malpel left for Montauban, and settled there. He urgently needed to put his affairs in order, so he sent me some paintings by Marquet, Picasso, and Vlaminck on consignment. He was in a hurry to sell, so I made a firm offer to buy them. But I didn't have any money; what could I do? Besides, I had debts to pay that I'd run up during the bombing . . . My sister-in-law, the war widow,[6] spontaneously offered to lend me the necessary sum, provided of course that I not wait too long to pay her back, since she herself had very little money. Which only made her lovely gesture that much more precious.

So I paid Malpel, and was under less pressure to sell the paintings too quickly.

I also took charge of all the Chabaud paintings that Mme Sagot owned and was gradually liquidating. Heuzé was pressuring her to turn over her gallery to him, but she was hesitating (quit or continue?). He had found a store on Faubourg Saint-Honoré whose rent was much higher than Sagot's or mine, even without counting the incidental expenses involved. Heuzé didn't want to take it on, and was urging me to rent the new store and give him mine . . . but he couldn't convince me that he wasn't just acting in his own interest.

A show of René Durey and Ortiz de Zárate; hardly any sales.

Then a show by Mainssieux . . . prolific . . .

In April, Veilleurs protégé Elmiro Celli had his group show. A few paintings sold.

In May, the trio of Charmy, Chabaud, and Heuzé exhibited. Very limited success.

Heuzé managed to rent the Sagot gallery at 46 rue Laffitte, which became the Galerie Pesson. Pesson was the named tenant

and the responsible party, but the gallery was actually a joint venture of Pesson, Heuzé, Bouche, Mainssieux, Asselin, Daragnès, and Charmy. They suggested I cooperate with them, and I agreed with pleasure.

The Galerie Pesson opened with an exhibition of paintings by Georges Bouche that I helped hang. The launch was well executed. Monster publicity, posters everywhere, even in the métro, and striking invitations. And the crowds came. Success! Success!

But what then? With the group's fear of a difficult beginning dissipated, my support was no longer needed, and they could drop me. I'd become an annoyance . . . When I showed up, these gentlemen started looking busy, as if they had no time to spare.

The second exhibition they did, of Charmy, was launched as masterfully as the first, and was wildly successful. And then? They acted as if we were strangers . . . Heuzé, that coward, totally avoided me. I won't dwell on the painful scenes that followed. Despite all my efforts, I've had a hard time erasing them from my memory.

One of M. Kapferer's friends wanted a Charmy from her show and asked me to arrange its purchase. I bought the Charmy from the Galerie Pesson, but wasn't given a dealer's discount . . . So I paid full price, and took the painting to Kapferer without making a sou in profit. But what did that matter, if the gesture was a handsome one?

Shortly afterward, Kapferer had me ask what contract conditions the Galerie Pesson would agree to give Charmy, along with him and me. Heuzé was furious, and refused to negotiate . . . Hee, hee, hee!

Vacation time. The Galerie Pesson shut its doors, and everyone left town.

When the season started up again, Pesson phoned Kapferer about the Charmy contract (they had thought it over).

"Did you let Mademoiselle Weill know?" asked Kapferer.

"No," said Pesson. "We don't want to do anything with her."

"In that case, there's no point in discussing it," he said, and hung up.

Kapferer himself told me what had happened. I was very grateful for the trust he showed me on that occasion.

Anyway, let's draw a curtain over that as well.

In June, Verhoeven exhibited some pleasing decorative paintings.

Charles Villette was having a hard time. The war had left him disabled, and he could no longer work as a framer. He helped me out when he could, while continuing to paint.

Auguste Bauchy, whom I mentioned at the start of this memoir but had never met, happened by the gallery and introduced himself. He was the collector who once owned the Café des Variétés and was among the first to buy Van Gogh, Gauguin, and Renoir. He was the nicest man imaginable, and I was very happy to meet him.

I went out of town in August for a couple of days; nothing worth telling about.

In September, I was given a collection of very rare books in exchange for paintings . . . A good start for the season! I so enjoyed filing those books. I love books, and love handling them!

In November, we launched the art book part of the gallery with a "black-and-white" show: drawings by Coubine, Derain, Raoul Dufy, Friesz, Galanis, Marquet, Matisse, L.-A. Moreau, Picasso, Jean Puy, Utter, Suzanne Valadon, Van Dongen, Vlaminck, etc., etc. Big success!

December saw the exhibition of decorative art that Mme de La Rocha had prepared in Bièvre under the Veilleurs' auspices that I mentioned earlier: cushions, lampshades, carpets, screens, and dresses, along with woven and painted silks. Completely transformed, the gallery had a wonderfully precious

intimacy. The effort was crowned with success—which is rare! A new journal, *Les Lettres parisiennes*,[7] came out. Like all the others, it appeared and disappeared.

Would *Le Nouveau spectateur*, entirely edited by Roger Allard, last any longer? An alert, very lively character, Allard cheerfully went after painting and painters. I didn't always agree with what he wrote, but it was always amusing.

1920. Monsieur Kapferer's trust in me was as strong as ever.

"How about this," he said. "I'll advance you the money, and you buy the pictures."

"What do you mean? What pictures?"

"Whatever you like. I'll leave that up to you."

"Still, I'd rather we went together."

"No, no. Go ahead and buy the art, and I'll see it later . . ."

All right. I first went to see Raoul Dufy, and bought four large, very beautiful paintings from him. "Inspired" critics called him a mere decorator, but that was hardly justified. Those four canvases were the work of a real painter . . .

I then ran to see Picasso. So as not to alarm my silent partner, I first bought a batch of sketches for my own account. Then I bought twelve gorgeous, very large drawings for Kapferer. I wanted to show him these initial purchases before continuing. I paid with the 10,000-franc check he'd given me, and left with my precious purchases.

When he came to see them, he said, "You're out of your mind!"

"But I asked you to come with me."

"I trusted you. I didn't imagine you were so crazy!"

"This certainly isn't very encouraging."

So that was my experience with a partnership . . . To settle up as fast as possible, I had to sell the pieces at fire-sale prices. Collectors bought the Dufys right away. The Picassos took much longer. I made some exchanges, and wasn't easily able to balance

the books. I wound up feeling like a ninny, as usual. ("Ah, Mademoiselle Weill, you must be rich . . ." same old song.)

In January, a very interesting group show: Bissière, Galanis, Gernez, Lhote, Lotiron, and Utter.

The work by les Jeunes was giving the academic painter J.-É. Blanche sleepless nights, and he was angrily dismissive of them. He came to see the exhibition, and wrote a review of the young painters and me that read like the rants of a fishwife.

I got interested in Bissière, who showed promise . . . That show generated a lot of talk—a good sign!

February: sketches by Luis de La Rocha; several sold. Les Veilleurs were watching . . .

March. Robert Diaz de Soria show. Pretentious!

Favory introduced me to a group of very young Jeunes, and asked me to give them a show with him. I agreed, and in April exhibited Clairin, Jean Dufy, Farrey, Favory, [Gabriel] Fournier, Portal, and Riou. Aside from Favory, none of these artists had yet proven himself. Patience!

A prosperous-looking middle-class couple came into the gallery one day . . . As the woman walked around the room, she kept laughing; her hilarity was almost naive. The man seemed annoyed, embarrassed by the laughter. Once she calmed down, she turned to me. (I had held back patiently, waiting to confront her.) "Does this art sell, madame?" "Of course it sells, madame. But tell me, why were you laughing?" "I don't understand!" "What? You're laughing because you don't understand? Do you understand English?" "No." (She had stopped laughing, unsure of where I was going.) "So when you open a book in English you must crack up because you don't understand it!" "Of course not!" "You would want to learn English, wouldn't you, to be able to read it? Well, with painting, you also have to learn to 'see,' to educate your eye." Without answering—or laughing—the two left, stiff as pokers. A few days later they came back, full of enthusiasm. "Madame, we've come to learn, and not to

laugh." "Perfect! Look around and I'll explain things, if need be." They looked around with interest, and promised to come back. A week later they showed up again, this time very excited. "Madame, we've thought it over very carefully, and we would like to buy some art." "Not yet! You aren't ready." "Madame is right," said the husband, happy not to have to follow through. "We should study and look some more." The woman was flabbergasted . . . She'd never met a *marchand* who refused to make a sale. It's possible that they became fervent collectors, but I never saw them again, having changed my location soon afterward. Too bad!

Basler showed me some work by Coubine and Gimmi. I liked Gimmi better. I didn't like Coubine's nudes; I found them cold. His landscapes and flowers pleased me more . . . Ah, how Coubine's Basler would hate the Gimmi I preferred!

So in May 1920, Gimmi exhibited in my gallery for the first time. Success.

In June, Coubine. The work held together.

Paul Guillaume was struggling in his little shop on Faubourg Saint-Honoré, and times were tough.[8] He sold me some twenty Derain drawings and watercolors . . . Then he got afloat again, and took a shop on rue la Boétie, the lucky stiff. I bought yet another first-class library in exchange for paintings; a few of the books were for myself . . .

Young Fels had just founded a new review, *Action*. It was probably destined to disappear, like the others.

Also new: *Le Crapouillot*. ("Crapouillot" . . . in peacetime?)[9]

Along came Marcoussis and his wife Halicka, who painted intelligently. He was a Cubist who painted on glass with very pretty colors. His painting? . . . What a fine artist that Picasso is!

I bought some paintings from Suzanne Valadon that showed unmistakable personality. She was such a great painter! And so was Utrillo!

The moment I get any money, I buy stuff. It's a mania!

18

AN INDEMNITY FOR LEAVING RUE TAITBOUT.—PESSON
BAILS OUT.—ON AUGUST 2, GALERIE PESSON BECOMES
GALERIE B. WEILL.—THE VEILLEURS SHOW.—A CLASH WITH
VANDERPYL.—*PETITE REVUE DES PEINTRES.*—MY ONE
HUNDREDTH EXHIBITION.—A PUPPET SHOW TO CELEBRATE.—
MY MOTHER DIES.—THE PAUWELS.—J.-J. BROUSSON.—KARS
SPEAKS.—MY ASSISTANT GETS A SWOLLEN HEAD.—SALON
DES PEINTRES FRANÇAIS, FOUNDED BY MARCEL GAILLARD.—
SMITH THE PORTUGUESE.—*UBU ROI* AT THE THÉÂTRE DE
L'ŒUVRE.—THE VALADON-UTRILLO EXHIBITIONS.

About June 15, 1920, an agent from the Lloyd's insurance company came to ask if I would assign them my lease; they were in negotiations with my landlord to buy the building. After a few days of bargaining, they agreed to pay me 80,000 francs. On June 25, the company wrote me a letter confirming the agreement, but under one condition, I had to vacate by October. Beyond that date, the agreement would be null and void.

All I had to do was find a new shop . . . and no longer be facing the police station!

But it was impossible to find anything without paying 100,000 to 150,000 francs in key money (a widespread and shameful practice). I would have to stay where I was, and too bad about the indemnity.

I had resigned myself to that, when a worried-looking Pesson suddenly blew into my shop on July 20. "Is anyone else here?" he asked. "No." "Shut the doors!" "Huh? What do you want with me?" "Would you like to take over my gallery?" I was startled. "What?" "Do you want my gallery?" "Wait a minute, explain yourself. What's going on? I thought your business was doing so well." "I want out. I don't want anything to do with Heuzé any-

more. I'm fed up." "But think about it for a moment. What will the others say?" "I don't care. I want to get rid of Heuzé, whatever it takes." "All right. I'll think about it, and let you know." "There's no time to lose. They're all out of town, so it would be very easy. Besides, I'm anxious to go on vacation myself." "I'll give you my thoughts very soon."

I wasn't seeing anybody from that gallery anymore, so how in the world could Pesson have known I was looking for a new space? He was heaven sent, no doubt about it. (This was such a fortuitous event!)

After we agreed on a (very reasonable) price, the paperwork was done on July 28, 1920. I moved on July 31, and the Lloyd's insurance company paid me the indemnity on August 2. I then paid Pesson, but on the condition that he write all his partners to let them know what was happening. With everything settled, he left town feeling lighthearted and satisfied . . . as did I!

Then all hell broke loose. Stop him, he's robbing us! So is she! They were going to sue me. We had no right . . . etc. But Pesson was the sole named party and had made the assignment before a notary, so he wasn't legally obligated to anybody.

Morally? . . . That was another story. I, on the other hand, wasn't bound by any such considerations.

Pesson was excoriated, and it was easy to see why . . . Anyway, let's not dwell on it. I'd been made an extraordinary offer, and would have been a real fool not to take advantage of it. The whole clan was angry at me, but . . . they would come around.

Now fixed up, 46 rue Laffitte, once Galerie Clovis Sagot and briefly Galerie Pesson, became Galerie B. Weill.

Around August 10, we opened for a few days, just to advertise the change of ownership, and then . . . some rest.

I was no longer allowed to sell antiques, because there was already an antique dealer in the building. So from then on, I could only count on modern art to make it . . . I really had to!

We began the season with the Veilleurs exhibition I mentioned earlier, initiated by Carlos Larronde. It drew people from provinces in the four corners of France to my gallery. Who wouldn't recognize the calm or anxious faces of occult society members? The faces of those who stupidly believed in the joy to come. That's what this provincial flood looked like.

Carlos Larronde welcomed his guests with unctuous condescension. In an eloquent speech, he urged them to unite for the common cause (what cause?).

It was amusing to watch this conference take itself so seriously.

The exhibition itself consisted of objects created by society members, and were of great interest to some collectors. But the result wasn't worth the effort. October's show was a collection of work by [René] Mendès-France.

To free up my time and let me go out occasionally, I hired a young man as a gallery assistant and cook.

I was again given a large library of deluxe editions. Selling books creates movement: I love books!

A large, eclectic exhibition marked the month of November: Angiboult, Archipenko (sculptor), Raoul and Jean Dufy, Gernez, Gleizes (who also belonged to Les Veilleurs), Halicka, Gimmi, Kars, Lewitska, Lhote, Marcoussis, Robert Mortier, and Survage . . . As you can see, the most varied of groups.

Vanderpyl, an art critic at the *Petit parisien*, joined Raoul Dufy in recommending a Polish artist to me, Rena Hassenberg, who painted under the name Irène Reno. I went to see her works in an uncomfortable ground-floor studio, and we agreed on an exhibition for January 1921.[1] She had taste, and this would give her time to put together an interesting collection.

I went into debt again to buy thirteen large Van Dongens from Léonce Rosenberg.[2] I always get too carried away, but some of the paintings were truly beautiful, though they proved fairly hard to sell.

From this batch, Dorival bought a superb nude, one of the most beautiful that Van Dongen ever painted. Have you ever seen Dorival get excited? . . . In this case, he was *really* excited.

If I were able to look at art dispassionately, like some of my colleagues, I would have acquired great prestige, and be as rich as they were.

The Reno exhibition was held, and it didn't go too badly. But while it was on, she pestered me daily for money, and I gave her some advances with the legitimate expectation that I would be repaid when the show closed and we settled up. That was when Reno's tone became aggressive. "I thought you would repay yourself by keeping some of the canvases." "I like to be free . . . I want to do what I please," I said.

Vanderpyl took her side against me, and spread the rumor that I had "exploited" the artist. (I wished I had! It would have saved him from telling a lie.)

Books continued to sell steadily, which was a great help when times were bad.

I had started working on an amusing project. At home in the evenings, I wrote *Petite revue des peintres*, a little play about painters that I hoped we could perform as a puppet show to celebrate the gallery's hundredth exhibition.

The script of my revue was ready in a few days; all we had to do was find a puppet theater. Hardy, a friend of Mendès-France's who worked a lot with marionettes, lent us his puppet theater and his support. We then had to sculpt the heads of the marionettes portraying the artists. Working from my thumbnail descriptions, Mendès-France did the job very well, even for people he didn't know. My own puppet was among the most striking, though of course he had the model right in front of him . . .

Rehearsals were hilarious; they couldn't have gone worse. The show was scheduled for February 21, but by the twentieth we were no further along than we'd been on our first day. I'd been pulling my hair out so frantically, it looked like a bramble bush.

"We'll never be ready to perform tomorrow!" said Hardy, who had lent us the theater and was directing the show.

"Too bad!" I said. "We're going on anyway. We'll perform with scripts in hand."

"That'll be kind of awkward."

"What can I say? It's too late to cancel the performance."

On February 21, 1921, the hundredth exhibition of a large number of varied works took place. That evening, with multicolored spotlights lighting the gallery and an audience of at least three hundred, the show went off with undreamed-of success. The set was the place du Tertre in Montmartre, painted by Mendès-France. I played the narrator, and King François was my partner. It all worked perfectly: Hardy, Mendès-France, [Paul] Jeanne, and B. Weill played their parts like real troupers. The spectators seemed amused, which was all I wanted. They called for a repeat performance, but that might break the spell . . . Besides, it had been such a drama! No, once was enough!

Among the guests—artists, collectors, critics, and dealers—I'll mention Suzanne Valadon, Charmy, Lewitska, Flandrin, Friesz, Jean Dufy, Clairin, Favory, Utter, L.-A. Moreau, the Luis de La Rochas, Gimmi, Lhote, Lotiron, Bissière, Galanis, Camoin, Girieud, Laprade, Amélie Matisse and her two sons, Manguin, Paviot, Dufrénoy, Metzinger, Waroquier, etc., etc., and others I've forgotten. Collectors included Dr. and Mme Desjardins, Pauwels, the Coquiots, de Jouvencel, the Dorivals, and more. All the critics were there, except the newborns. Dealers included the Ebsteins, the Paul Guillaumes, Galerie Druet representatives, Basler, Zborowski, etc., etc. Mainssieux and his string quartet played during the interludes.

That was the real launch of the gallery on rue Laffitte. As it happens, the one hundredth exhibition was enormously successful.

February was a good month!

March saw the first show of a body of work by young P.-E. Clairin. Collectors were taken by the artist's enthusiasm. Let's hope they aren't disappointed!

Mourning! After a three-day illness, my mother died on March 22. The very old are like children to us. We put up with and forgive them their quirks, and when they die, they leave a great void. Mourning!

In April, the group of Favory, Farrey, Gabriel Fournier, Jean Dufy, Riou, Clairin, Portal, and Utter. A good exhibition.

A pair of new collectors, [Robert and Lucie] Pauwels, took an interest in les Jeunes, and wanted to build a collection. They bought a few good paintings, but were a bit snobbish about it. Also, they were impatient . . . prices *had* to go up.

A collection of paintings isn't like a stock portfolio. I was afraid they had neither confidence nor perseverance.

More than anything, however, the Pauwels "adored" artists, and had them over once a month for singing and poetry recitations along with their choice of tea or lemonade. I got an invitation to one of those teas for the same day I'd been invited to lunch by J.-J. Brousson. I didn't really know him, but he was inviting some of my friends and extended the invitation to me, so I went. His place was crammed with masses of bric-a-brac. The lunch, which Brousson himself cooked and served with plenty of wine, was lavish and excellent. This put us in a perfect mood to admire his "marvels." He told us the stories behind them with conviction, tempered with a touch of self-deprecating irony. When he joined his hands, his tales sounded sacerdotal; when he waved them, demonic.

Looking secretive, Brousson showed us a manuscript he said was a biography of Anatole France that he claimed would make

a lot of noise when it was published.[3] He and his publisher were all set . . . but the *maître* seemed in no hurry to die! The book was to come out only after France's death.

We didn't then know about the crazy stuff in that manuscript, but at that moment I decided my host was a cynical hypocrite. (Like him, I bite the hand that feeds me.)

After that sumptuous lunch we went over to the Pauwels. It was a select gathering, but barren of any intimacy. We all looked at each other, a little embarrassed to be there, surprised to see each other. Music, poetry recitation, tea, lemonade—a charming day. The air was chilly both inside and out, it was snowing. Brrr! It was so cold, everyone seemed to be wondering, what are we doing here? There's no life in this house!

<center>○─○</center>

The painter Tobeen had been quietly making his way. He would paint, place his paintings as he went along, turn around three times and leave . . . Then he would do it again—and again.

In June, a Frank Burty exhibition.

Then the group of Barat-Levraux, Frédureau, Gimmi, Kars, and Robert Mortier.

I just remembered something about Kars, one of my good friends, that illustrates that very talented artist's modesty. For more than twenty years, he came to see all my exhibitions. He never spoke to me, and I never knew who he was or even suspected that he was a painter. But I noticed him each time, and he intrigued me. I would ask myself, "Will he talk, or won't he?" It was only when I moved to rue Laffitte that I finally made his acquaintance. And when a friend told me about him, I exclaimed, "What, he paints? I thought he was mute! So that's Kars?" He has since become a charming and witty comrade.

Nothing to report about the last two exhibitions . . .

And to wind up the pictorial season, a group of works by Utrillo and Suzanne Valadon. The Utrillos sold for 1,500 to 2,000 francs.

Three or four days of vacation in July and August. My place on rue Victor Massé was outfitted with all the modern conveniences . . .

Everyone was coming back to town! Time to organize the season's exhibitions.

My young assistant would be fine except that he got it into his head to become the boss. I'm telling you!

Angry at not being taken seriously, he left. And that's when my nephew, who was doing his military service, showed up while on leave to be initiated into the arcana of the modern art business.

The Swiss painter Hogg had a solo show in October. When he became better known, people would take an interest in him. Lepoutre, a dealer on rue Laffitte, got a promotion. He took a shop on rue la Boétie and inaugurated it with a sensational exhibition of Utrillo paintings. Oh, how prices have risen! People were screaming. But having a succès d'estime had paid off. This *charming* painter had definitely made it, and the big dealers were swinging into action.

Marcel Gaillard, back from a trip to Congo and Dahomey, inaugurated the year 1922. His very interesting collection of work showed promise. In 1917, he founded the Salon des Peintres Français for artists and others who had been mobilized. The salon took place every year, and while hardly lucrative, has been well attended up to today.

I had been meaning to go see paintings by the Portuguese artist Francis Smith for more than a year. When I finally did, I was struck by the exquisite sensitivity of some of them, which led me to give him a show in February. Given that it was the first time he was exhibiting with me, the result was satisfactory.

Ubu Roi was playing at the Théâtre de l'Œuvre. When this farce was first put on, it generated a lot of ink. The revival took place in calmer times.[4] People were barely startled by Ubu's first words: "Sheee-yit!" They even laughed. Spectators used it in calling out to each other. A society woman was even heard to say, "Sheee-yit! I can't find my gloves!"

March. Zadkine, a young Cubist sculptor, put on a very interesting exhibition of watercolors. "It's not going very well," I told him, "but when you're better known—" "But I am very well known!" "Yes, I know; everybody knows it. But so is the planet Mars." I didn't feel too bad for him, actually. He was looking out for himself.

The young painter Edy Legrand lived on the same landing as me on rue Victor Massé. He did illustration, at which he was very skilled, and this allowed him to paint as he pleased, at his own pace. The works he exhibited in March and April were quite interesting, and were praised by Thiébault-Sisson, the art critic at *Le Temps*. He was a critic I didn't always agree with, but I liked his sincerity. Though often wrong, he loved painting and paid no attention to rising or falling prices, a rare attribute among art critics.

Valadon's ascendance in the Valadon-Utrillo exhibition was worth noting. As usual, the collection of her works was remarkably strong. But she had so many detractors! To her great credit, she never made any concessions. A great artist!

Gimmi and Bissière were in fashion. But . . . books, books!

19

KAYSER, A MODERN-DAY COROT.—PIERRE ALBERT-BIROT'S POEMS AT THE MOVIES.—LÉONCE ROSENBERG CROSSES ME.—CHABAUD WRITES ON AND ON.—HOW MONTMARTRE DENIZENS VIEW UTRILLO.—EBERL, THE GREAT BUSINESSMAN.—CHRISTMAS AT UTRILLO'S.—MY *BULLETIN* COMES OUT.—"FOLIE DENTAIRE."—*LE BOUSILLEUR.*—AN INTERVIEW WITH VLAMINCK.—THE GROMAIRE GROUP.—CLEVER VERGÉ-SARRAT.—LURÇAT'S ISOLATION.—PER KROHG AND HIS COMPOSITIONS.

The Kayser paintings that Basler told me about showed a profound temperament that becomes apparent only after long study. The exhibition of his work in May immediately got him ranked as a modern Corot. I can already see the smiles. (I just feel that way; what can I say?) His work just isn't flashy.

I was taken aback by the unusual idea that Pierre Albert-Birot, the avant-garde poet, had of putting on an exhibition of his poems. I did it anyway, but when he suggested it be filmed and shown in a movie theater, I thought he was out of his mind. What was there to film? Those barely visible little squares? You'd have to shoot them with a microscope. Besides, what would the cinematographic interest be? Little success . . .

A group show that ran through mid-July: Hayden, Herbin, Irène Lagut, Metzinger, Severini, and Survage. This was the Léonce Rosenberg group. A fiasco.

Book purchases . . . good books! Books, always!

Another Utrillo and Suzanne Valadon show. As with earlier ones, Utrillo attracted almost all the interest. As for Valadon, her success had slowed. Collectors weren't on board yet, but they would be!

My nephew gave up being a picture dealer. (Young people

lack perseverance!) He didn't want to vegetate his whole life, like me. This way of life suits me, but I have no right to impose it on others.

The businessman Roger Allard, a talented poet, sold me a few watercolors by Rouault and de La Fresnaye, and some books.

No vacation this year. Problems . . .

Léonce Rosenberg played a dirty trick on me that could have turned out badly. Very worrisome! In our business, you can't be too much of an artist or too enthusiastic, but he was all that, and I loved him for it. It's the opposite of what you need in order to make money.

Pascin brought me a portrait of a little girl in pink, a real jewel! I was very sad to have to sell it quickly.

As I said earlier, there were some paintings by Chabaud among the items I bought from Mme Sagot when she liquidated her stock, so I decided to offer to exhibit him. Chabaud agreed, and sent me a couple of canvases. But when I described the sales conditions and asked him what prices I should set, he wrote, "Why would that interest anyone? What's the point of showing them?" It took him four pages of philosophical pronouncements to get to those two sentences . . . Each of his letters ran four to six pages and never answered any of my questions or told me anything positive. I dropped him.

Juan Gris was very shy and didn't dare bring me his paintings. He was bolder when he was selling books, which I gladly bought from him. This nice young man was a bit out of place in the Cubist milieu . . . at least according to the gentlemen Cubists.

Utrillo's exhibitions always brought the painting parasites out of the woodwork, and it happened again at a recent show I put on. A number of Montmartre denizens came to confirm that they had scored good deals by accepting paintings or buying them when the artist was, shall we say, more than usually tipsy. His current prices were between 2,000 and 3,000 francs. At the

show, I decided to have some fun and explore these noble and disinterested collectors' thinking. When they asked (mainly out of curiosity), I quoted them ridiculously low prices ... "How much is that Utrillo?" (It was 3,000 francs.) "Three hundred francs." "What about that one?" (It was 2,000 francs.) "Two hundred francs." This went on for several days. Each time, their faces fell. They had been told that Utrillo's work was worth much more, which meant they hadn't made such a great deal! Yet not one of them took me at my word, or expressed any satisfaction, or tried to make a purchase. I kept hoping they would, and looked forward to the moment with delight, but in vain. But after the exhibition closed, one of them, who had probably been asking around, burst into the gallery. "I'm here for those two Utrillos you offered me at 200 and 300 francs!" "Oh, they've all been sold—as you can imagine, at those prices." "Ah, what bad luck! This isn't the first time I've missed a good deal." "Sometimes you have to make a quick decision. The other people didn't hesitate." He must have thought I was a real dunce!

The Halicka show of paintings and gouaches in November did well. I sold the series of fine gouaches called "The Krakow Ghetto" to M. Kapferer.

The group that exhibited in December—Dubreuil, Favory, Gimmi, Kars, Kisling, Portal, Sabbagh, and Utter—attracted many visitors and sold very decently.

To close out 1922, an exhibition by Eberl. He was having trouble getting by.

"I'm going to bring a very rich collector," he said to me. "Raise the prices."

"I'll quote him the same prices as anyone else."

The "very rich" collector showed up and, talking quietly with Eberl, first persuaded him to give up his dealer's commission, then squeezed 200 francs out of two small canvases selling for 200 francs apiece. So this was the "rich" collector! "That bas-

tard!" said Eberl. Another time, he asked me to obtain a painting by Tobeen that one of his collectors had noticed at the Salon d'Automne. As it happens, I had just bought it, so I consigned it to him at a certain price. Eberl returned and asked me to cut the price a little; I agreed. All right! He took the picture with him; I was to pick up the check the following day. Next day, Eberl showed up with the painting. "He didn't leave the check, so I'm bringing the painting back." He came again the day after that, and said, "You know, we still aren't done with that guy. I went to find him and said, 'Isn't your word worth anything? You're like an old woman!' (*sic*) So he threw a punch at me, and broke the brim of my bowler. I hit back, and punched him right in the kisser. He's got a black eye. You should see it! Tell me, do you suppose he'll come to get the painting?" "Oh, I'm sure of it," I said.

What a way to sell art! It would really have been too bad if Eberl had actually sold the painting. That burlesque scene wouldn't have happened, and I would've missed this funny artist's hysterical miming and dialogue, with his Czech accent and all!

Christmas. A big blowout at Utrillo, Utter, and Valadon's. A groaning board, dancing and singing until dawn, no drunken carousing—it was delightful! Utrillo got quite tipsy, but within limits. He was great. So who do you think got really lit up? Zamaron, the policeman! "Faridondaine, la faridondon . . ."[1]

1923. Eisenschitz show in January: a success. In February, a most interesting group: Billette, Frélaut, Hermine David, Kayser, Léopold Lévy, Pascin, Per Krohg, Vergé-Sarrat, and the great sculptor Despiau. Not a single sale—for shame! So it goes . . .

Pierre Dubreuil exhibition in March.

Books! Books!

April. A nice grouping of paintings and watercolors by Hermine David. For the preview, a grand evening at Pascin's on bou-

levard de Clichy. Food and drink in impressive quantities. People served themselves generously, hungrily, piggishly... It was turning into an orgy; time to leave. Out on the boulevard, the overflow was dispersing. A few people were clinging to trees, trying to drag them away. Let's get out of here!

I was all set to put on an Utrillo exhibition and had completed the negotiations with Bernheim-Jeune when they dropped out at the last moment. It was too late for me to cancel, so I went out and quickly gathered some twenty first-rate paintings. The show was a big success... the last one for me.

In May, second Edy Legrand show. Success.

Group show in June: Bissière, Raoul Dufy, Gernez, Gimmi, Lhote, and Simon Lévy. The year 1923 was dragging by. Why can't I earn a little money? Why the others, and not me? It was because they held on to it, and only bought when it was a sure thing, whereas I was totally committed to the artists. What a fool!

Basler suggested giving Coubine a show. It took place in October. The lack of success was put down to critics and competitors...

Marcel Mouillot was already showing a forceful personality. He had some success with his first exhibition in November 1923. The end of the year offered nothing transcendent except for the Widhopff exhibition (a former draftsman for *Le Courrier français*, he had thrown himself into painting, and his great sensitivity might someday get him recognized as a good painter) and a show of two notable artists, Charmy and Favory (who deserves special mention).

The first edition of the Galerie B. Weill *Bulletin* came out, and served as the catalog for the current exhibition, as would later

editions.[2] The November 1923 issue featured painter Jacques Thévenet, presented by the talented Roger Allard. This young artist's personality hadn't yet established itself, but he was certainly a painter.

Bulletin number 1 was warmly welcomed. Allard wrote the text and designed and did the layout. We hoped it would be successful enough for us to continue.

As luck would have it, number 2 was delayed, which somewhat hurt the Sabbagh-Sabert show. But it finally arrived, and brought in a few serious art lovers.

Some collectors decided to form a group, with the dentist Dr. Tzanck as their president.[3] His speeches so moved and excited the members, they decided they loved Jeune painting. Tzanck had the bright idea of putting on a little salon to be called the "Salon Folie Dentaire."

A group of five painters had sworn not to exhibit at any of the shows, to let themselves be forgotten. Their modesty was legendary: Favory, Friesz, Utrillo, Utter, and Valadon. Which explains what we saw when we walked into the "Folie" exhibition: a huge gap-toothed cavity where the five might have been. We searched for the "unfindable five," but in vain. Why, oh why would whoever mounted this hodgepodge have it in for those poor artists, to have hung their paintings that way?

The bridgework just gummed everything up . . .

It was hard to extract the (Cubist) root from the central panel; Picassist cooking really sticks to your teeth. Why, oh why, did he have it in for those poor artists? Yugos, yukiss, polacks, poliss, czeckos, chekists, croakos, croakists, stood open-mouthed, eagerly taking it in.[4]

Oh, let me fill your

Big back tooth (Jules Moy)[5]

The latest catchphrase in art criticism:

Don't say, "It's saturated." Instead say, "Now that's painting! It isn't jazz band painting."

Valentine Prax exhibition in January 1924. This much-praised young artist's painting lacked personality, but it had charm. Let's wait!

Issue number 3 of our bulletin accompanied the birth of the gallery's house organ, *Le Bousilleur*,[6] a journal that would feature contributions from the best critics writing about painting. The younger generation of art critics objected: we were trampling their terrain, horning in on their turf. Brrr! Grumblings . . .

Feeling overwhelmed by the young, the Salon des Indépendants committee cast about for sensational innovations. The best it could come up with was to stick the foreign artists in separate rooms; each country would have its own. Word got around fast. This was completely idiotic! A general hue and cry arose. Oh, let's trust the committee. They were sure to get their act together and find something better . . . watch out for the bomb!

The fine ensemble [of works] that Kayser exhibited in February was a success.

Derain became the victim of collectors; the bell on the door never stopped ringing. What a scene! The noise annoyed Vlaminck, who lashed out at his friend. What was wrong with him? Weren't those two friends? They were . . . or they used to be. I had to find out for sure, as a matter of professional duty and to get the story for *Le Bousilleur*. So I went to Vlaminck's place to interview him. But I was too late and my journal was too new: someone had gotten there ahead of me. Still, I slipped inside and crouched next to the fireplace, where I could listen unseen to Vlaminck's declaration of faith.[7] Because of my odd position, I could only hear the questions; what little I could make out of the answers was unclear. From time to time I would hear just a few words (always the same ones), probably spoken more forcefully. When Champignol began his questioning, I was all ears.[8]

"Does this setting delight you? It must be pure pleasure!"

"I-I-I-I-I . . . for-for-for . . . me-me-me-me . . ."

"No, not table settings. I mean the landscapes, the lush countryside around Valmondois and Antwerp that inspired so many great painters."

"But-but-but . . . I-I-I-I-I . . ."

"Well, you, of course, but I was also thinking of people like Cézanne and Van Gogh."

"I-I-I-I-I . . . for-for-for . . . me-me-me-me . . ."

"So they really weren't such great painters? Unbelievable, the things people write!"

"Me-me-me-me . . . I-I-I-I-I . . ."

"It's true that you avoided those cliques. In your ivory tower, artistic movements don't disturb you."

"I-I-I-I-I . . . for-for-for . . . me-me-me-me . . ."

"What a nasty world this is! Twice in the morning then, and twice again in the evening. Not one less?"

"I-I-I-I-I . . . for-for-for . . . me-me-me-me . . ."

"Well, of course! There are times when an artistic movement is appealing in spite of everything. So it's all in the wrist? Did we say four? Oh, only three?"

"I-I-I-I-I . . . for-for-for . . . me-me-me-me . . ."

"You're a daddy? Well, you do have five children, after all." (*Laughter.*)

(*Furiously.*) "I-I-I-I-I . . . for-for-for . . . me-me-me-me . . ."

"I'm sorry, I was confused. You meant Dada, the movement. You killed it? I hope you were given your choice of weapons."

"I-I-I-I-I . . . for-for-for . . . me-me-me-me . . ."

"Oh, of course—you killed it spiritually. I understand! Wasn't Apollinaire a Dadaist?"

"But-but-but . . . I-I-I-I-I . . ."

"Are you sure? Reading your verses, one feels that tapeworm medicine would be superfluous; it's expelled so naturally. Such genius! Apollinaire was right to learn from you. He owes you a great deal!"

"I-I-I-I-I . . . for-for-for . . . me-me-me-me . . ."

"So you're that crazy about cars and motorcycles? . . . You flee fame, yet it pursues you, and drops its heavenly manna on you. That's rich!"

"I-I-I-I-I . . . for-for-for . . . me-me-me-me . . ."

"These African sculptures are admirable! Is that the patina of age?"

"But-but-but . . . I-I-I-I-I . . ."

"Seriously? Is that all? Here I thought African art was at least a hundred and fifty years old. But you actually invented it? What an amazing accomplishment! And all this is your work?" (I heard the sound of slaps . . . No, they were shaking hands.) "Your friend Derain must have helped you."

"But-but-but . . . I-I-I-I-I . . ."

"He really didn't understand it, so he took your advice?"

"I-I-I-I-I . . . for-for-for . . . me-me-me-me . . ."

"Oh, of course. The serenity of the battlefields, ha, ha." (*Laughter*.) "And there you were, wearing yourself out painting, while practicing individual anarchism at home. It's true that it's dangerous to join a party, any party. You never know what might happen."

"I-I-I-I-I . . . for-for-for . . . me-me-me-me . . ."

"You know, it may have been wrong of you to abandon poor Derain. Your teachings could still have helped him. You might have gotten him to turn out several canvases a day. I don't want to contradict you, dear *maître*, but he was your friend, after all. He may have shouted, 'Down with the priests!' as you say, but if it had been, 'Down with the pants!' you'd have risked a whipping!"

"I-I-I-I-I . . . for-for-for . . . me-me-me-me . . ."

"I'm sure that's right! Neither he nor Picasso, either. The critics are wary of Picasso, but they laud his innovations and discoveries, and I think they're right to sing his praises." (*Burst of thunderous laughter*.)

"Only I-I-I-I-I . . . for-for-for . . . me-me-me-me . . ."

"Really? A trickster and copycat? When I think how completely I've been taken in! You can't believe anyone, can you?"

"I-I-I-I-I . . . for-for-for . . . me-me-me-me . . ."

"Is that so? You couldn't get to sleep? You had to have an Odilon Redon, and you got it. Well, necessity knows no rules. And you sold it the next day, but were still able to sleep![9] You've done so many good deeds! Didn't you discover Rouault and Utrillo as well?"

"I-I-I-I-I . . . for-for-for . . . me-me-me-me . . ."

"So Utrillo has been emulating Vlaminck? That's fantastic! And you also introduced Rouault to Vollard, didn't you? What a good teacher and friend you have been for those who reached your level."

"I-I-I-I-I . . . for-for-for . . . me-me-me-me . . ."

"You're also a man of letters, of course! Someday, your favorite authors will realize how indebted they are to you: Obèse, Aztèque, Prolifère, and Microbiol."[10]

Daylight was fading, as I could tell by the shadows the two men cast on the floor. I cautiously stuck my head out, and heard this cry in the countryside: "Who doesn't have his own little Vlaminck?"

The group of Dubreuil, Gromaire, Makowski, Pascin, and Per Krohg had first exhibited at the Galerie La Licorne started by Dr. Girardin, the dentist. They went their separate ways soon afterward, but decided to continue exhibiting at my place every year. The exhibition was held in March. I wrote introductions for each artist in my bulletin number 5, and people found them very funny.

All my exhibitors were introduced with a preface in my bulletin written by me or someone else, a fact that didn't need to be noted each time.

The group of paintings that Odette des Garets showed in April looked good together.

In great secrecy, word went around that a bar would be opening in the Saint-Philippe-du-Roule neighborhood. This set the artists' world abuzz. Whenever there was talk of bending an elbow, they were all in . . . But the project fell through.

Worthy of note: *Philosophie*, a new review, appeared.[11] The oldest of those philosophers was . . . twenty-two. It's true that by the time they're fifty, they'll be happy little lunatics.

Vergé-Sarrat exhibited for the first time in late April . . . a big success!

The trio of Léopold Levy, Kayser, and Vergé-Sarrat was just becoming known. These three friends, born painters, had endured pretty hard times. Their etching expertise helped get them through the worst days, while making them known as artist-engravers. The deftness they acquired gave their painting a fineness of detail that yielded luminous touches of undeniable character.

Grillon had been painting so conscientiously, he deserved to be encouraged.

Likewise Paviot, who wasn't influenced by fashion. He showed little or none of the joy he took in painting. But he didn't mind, just went on working.

Cottereau, the charming rue Laffitte dealer, introduced me to Lurçat, a strange artist who didn't seem to know anyone. "But you must have heard of Derain? What about Picasso?" "No . . . People have only been telling me about them just now." Lurçat would make his way. He had very good taste as a decorator, as it happens. Cubism, about which he knew nothing one day, held no secrets for him by the next. Some of his experiments were amusing.

A few collectors were closely following Gimmi's happy evolution.

Since Makowski started exhibiting with the Gromaire group, his work also drew notice. A painter to be reckoned with someday, if he lived up to his promise. Per Krohg's composition

and way of painting were so imaginative as to command attention . . . and people were starting to get him!

Unlike Krohg, we weren't following the painter Théophile Robert especially. But under M. Pacquement's auspices, the Galerie Druet took him under its wing and boosted the prices of his works outrageously (the poor man imagined he had made it) . . . then suddenly dropped him. What a sleazy trick! As a protest, I bought a painting from him. So there!

Léopold Lévy was evolving slowly but surely; he interested me.

Another new review, called *Partisans* . . . Stillborn.

Back from Italy, Eisenschitz and his wife Claire Bertrand had a very good exhibition in May.

The great pianist Brailowsky gave an enchanting Chopin recital at the Opéra. What higher praise could there be for such an artist as the conspiracy of silence that marked each of his recitals.

The sunny vision of Francis Smith, who in June exhibited "Vues de Paris" (gouaches), happily contrasted the capital's gray atmosphere with Lisbon's dazzling one. The Portuguese colorist met with well-deserved success.

Raoul Dufy, whose increasingly striking watercolors were being snatched up by collectors, remained in vogue. His pictures sold steadily for 300 to 400 francs. Dufy's personality was undeniable.

Hughes Simon, a serious art lover, went around pretending to be a rich collector. He would dazzle dealers by flashing wads of banknotes before their eyes before—presto!—they vanished back into his pockets. See? Nothing in my hands! Gentleman, gentleman! If he happened to buy something, he would walk the streets of Paris peddling his junk . . .

20

A SENSATIONAL DUEL.—A TRIP, A LETDOWN, A FOREBODING.—DESPIAU, A GREAT MAN.—"THE FLOWER" EXHIBITION.—COPYING CRAVAN.—*L'ART VIVANT*.—SPECULATION.—A TIFF WITH ROBERT REY.—WE CONGRATULATE OURSELVES.—CAPON CONSCIOUSNESS.—FIFTY YEARS OF PAINTING AT THE MUSÉE DES ARTS DÉCORATIFS.

Two of our young critics had been trading insults over a question of honor. They now stood back-to-back, eyes wild, frothing at the mouth, chests out and swords in hand, prepared to settle the matter at fifteen paces. They leapt about, slashing the air and looking for their opponent . . . in vain. "He ran away, the coward!" Damnation! In their fury, the unfortunate pair forgot they were facing away from each other as they dueled . . . So each ran chasing after an opponent he could no longer see. Honor was saved!

I liked Kisling's painting, so why did it sometimes disappoint me?

What about Jean Dufy, Raoul's brother? When I met Jean in 1914, he had his own personality, but his terrible brother was so . . . persuasive. Not to worry! Trust is the mother of patience.

In July 1924, a sensational group to close out the season: Bosshard, Raoul Dufy, Hermine David, Kisling, Lurçat, Marcoussis, and the sculptor Zamoyski. So many visitors! What crowds! Not a single sale!

The month of August was rainy. Nonetheless, I decided to spend two weeks in a little village near Épinal where a friend lived whom I hadn't seen in twenty-five years. Believe me, you should keep the good memory of the friends you knew when you were young, and never see them again. It will spare you so much

disappointment! As life goes on, monotonous for some, agitated for others, it changes each person's outlook. In my friend, I found neither the image I had retained nor what I had loved in her. I was cordially welcomed by the good peasant she had become, concerned only with her washing and the beans that weren't growing. But in fact, wasn't she in the right?

Using the awful weather as a pretext, I was back home in three days. But I was deeply impressed by a strange fact: this trip, which I'd decided to take on two days' notice despite the weather, as if it were extremely urgent, felt very much like a prescient impulse. My friend died three months later ...

In October 1924, the exhibition series opened with a group of five artists: Barat-Levraux, Eberl, Goerg, Ramey, and Savin. Sales were nothing special, but a few of those Jeunes should make an impact.

I treated this appealing group to dinner in Montmartre and invited Charmy and Francis Smith and his wife to join us. A delightful evening!

I was enthusiastic about Despiau's work and visited his studio. It wouldn't be long before he took his place among the great sculptors. People were starting to appreciate him. And Rodin had a high opinion of him, as both an artist and a man.

Lewitska exhibition; minor success.

Then a show by the talented, clever, and charming Hermine David.

For the end of the year, I launched a group show that I planned to put on annually in December–January. Each year I would suggest a new theme to all the artists who had exhibited in my gallery since it started in 1901.

For this end of 1924, I suggested "The Flower."

Few artists failed to show, and the rest gave their fantasy free rein. It was an enormous success! Never before had we had such a varied, sparkling, and harmonious ensemble ... and good sales!

After an exhibition like that, it was dangerous for a solo artist to show a body of work, but Leprin carried it off . . . Success!

In an article published on November 10, 1911, our national critic Waldemar George had once called Maurice Utrillo "a rascal with an expert talent for lining his pockets." (Poor Utrillo!) Now he was writing an ecstatic article about this "rascal" . . . Want to bet that the Utrillo market had taken off? I was sure it had . . . And long live Poland, gentlemen![1]

Our friend Girieud, who was in the 1901 group show that launched the Galerie B. Weill, has followed his own path, evolving slowly and sincerely. The paintings he was showing now (February 1925) put him in good company.

A new journal (yet another one!) called *CAP*,[2] edited by Marcel Hiver, was scandalizing Montparnasse. Following in the unfortunate Cravan's footsteps, Hiver insulted artists in it, using this inelegant tactic to get some publicity. Result: negative feedback and bad publicity.

Among the young artists, Gromaire was leading the way. He was a talented painter, and would be first class when he dropped the somewhat annoying formula that hindered his evolution.

Though a little more superficial, Goerg might join him . . . if he didn't slip into genre facility.

Florent Fels, who with Robert Mortier had edited *Action* (which folded after publishing about fifteen issues), became the editor-in-chief of a new journal, *L'Art vivant*. "L'Art vivant" was the title of a book about young painters written by my friend André Salmon and published by Larousse.[3] Here's hoping the journal's young editors make it a lively organ, but also keep it alive . . . something we weren't accustomed to.

In February 1925, we exhibited Jeanne Rosoy, Yves Alix's wife.

March. The third annual group show of Dubreuil, Goerg, Gromaire, Makowski, Pascin, and Per Krohg. Speculators

happily swooped in ... I hoped their little games wouldn't start setting our young painters' brains on fire.

We then offered collectors a body of paintings by Goerg. This new work still upset some of them, but a thirst for novelty, not to mention the speculative fever that seized those who hesitated, guaranteed the show's success.

The Kayser exhibition that followed was a triumph of line and shape, the work of a master who loved his art. A day would come ...

Well, well, what do you know? The way I introduced the artists in my bulletin wasn't to Robert Rey's taste. It seems my music-hall-style prefaces got under his skin. He vented his spleen in an issue of the flag-waving *Le Crapouillot* that insulted me in such crude terms that some artists spontaneously drafted an outraged letter of protest, which drew more than three hundred signatures. I was deeply touched by this display of friendly support, but I opposed their sending it.* I promised I would put the gentleman in his place in my bulletin, which I gleefully did.[4]

Would those days ever return when my friend André Lhote's first solo show in rue Victor Massé would sell out? Perhaps. Would the fine group of paintings he exhibited in the pretty month of May attract collectors? No, as it turned out! ... Take it from me: they were wrong ...

Fresh back from Morocco, Vergé-Sarrat exhibited some really evocative paintings. Almost everything sold ... Was this a *critérium*?[5] Yes, for once.

Another still-young painter with a name to remember: Georges Capon. His first exhibition in June was a big success, and well deserved.

*To be fair, I have to say that Robert Rey soon admitted that he had been wrong, and I never held the event against him.

Vauxcelles joined his friend Waldemar George in founding a major review they hoped would displace all the others: *L'Amour de l'art*.[6] Not long afterward, Vauxcelles was himself . . . displaced . . . perhaps for failing to displace the others. From then on, Waldemar alone presided over the fate of the review, which naturally turned tendentious.

Berthe Martinie exhibited some sepia drawings in the second week of June. The artist's romantic vision gave the show an old-fashioned look, but it was still lively. Success.

A very important exhibition was organized at the Musée des Arts Décoratifs: fifty years of painting, from Impressionism to the present.

But the museum neglected to invite Suzanne Valadon, who I think matters today, and also Charmy. Oh, that's right; they weren't hot properties yet . . . When I remarked on this to Vauxcelles, who curated the show, he said, "I don't like Valadon's painting. Or Charmy's, either." Later, he wrote a book about painting by women. Needless to say, he again "forgot" them. So the history of painting by women depends on who the author likes or feels is worthwhile; artists he doesn't like are stricken from the history of art.[7]

"Art" itself is too subject to the whims of speculation.

Can you imagine a historian passing over the reign of Louis XI, for example, because they didn't like that particular king?

The pictorial season ended in July with an exhibition of Raoul Dufy, Laglenne, Lurçat, and Marcoussis. Though late in the season, the group was very favorably received. Dufy's star was rising, rising . . . What about Charmy? Would people finally open their eyes and see her artistic oeuvre? People kept asking about her.

21

SAINT-TROPEZ AND ENVIRONS.—THE INTERVIEW
CRAZE.—DECEITFUL DEALS AT HÔTEL DROUOT.—WAR
PROFITS!!—THE PASCIN BANQUET.—MY BANQUET.—
QUELVÉE, THE DECORATOR.—MAURICE SAVIN.—THE
VAUXCELLES BANQUET.—THE ANDRÉ WARNOD BANQUET.—
MY PEDESTROMOBILE.—HECHT.—FERNAND SIMÉON.—THE
GALLERY'S TWENTY-FIFTH ANNIVERSARY.—APPENDIX.

Vacation time. I traveled to Avignon, from which a taxi took me
to Villeneuve. There, lord and master Simon Lévy did me the
honor of showing me around his domain. After my sleepless
night in the train, walking up to Fort Saint-André in hot sun-
shine felt great. After two very pleasant days, Mouillot drove
over from Saint-Tropez and took delivery of my person. We vis-
ited some of the most picturesque corners of Provence under a
hot sky in blazing heat. In Sanary, all of Montparnasse was play-
ing *pétanque* [lawn bowling], so we gave it a try. All Paris from
the worlds of theater, fashion, and painting—not to mention
politics—was in Saint-Tropez. The charming port was bursting
with the crush of snobs trailing Poiret, Colette, Paul Guillaume
and his wife, Picabia, Segonzac, Damia, Dorny, Vildrac and his
family, the singer Kubitzky, Gignoux, L.-A. Moreau, and paint-
ers, painters, and more painters . . .

Mouillot's little house was charming, its interior enlivened
by his wife and daughter. But what's this? Drama? *Une petite
amie* showed up, sowing discord . . .

No snobs, Francis Smith, his wife, and their two daughters
led a healthy life there, amused by the swarming, colorful crowd.

On the way home, we stopped in Marseille, a cosmopolitan
city where the intensity of life initially feels alarming. But as

you mingle with the crowds and start sharing that life, you gradually wind up loving it. Communicative warmth. This was my first trip to the South of France, the first time I saw Marseille. My friend Simon Lévy, who was with us, was surprised. "What? You've never seen Marseille or its harbor? Here, let me introduce you." He stood, turned toward the water, and said "Mediterranean Sea, see Mother Weill!"[1] His spontaneity cracked me up. This was my first encounter with Marseille.

Back in Paris, everything started up again: exhibitions and openings of new galleries, whose number kept growing every day. Scary, how many there were!

Each new season came with its own variety of hogwash. This year, it was the interview craze. Young art critics gunning to make a name for themselves were taking potshots at everyone. Then it was the turn of the *marchands de tableaux* to be interviewed. Here is how mine went: "Tell us, how did you start out?" "Well, I could barely walk, my legs were wobbly and none too solid. I trembled and hesitated, afraid to risk walking. Even using my arms for balance, I fell down on the floor. Crying and tears . . . Then I was given a pillow." "Excuse me, I meant how did you start out selling pictures?" "Oh, I'm sorry. I misunderstood you." The interview was put off, as you can imagine.

Mouillot was making progress. His landscapes of Provence were getting noticed.

This year, the Salon d'Automne was held in barracks, which was all to the good. The Grand Palais was making it look so splenetic.[2]

Simon Lévy's show was a big success . . . morally.

To wrap up the year 1925, I chose "Animated Flowers" as the theme for the big annual exhibition. A resounding success!

The Hôtel Drouot auctioneer Bellier was soliciting desirable paintings from dealers and collectors to create an inflated and outrageously artificial market. These new tactics, carried out in

plain sight and in complete freedom, were sure to kill the picture trade. Shameless speculation was rampant, and talented artists who weren't lucky enough to be in demand (which in no way diminished their worth) watched their paintings get caught in the trading pit and their prices fall to zero.

Seven lean years wouldn't be long in coming, I'd wager.

During the war, I had done some business in postcards and maps. In 1917, when I was broke, I moved from rue Victor Massé to rue Taitbout. In August 1920, I was indemnified for leaving rue Taitbout to set up shop in rue Laffitte. The tax authorities were now treating that payment as war profits, even though the law on war profits didn't apply to income after late June 1920, and I had received the indemnity in August. In addition, I was fined for not declaring those "scandalous" profits. I was pursued despite my objections and supporting proof. The blinkered tax people hounded me so relentlessly, it became dramatic. Such a sweet country for single women! You are subject to harassment, insidious investigations, and slanderous denunciations by shady characters with ties to the police—in short, it was the Inquisition, except of course for the real cheats. A sweet country!

The year 1926. In January, the work that Eberl exhibited was mainly decorative.

For Pascin's fortieth birthday, we threw him a banquet at Dagorno's. A delightful meal and evening, without too much drinking. Pascin was wrong to only surround himself with parasites. He knew he had good and true friends who loved him, and they all showed up that evening.

How is it that three or four painters were always the same ones announced when new galleries opened that could feed two or three hundred others? It's quite simple. The director of the gallery that's opening goes to talk to the one that opened yesterday, who in turn goes to talk to . . . and so forth, asking for

paintings that aren't under an exclusivity contract. So yesterday's director goes to the one before, etc., etc. And that's why you kept seeing the same canvases exhibited over and over—the most inflated ones, of course. It was an unhealthy time for art and for business, a corrupt period rife with speculation and deceit. It's true that I'm old fashioned. We would see.

Some fifty artists treated me to a very cordial and successful banquet.[3] A few collectors were good enough to join them. A delicious meal nicely prepared by Dagorno at La Villette. Led by Gen-Paul, the four jazz musicians walked in dressed as La Villette butchers, a triumphant entrance that delighted everyone.[4]

Girieud began the toasts. "I came from the country, and this was my first exhibition, so I wore a jacket and top hat to the preview; quite a sight!" Raoul Dufy sent a telegram that read, "All together now, long live *le môme* [colloquial for "the kid"] Weill!" Applause. Dufrénoy, who was as irreverent as Dufy, said a few words about starting out with me, then raised his glass and shouted, "Long live *le môme* Weill!" In verse, Tabarant covered me with flowers . . . I was touched. Using a rolled-up cardboard megaphone, I thanked all the speakers. Then we pushed back the tables and danced.

This charming gathering included Yves Alix and his wife, the Chagalls, the Gromaires, the Kars, the Girieuds, the Lombards, the Barat-Levrauxes, the Largys, the de La Rochas, the Waroquiers, Mme Amos, Mme Abranski and M. Gimmi, Suzanne Valadon, Utter, Charmy, Kayser, Per Krohg, Léopold Lévy, Simon Lévy, Favory, Lewitska, O. des Garets, Vergé-Sarrat, Fels, Charensol, Waldemar George, Quelvée, etc., etc. Letters of congratulations and regrets poured in, and we all went home around one in the morning, feeling cheerful and satisfied.

Quelvée was making a name for himself as a decorator, a fact more than borne out by his very interesting exhibition.

Dubreuil was still finding his way.

The very young Cherniavsky showed promising works, without deceit or detours.

And as usual—for the fourth year now—we exhibited the group of Dubreuil, Goerg, Gromaire, Makowski, Pascin, and Per Krohg. Speculation fever was in the air, and the show attracted many investors.

Artists are such big children. Each time a new gallery opens, their hopeful hearts sing, "This time, it's our turn!" And they're promptly disappointed. Again and again, you saw the same three or four painters on the walls. Button, button, who's got the button?

Collectors were drawn to young Maurice Savin's large compositions at the Salon d'Automne. His first show here didn't disappoint them. It was a *critérium*.

Major retrospective at the Indépendants. A first-class, well-organized exhibition of work by all the artists to appear in the Salon from its 1884 founding to 1914.

Vergé-Sarrat came from Corsica with some twenty paintings that he exhibited in April. What an enthusiastic painter! What personality! His art was becoming more and more focused. A big success!

The worrisome fall of the franc produced some financially motivated transactions. Collectors looking for profitable investments were driven to buy artworks that were as deplorable as the taste guiding their selection. I probably seemed pretty grumpy. What's the matter, aren't you making any sales? Yes, I am, far too many! I worried about the likely consequences of this frenzy.

Albert Huyot's personality hadn't come through yet, but he had craft, and we had every reason to hope for his success. He was a shy man, and I had to step in to resolve a problem he was having with two of his friends, who were too clever by half. The affair was a murky one and not to the two friends' credit. They objected to my involvement, but I cooled their bellicose ardor

by resolving the conflict to the satisfaction of all concerned. My word! The picture business isn't without its problems, is it?

A banquet thrown for the art critic Louis Vauxcelles attracted three hundred guests. Here's a recommendation for the restaurant they chose: if you wanted to poison people, you couldn't find a better place. The organizers of the banquet were getting a cut.

The stormy mood may have been due to the guests' disappointment. People sat staring blankly at each other. Two loud slaps rang out: a couple of our young art critics were noisily congratulating each other. A speech by de Monzie was greeted with whistles and catcalls, with young Charensol leading the hotheads; he was probably hungry. We quietly slipped out at ten o'clock, our stomachs still empty. Apparently there was dancing later, probably in front of the buffet! When I think of the wonderfully cordial banquet that was thrown for me. Long live small committees!

In June, the Georges Capon exhibition was an enormous success. He was developing slowly but surely, as his personality emerged.

The pictorial season ended with the Grillon show.

A banquet (what an epidemic!) was held for André Warnod, and some guests wound up rolling under the tables. Pascin and Galtier-Boissière got into a drunken shouting match. They needed to be calmed down, but nobody could stand upright. Soon after that memorable evening, the *Crapouillot* publisher filled its columns with a distorted version of the matter under drunken debate. At Pascin's expense, of course. Using your scandal sheet for such an end was pretty low. Pascin didn't have any such advantage, and wouldn't have stooped to use it if he had. He was an openhanded man; many artists and others had benefited by his largesse. In my bulletin, I refuted all the lies *Le Crapouillot* told about Pascin, who was defenseless, and so nice and witty . . . when he was sober.

That year, I spent my vacation in Paris.

You have no idea how pleasant it is during the month of August.

Alas, the inquisitors again turned their guns on me. The tax people came to rummage through my books, congratulated me on their clarity and accuracy, and . . . I'll tell the whole story someday. But if I hadn't kept my usual sang-froid, I would have loved to make those animals pay! Some of life's pleasures will always be denied us, unfortunately. Bad faith disgusts me the most.

I took a wonderful trip by pedestromobile that summer, at full speed, and in place.

Finally, everyone came back to town. And then, here we go again! . . . A blizzard of green, red, and white legal documents—not even in our national colors. Would they never leave me in peace?

The second week of October 1926 saw the exhibition by the painter and engraver Józef Hecht. He was very well known as an engraver, and his superb etchings were in great demand. His painting didn't add much, but he was enthusiastic, so here's hoping he would evolve as time went by.

Every day, some new painter was being "launched." The art world's big shots, the fat-cat capitalists, conferred every year to decide who they would devour this time, which Jeune to place their bets on. The lucky winner was the most trusting one.

In November, an exhibition of Fernand Siméon, who was already known as a very talented illustrator. A good body of work.

He painted and drew with the skill of an engraver, and his witty sense of composition gave his work a lot of life. Success.*

*Since writing this, we have learned of the charming painter's premature death. He died in three days, lost to the affection of his family and many friends.

It was time for me to think of the celebration I would host for the gallery's twenty-fifth anniversary. As every year, we exhibited all the artists who had helped the gallery along the way from 1901 to today, on rues Victor Massé, Taitbout, and Laffitte. This year's theme would be "Flowered Windows."

But before that, an exhibition of Georges Cyr in November.

Blowing pea whistles wherever they went, the rich-kid Surrealists were noisily claiming leadership in art. As if they somehow wouldn't be noticed—imagine that! But in reality, all that noise just revealed stagnation: the avant-garde was stuck, and it wasn't moving forward. They were so young, though! The future was theirs. But the establishment had its eye on them, so beware of avant-gardes!

My housekeeper, a good Alsatian woman, exclaimed one morning: "Mat'moizel, d'you know them assembly deputies make 25 francs each hour?" "I can't believe it. Who told you that?" "It's in ze newspaper, mat'moizel can zee for herzelf." "Maybe, but I didn't see it. Does it say how many hours they work?" "Vell, I don' know, but I think das ist shameful!" She earns 3 francs an hour.

And now it's finished. This memoir will end with the gallery's jubilee, "Twenty-five years of painting."

The "Flowered Windows" group show was gorgeous. At the preview, we had chamber music performed by the talented Mme Patorni-Casadesus on harpsichord and her equally talented sister-in-law Mlle Casadesus on violin. The program selected by those two elite artists was splendid, and their success would be hard to describe.

Flowers everywhere, as if at a wedding, were heaped among the paintings, and made a fairy-tale spectacle, a mix of natural flowers and painted ones.

The mood was intimate, friendly, heartwarming.

That evening, I had some twenty friends to dinner at Dagorno's. We danced afterward. And a week later, we wrapped up the festivities with a big costume party at the same place. The artists unleashed their imagination in their costumes, and some of them were pure genius. Joy and good humor reigned until dawn . . . without a single discordant note. Twenty-five years of painting! And it goes on!

If this memoir gets any notoriety, I don't think anyone will challenge the truth of what I have revealed in it, if a bit . . . harshly. It's something of an exculpation, and at the same time a reply to those critical people who kept harping on the refrain, "Ah, Mademoiselle Weill, you must be rich, seeing all the things that have passed through your hands." Those are the same people who never dared take a chance on works by unknown artists; who pitied me for my perseverance; who sniggered at the sight of works they didn't understand then and still don't understand today, but who are excited by their staggering rise in price.

Well, my efforts have been crowned with success! All of my "children," or nearly all, have succeeded! But here's the thing, I'm now the old mother that people are ashamed of, the one you don't want to bring out in public. Success has certainly come, but the detractors were the only ones to benefit from it. Was my role to make money? No, my role was to be left holding the bag. Not only that, but if I said that just as I was able to relax, that I had put a little money aside, thinking, "I'm saved!" what do you think happened? "What's this, what's this? This little dealer thinks she can make money? Something's not right here. Shady dealings . . ." The tax people grabbed it all, and more! I protested in vain to the authorities, but nobody supported me. And as usual, nobody took me seriously, because I don't whimper and I don't beg . . . I don't know . . . A single woman has just one goal her whole life: to defend herself!

In closing, I apologize to those people I may have roughed up a little; I hope they won't resent me for it. In everything I've described, I simply stated the facts, making no complaint. I don't want anyone pitying my fate because, as I've said before, I chose this line of conduct myself. I have such a difficult personality that it probably drives away people who might have wanted to extend a helping hand . . . So I only have myself to blame . . . except that I don't regret anything!

I feel surrounded by my friends' great affection, which amply repays me, and for which I thank them.

Twenty-five years of painting! . . . Crazy!

APPENDIX

1932. Six years have passed since that memorable jubilee! Six years! We celebrated the gallery's thirtieth anniversary in December. I had thought I should end this memoir after twenty-five years of painting (1926) for fear of having to put too much stress on this era of scandalous speculation, which especially hurt the art business. Large-scale legal swindles; what else had the big prosecuted financiers accomplished? Launching fictional values? And what was done in painting?

I don't begrudge high-priced artists their talent. They know I love them, and we both know that a price spike doesn't spell genius. A few may have played along with this dangerous game too willingly, and unfortunately are now its biggest victims. The lesson is a hard one, but it will be profitable.

We need new collectors who will come to modern painting on their own, without the spirit of lucre. And they will appear, I'm sure.

Lack of trust and the anxiety generated by the fictional sales at Hôtel Drouot led to the current crisis in painting. Now that

the feverish speculation has died down, there's nothing left to hold the speculators' interest.

This healthy crisis is cleaning up the market.

A new era is beginning.

And to end, these few lines:

At the start of this memoir, I put down Vollard a little. I'm sure he will confirm that what I've written is the exact truth. But I have to say that among dealers, he is one of the few who was never deceitful. He was lucky, came along at the right time, and quickly acquired a taste for beautiful things. His success in the business is due only to his luck and good taste. After giving him such a hard time, I at least owe him that last truth.

Besides, I am sure he wouldn't resent me for it.

And a final thought in memory of my poor Pascin.

A year ago, we buried this friend, who was beloved by all. His great goodness, talent, and spirit have left an unforgettable memory in our hearts. The sensibility of a soul untouched by any baseness came through even when he was being sarcastic. It's my sacred duty to end this memoir with these few words spoken out of friendship.

May 1932

THE END

APPENDIX A

Preface: First, A Few Words . . .

Paul Reboux

"Gather round, children," said the kindly old grandfather. "Come a little closer. My eyesight has dimmed, and my hearing is no longer sharp enough for me to hear your questions. I'm going to tell you a marvelous story.

"Once upon a time, there was a great and noble people, to whom you have the honor of belonging: the French. These people had literature, music, and architecture that matched their fame.

"We are talking about the period between 1890 and the time of the Great War.

"But these people settled for painting that really wasn't worthy of them. The annual Salon exhibitions would hang huge, decorative panels that were nothing but enlargements of images from history, like the ones on your schoolbooks. A foolish public found this quite satisfactory.

"The portraits looked like photographs that had been touched up by a pastry chef. The landscapes were soulless amateur photographs of scenery, but in sharp focus, showing the tiniest detail.

"Above all, those salons exhibited a huge number of what are called 'genre paintings,' silly, banal, childish little scenes that make one despair of the nation's good taste.

"They might show a dog on a riverbank, barking at a hat as it drifts away downstream. Or kittens playfully batting skeins

of wool from a basket they knocked over. An altar boy teasing a parrot in a sacristy. The Creuse River valley alive with pink heather and looking like a needlepoint pillowcase. To decorate a dining room, a painting of some dusty bottles next to a pile of vegetables and flowers, or a hunter in a thicket shooting a pheasant falling amid a scatter of feathers. A little Italian urchin dozing on a stairway, her tambourine begging bowl on her knees. It could be a Cupid-like child asleep on a bed of leaves in the woods with a nightingale singing on a bramble branch overhead. Prussian soldiers in spiked helmets beating an old peasant with rifle butts to make him point the way to the river ford. A hunting scene, with dogs and riders gathered for the kill under an evening sky the color of red currant jam. Or a little chimney sweep shooting marbles with an apprentice cook who has set down his lunch basket, unaware that a dog has caught the aroma of his steaming meat patty and is about to eat it.

"Touching paintings, clever ideas, a high expression of the national soul, the artistic output of 'the wittiest people on Earth.'

"Yet this was at a time when Claude Monet's powerful, delicate works expressed the shimmering of light on fields, cathedrals, and water. When Pissarro's deft touches skillfully translated the humble, moving soul of rustic landscapes. When Cézanne was creating powerful landscapes and portraits that masterfully juxtaposed the shapes of matter, omitting anything that doesn't serve pictorial expression. When Degas could create deeply human figures with just a few lines and dabs of color; when Renoir's brush brought flesh to life with a loving touch that the Dutch masters could never equal; when Van Gogh turned fireworks of color and paint into images both supernatural and true.

"And more than these older painters needed to be defended against public opinion.

"A crowd of their juniors were eager for the chance to show off what they could do.

"This crowd included Bonnard, who painted interiors of appealing lushness; Van Dongen, witty and powerful, harking back to northern painters; Raoul Dufy, whose decorative genius appears in the least of his sketches; the powerful Marquet; Henri Matisse; rough Rouault; Picasso, both bold and traditional; Friesz; the brilliant Marval; Vlaminck, whose landscapes have such pathos; Utrillo, who put so much poetry into his rendering of the small houses of the poor and blighted suburban landscapes, combining the conscience of a humble French artisan with the poetry and generosity of a great heart.

"A few *marchands de tableaux* realized that it was time to warn the public that lingering over frivolity while overlooking these masterpieces and new directions would diminish France's artistic fame.

"So they agreed to promote these still obscure and neglected artists to collectors and gallery owners. They urged art critics to write articles and spread the word about this renewed art.

"Their efforts succeeded, fortunately, but not without difficulty. They had to struggle to get the public to give up its taste for toy poodles, mischievous kittens, still lifes, and little pastry cooks, not to mention paintings of cardinals dining on *patés en croûte* and Louis XIII aristocrats fighting duels or stroking strumpets.

"Beauty and good sense triumphed together.

"Men like Moline, Druet, and Vollard—and a woman, Berthe Weill—were able to turn public opinion around.

"And because there is some justice after all, the collectors who bought those artists' paintings saw the value of their canvases soar to dizzying heights. By contrast, those who had acquired anecdotal chromolithographs by Henner, Vibert, Bouguereau, Chocarne-Moreau, and others were dismayed to dis-

cover that even American pork traders weren't interested in that kind of painting.

"So you see, children, I'll say it again: it's wrong to claim there's no justice in this world.

"When you're driven by respect for what is beautiful, a love of human truth, and art, you will always succeed."

"Grandfather," said one of the children, "were those paintings worth a lot of money?"

"Yes, children. A painting bought for a hundred francs might have been resold later for fifty thousand, eighty thousand, two hundred thousand, or even more."

All the little jaws dropped in astonishment.

"So did those painters all get as rich as lords, Grandfather?" asked a little girl.

"Alas, no, child," said the grandfather. "The satisfaction that Providence gives us is mainly spiritual."

Another girl piped up:

"But at least the dealers who sold those paintings for so much money must've gotten very rich, right?"

"Yes, dear, very rich. All except Mademoiselle Berthe Weill."

"Why, Grandfather?"

"Because she always put other people first. Because she cared more about the artists she supported becoming successful than filling her coffers with the profits she could have made off them. Because she encouraged the ones she felt deserved it, instead of only spending money acquiring works that would be in demand. Because for her whole life she was an extraordinary example of openhandedness, disdain for calculation of any kind, and respect and tenderness for all those who had the divine spark."

"So, Grandfather, if she doesn't have much money, she must be unhappy."

"No, dear. She isn't unhappy because she knows that she is among the two or three people responsible for modern French

art having such a bright place in the world. She isn't unhappy because she always put the satisfaction of her conscience, the concern for her dignity, and the realization of her ideals above life's petty material satisfactions."

Berthe Weill is now publishing her memoir.

When I was asked to write a few lines as a preface, I decided to go meet Mlle Weill, whom I knew only by reputation.

So I went to 46 rue Laffitte, to the gallery where she offered the public tastefully chosen books—art books and unusual editions—along with frequently changing art exhibitions.

Since I didn't know Mlle Weill, I tried to imagine her.

She had been fighting for so long, I was sure her hair must have a touch of gray. All right. And she had fought so strenuously, she must be built to face life's adversities. I imagined her as a kind of husky giant with thick shoulders and fists clenched at the ends of powerful wrestlers' arms. An athletic stature, built to take on all difficulties in hand-to-hand combat and slam them to the mat. I imagined the fine, toned body of a conqueror with large, light eyes glowing with inspiration, basing my anticipation of her physique on two elements, strength and faith.

I entered the shop, and Mlle Weill was summoned.

There she was.

In the words of an old prewar song, she was "an itty-bitty little woman no taller than this." And I mean little . . . She scurried over like a mouse, with thin, sloping shoulders, a frail body, and slender arms. A calm, modest face hidden by a huge pair of glasses under a head of gray-streaked hair.

What? Was this the heroic slayer of the dragon of banality? The magnificent fighter who fought for beauty and the nobility of French art her whole life?

As still as a porcelain figurine, Mlle Weill didn't make a move or say a word. But behind the giant discs of her glasses, a pair of eyes were giving me an appraising look, the same look that, when turned to a work of art, could weigh its creator's soul and future.

I said something that made her smile, a good, honest smile. Her slender arms spread hesitantly, like the wings of a tiny insect emerging from its chrysalis. I mentioned an enthusiasm we shared, and her little face suddenly lit up. When I touched on an aesthetic matter we both disliked, Mlle Weill happily joined in, laughing that hearty laugh that artists share in the studio after a work session, or out in the countryside, relaxing after a long day painting landscapes at the easel. Actually, this was even better! A complete change had come over Mlle Weill, with her slender shoulders, dainty steps, and expressionless face. She was full of enthusiasm, élan, and vitality. She exulted. She exploded. The molehill had become a volcano.

Then she settled down again. The slim arms fell back to her sides. Behind the big round glasses, her eyes grew worried, concerned at having displayed so much vivacity in front of a stranger.

But as she relaxed, it erased my initial impression of a mysterious, chilly, monk-like woman. As we warmed to each other, I could sense what kind of life this heroic, simple soul, as straight and shiny as a dagger blade, had led. I sensed no lust for lucre in a heart filled with the loyalty, friendly generosity, and comradeship that had made her the friend of all those she knew when they were just starting out, and whose careers she helped. They had gone on to fame without ever breaking with her. They didn't forget her encouragement or the money she'd loaned them, even when generosity had emptied her purse.

○─○

"So, you think these little things should be published?" she asked, gesturing to her manuscript: two ordinary ruled notebooks, their pages filled with clear, rounded handwriting. I recognized the handwriting. It's like the one I once saw in a manuscript by Marguerite Audoux.

"I just put everything in there, you know," she continued. "Everything I saw, everything that happened to me. Do you think people will be interested? I didn't take the trouble to write beautiful sentences. And I often give the prices of paintings. It's only of interest as a document."

"But a document is exactly what the public wants today, mademoiselle," I said, interrupting her. "It's tired of all that literary verbiage, all those ponderous sentences and rambling discourses. A document is admirable. It sounds just like truth, just like life!"

I leafed through a few pages of the notebooks, and realized that this really was an extraordinary document, both artistic and psychological.

Artistic, in what it told about so many artists' beginnings and their initial struggles, everything that had crowded the French painting scene over the last twenty-five years.

Psychological, in what those sentences—and it would be sacrilege to change a word of them—said about a courageous, tenacious, visionary, and enthusiastic soul.

It was a mix of despondency, high spirits, credulity, and indignation—the whole range of feelings that Berthe Weill experienced during those twenty-five years of artistic struggle, wonderfully expressed in disjointed, punchy sentences that weren't so much written as spoken, they were so natural and alive.

It resembled the commonplace books that people used in Montaigne's time, where every day, the master of the house would randomly jot down his expenses, moral thoughts, the

weather, philosophical maxims, the estate's income, and a record of visits paid and received.

Berthe Weill's manuscript was also an exact, minute, pitiless, generous, jovial, and sometimes tragic picture of the life of this tiny muse, from whose inspiration so many painters took the self-confidence to persevere and succeed.

OO

"So what do you want to call it?"

"Well, I did think of a title," said Mlle Weill, standing motionless, even more self-contained, almost like a guilty child who won't admit to misbehaving.

"What?"

Her little arm gestured. Her eye brightened. She chuckled.

"I have a mind to call it, 'Pow! Right in the eye!'"[1] She gave a rich, hearty laugh. It was almost a joke, a prank played among pals. The idea of mystification amused her. But she turned serious again when I said, "An excellent title. The public will love it."

"Do you really think so?"

"Yes, I do, mademoiselle. A title that's a kind of symbol. It expresses both the amazement your beloved painters caused the bourgeoisie and the richness and sonority of those works, bursting with truth and beauty. At the same time, the title strikes a blow against dull mediocrity that has to be violently displaced, and frightened away. It's the symbol of an aesthetic revolution of eye-catching splendor."

But Mlle Weill had some reservations.

"I'm not sure this stuff should really be published. It's a jumble. I wrote down things that are true but shouldn't be put in books. I wrote the way people talk, sometimes much too freely. And finally, I don't write the way people usually write. I write the way I think."

At that point I picked up the little notebooks and said, "You won't see these two notebooks again until after they are printed. You say you write the way you think, mademoiselle? In that case, you should realize that for almost all the world's writers, your book will be a great example and a great lesson."

APPENDIX B

Avant-propos

Berthe Weill

Before beginning my memoir, I feel I should insert this response I wrote in 1916 to an article by A. Vollard that appeared in the *Mercure de France* under the title "Figures d'amateurs" (Portraits of collectors).[1] The article would be the first of many. Its author had the ingenious but inelegant idea of starting by describing the character of the late Isaac de Camondo, who had recently died and left his magnificent art collection to the Louvre.

That handsome gesture and the memory of this generous collector should have called for silence and respect from the less enlightened. Instead, the author of the article in question gave free rein to his presumptuousness and ingratitude (Camondo had played an early part in making the man's fortune).

When I sent my response to the *Mercure de France*, it was turned down because, they said, "We don't publish direct attacks."

Attacking Camondo after his death was indirect, I suppose. So I published my piece as a little pamphlet. I had originally used the name of the person I was criticizing. He had started out around the same time I did, since I was an apprentice in Mayer's shop in those days. But I changed the name and called it "Les Débuts de Dolikhos" (Dolikhos's beginnings).[2]

I developed my taste for works of art by being around [Salvator] Mayer, that merchant who was so curious and artistic. The amusing comings and goings in his shop were emblematic of an era, and they deserve this special chapter.

APPENDIX C

Dolikhos's Beginnings

Berthe Weill

"Ah, Monsieur Sardou,[1] you've come at just the right time!"

"Mayer, you know my feet take me to your place of their own accord. So, my friendly treasure-hunter, let's see what you have to show me."

As if blown by a gust of wind, the shop door swung open.

"Did you find me a picture of La Clairon, Mayer?"

"Yes, I did, and it's a real beauty, Monsieur Claretie."

"Sardou! Well, what do you know! How are you?"

After conversation and handshakes, the two men left, each carefully carrying the rarity they'd been coveting. Before going out, Sardou reminded Monsieur Mayer:

"So we're agreed, right? Get it to Sarah before she eats at number 2.[2] As for Réjane, can you promise to find something sensational for the *Sans-Gêne* premiere?"[3]

"You can count on me, maestro."

There was never a dull moment at Mayer's.

An agitated man with a battered hat and the face of a gorilla came in: [Camille] Groult was still trembling with rage after a scuffle with his son, whom he had caught riding in a phaeton in female company. Slaps were exchanged, carriage shafts broken. "You'll wind up on the gallows!" yelled the pasta magnate, al dente. But now he was in a hurry; time to get down to "serious" things.

"Quick, show me this eighteenth-century terra-cotta I heard about."

"I can't, I just sold it to Doucet."

"Damn! Couldn't you at least warn me?"

"I didn't have time. As you know, things here fly out the door as fast as they come in. They don't sit around gathering moss."

"I'm never setting foot in here again."

"Suit yourself, Monsieur Groult, but it's your loss. Anyway, I don't like it when people give me a hard time."

Beurdeley entered in time to hear this friendly exchange, and grinned.

Next day, Groult was back at the famous searcher's shop, and found Edmond de Goncourt in animated conversation with Chéramy.

"The stupid cabal almost spoiled everything.* I had a vision of canes and stools raining down on the stage, and I momentarily lost track of everything. When Germinie, who is wracked with pain, serves the children tea, the audience began to mutter, and by Crosnier's tirade, they were hooting."[4]

"I think you're going to have to make some cuts, Goncourt."

They continued talking in low voices. As Goncourt left, he said:

"Don't forget, Mayer. Try to get me that Hokusai my collection is missing."

"Well, hello, Lassouche! Still on the prowl?"

"More than ever. And would you know, I just found a gold Louis XVI box, a real marvel. A marvel, I tell you!"

Eyes gleaming, the actor promptly climbed astride his favorite hobbyhorse—his love affair with Blanche d'Antigny— and rode it hard enough to make Aimé, the nice shop assistant, blush. Lassouche followed this with a string of other anecdotes for his amused audience.

You had to be careful not to boast about republicanism in

*This is about the premiere of *Germinie Lacerteux*.

front of Monsieur Bouquin de La Souche: "I regret it for myself," he said. "I thought I was speaking with a man of wit."

Lassouche's disarming sense of humor could always get a laugh.

The always affable Nuitter said little, appeared and disappeared like a ghost, constantly searching for some precious document to enrich "his" library at the Opéra.

Rouart, Degas, Bonnat, Duret, Béraldi, Arm, Dayot, Roger Marx, Pissarro, Viau, Bertrand, the director of the Opéra, Samuel, the director of the Variétés, Rodrigue (Ramiro), Brébant, Poniatowski, Decourcelle (handsome Pierre), Doistau, the Ephrussis, Moreau-Nélaton, and others—and I'm skipping some major figures—would all pass through this temple of art every day.

Bonnat was talking to Degas about their respective collections, which were rich in works by Delacroix, Daumier, Ingres, Corot, Courbet, and other nineteenth-century masters, selected with a shared care and passion for great art.

Degas has been credited with many witticisms. The equally witty Bonnat invited him to come see his collection. Bonnat smiled modestly, but there was a glint behind his pince-nez. He said, "I promise not to slip in any of my own works."

"Do you believe in Impressionism, Mayer?" asked the Bernheim brothers, his neighbors across rue Laffitte.

"I believe in whatever I feel. From a business standpoint, I don't give a damn. If I like it, that's all that matters."

"At least explain this new conception of painting to us."

"You don't explain it, you feel it. You just have a feeling." (Today, people explain, they don't feel.) "Anyway, I'm very busy. Ask this young man what he thinks of it."

Amid these comings and goings, a tall fellow with a pug nose was standing in a dark corner of the shop, as he did every evening. He was studying for a degree in literature (to please his father) but was learning the ins and outs of business (for himself). This was Dolikhos.[5]

To make people put up with him hanging around, he dipped into his meager savings from time to time to buy a Méry watercolor (little birdies), or even a canvas by the same. His untrained eye and lack of flair (due to a pugged-up nose) made that unfortunate choice quite forgivable.

Dolikhos was indifferent to the conversations around him, but took an interest in the impressive whirl of business deals being struck.

An Odilon Redon drawing left him unmoved and baffled.

"Tell me, Mayer, do you think it will amount to something?" he asked in his strong Papuan accent.[6]

What a question! Part of a wall nearly collapsed laughing.

"Will it to be, or will it not to be," said Mayer. "That is the question!"

Mayer was laying it on a bit thick, and his sarcasm could be misleading. How can you learn from a teacher like that?

"No, seriously, just tell me. I don't see anything in it."

"Listen, Dolikhos, I've told you a hundred times: You may never see anything in it. Me, I'm drawn to these new directions people are taking. If you're only interested in how much something is worth, then forget the whole thing. This isn't for you."

He left Dolikhos feeling on edge, like a hunting dog on the scent of a tantalizing quarry. (Hm, flair . . . ! He was getting unpugged!)

Mayer saw a parade of everybody who was anybody in the world of arts and letters—big financiers, the flower of the judiciary, theater people, etc.—passing through his shop, but he never took advantage of his privileged position. He had just one

ambition, one goal: finding hidden treasures. Trusting collectors followed him like a pack of hounds on a hunt, jostling each other to get at the choice engravings he brought back in bales from the Hôtel des Ventes before he could even unpack them.

Mayer didn't always score, but the hustle and the crowds excited him, and he went back every day, to the great joy of his regular customers, their appetites sharpened by this unstoppable cutup.

As a result, Manzi acquired some handsome Japanese woodblock prints, as well as works by Degas, Manet, Lautrec, and many other first-class artists. He later sold them to Camondo, who hadn't yet begun to patronize Mayer.

Inevitably, the flashes of wit and good taste assembled in the little shop attracted the financier, who soon became one of its regulars.

Camondo admitted to mistrusting modern art, and his financial preoccupations slightly impeded his artistic vision, but not to the extent of rejecting the advice of experienced initiates. Fortunately, they gave him excellent guidance.

Was it the influence of the milieu? At Mayer's, Camondo never uttered the stupidities that have been attributed to him.[*] He trusted the artist-merchant to the point of never doubting the least of his pronouncements. Other dealers' commercialism had given him good reason to be cautious.

But what had become of Dolikhos . . . ? After visiting the shop less and less often, he disappeared. Sometime later, he turned up in a little nook on rue Laffitte, wondering what in the world he could sell there.

Looking around and wondering ("Tell me?"), he made his choice: painting.

[*]In the *Mercure de France*, December 16, 1916, article "Figures d'amateurs." [Weill is referencing Vollard's negative characterization of Camondo in his article.—Eds.]

Pissarro, whom he met at Mayer's, was his first advisor, and helped Dolikhos recognize Manet's *The Horsewoman* in a batch of canvases he had bought from a bric-a-brac dealer. (Flair, right?) He went to Renoir to have it authenticated. (Flair! Flair!)

When a new business opens, people will give it a shot, so a few artists wandered in. One day, an artist showed up with a bundle of some twenty rolled-up canvases. Dolikhos had very nice manners, but he didn't like people yanking his chain. When he saw the . . . pixilations, he nearly threw the impostor out. Pissarro arrived in time to calm him down. He took a look at the canvases, and advised Dolikhos to buy them. He did, acquiring the object of his scorn for about a hundred francs . . .

When somebody unexpectedly spreads twenty Cézannes in front of you, how are you supposed to react? (Was that luck, or flair?)

Dolikhos left the bundle lying in a corner.

At the Hôtel des Ventes, Dolikhos met Auguste Bauchy, who owned the Café des Variétés. An artist at heart, Bauchy always kept an open table for anyone who wanted to talk about art. He often neglected his customers to spend time with Cézannes, Gauguins, Van Goghs, and the emerging artists of the period, whom he gladly exhibited in his café. He was also happy to do the honors when some collector (mockingly) asked to see his collection. He was so pleased, he didn't notice the departing visitor's smile, which seemed to say, "The man's crazy, let's not upset him!"

Bauchy was one of that era's most appealing characters, and we would have enjoyed seeing him acquire a following. Unfortunately, he remained one of a kind.

An artistic dreamer like that could never succeed as a café owner. He was forced to close, all for the love of art.

For Dolikhos, making this new acquaintance was the start of his fortune. The two men exchanged a few canvases. The bundle of Cézannes was finally unrolled. A few were even sold.

Bauchy also talked up Gauguin, Van Gogh, and many others with great enthusiasm.

Thus blessed by circumstances, Dolikhos was launched, and he could cruise along, not in a dugout canoe, but in a gondola...

This transitional period in art was propitious for pictorial transactions. And once again, luck smiled on Dolikhos, who was in the right place at the right time. Ten years earlier, he might not have succeeded. Père Tanguy stagnated his whole life,[7] surrounded by his Van Goghs, Gauguins, Cézannes, and Courbets. Good-old Durand-Ruel,[8] having amassed all those masterpieces in his gallery, went bust three times. Thank heaven Dolikhos came along, because without him, art was finished. *Veni, vidi, vici...!*

Pissarro, Sisley, and Monet, who had all been rejected when they were starting out, finally had vigorous defenders. The revolutionaries' color and vision gave the (still rare) collectors a taste for harmony and a new perception of nature.

The dangerous corner had been turned.

Their contemporaries Cézanne, Van Gogh, Gauguin, and Renoir followed, but to those Impressionists' color, les Jeunes added their experiments with shape, volume, and substance. In so doing, they encountered plenty of obstacles, but eventually overcame them.

At that very moment, Dolikhos was seeing the value of their work begin to take off (Fortune! Intellect!). And just as he felt stirred by this new passion, a throng of advisors showed up. Thanks to them, he finally realized how valuable Cézanne was. He appreciated him, liked him, got close to him.

And the artist had every reason to be grateful to Dolikhos.

The dealer had made him, invented him, so much so that you sometimes wondered which of the two was the more gifted.

But for Dolikhos, it was no longer love, but fury, delirium. He piled up canvas after canvas so relentlessly, it was alarming.

He then took an interest in Gauguin, but his approaches went nowhere. The artist didn't understand him. Misunderstood but persevering, Dolikhos still managed to acquire some of his paintings, for which he deserves praise... Who, him? No, the other one, Gauguin.

The gold nuggets kept accumulating. Dolikhos grew, exhibited paintings, raised their prices. Because of the run-up, foreigners began to get it. Fascinated by this new kind of art, the Germans paid top prices. An exodus of paintings began.

The French, who in the beginning weren't interested, acquired a few works. But others balked at the asking prices and hung back, to their great regret later. (No one is a prophet in their own country.) The exodus continued.

But Camondo had an idea: he set prices that would allow him to keep certain important works from leaving the country. Pleased by this intervention, Dolikhos felt very small. He was reborn. He was even daunted by the financier's Mercedes. He was so respectful, he was tempted to take his shoes off before getting in.

Allo! Allah! Allah! Alli!
Li si baladi
His zi, his pan,
Zizi, panpan!

The fact that Camondo knew real, live princesses made Dolikhos as happy as a child, as fluttery as a virgin.[9]

More than anything, our Papuan loved bright colors and lots of gilt, but he didn't like Frantz Jourdain's Samaritaine.[10] So he was chagrined to see Camondo admire the Saint-Germain-l'Auxerrois church, only to go into ecstasies before the department store.*

So sad!

Dolikhos also had black-and-white Odilon Redons in his cellar. He had finally realized that the art "would amount to something," and with good reason. The artist had just died. It was time to bring them out, oh Dolikhos . . . time to go dancing for dollars . . . !

Not yet, you say . . . ? Let us heed Dolikhos, and wait. Patience is the prerogative of the wise.

And Renoirs, too! Nobody mentioned it, but everybody knew that Dolikhos had accumulated them by the hundreds. The master did him some touching favors, and Dolikhos guarded him well. Every day, he made sure the artist's brilliant palette was within reach, and especially that no intruder interrupted the great painter's work.

The door was barred even to God!

Still, an eavesdropper (how nasty!) caught this exchange between the master and his slave driver . . . I mean his manager . . . No, I mean his . . . Oh, never mind!

"Someone's knocking," said Dolikhos, cocking an ear.

"It's just the cat purring," answered the *maître*.

"No. I'm sure someone's knocking."

"Then crack the door, oh Dolikhos . . . ! Ah, it's dear so-and-so . . . ! Goodbye, Dolikhos."

"But . . ."

* Read in the *Mercure de France* of December 16, 1916, "Figures d'amateurs."

"Goodbye, goodbye!"

"Ananke . . . !"[11]

Furious, Dolikhos lay down in front of the door.

○─○

Dolikhos should be loved for the solicitude and care he gave our great artists, and it would be sad if his fortune, earned with such difficulty, were to collapse. You, the very youngest, whom he always welcomed so liberally, please support him. Open your hearts to gratitude: *Sursum Corda.*[12]

If Renoir, on a day that we hope would be far off, gave up the ghost, returning the soul that God had loaned him, Dolikhos would sacrifice himself and empty his cellar. It wouldn't be the deutschemark that would outbid the French louis—Dolikhos was a patriot, after all—but the dollar. America was the beloved ally he had been waiting for.

Yes, let us love Dolikhos for the love he bore our great painters, and which he wanted to see reciprocated. But let's also be thankful to Camondo for the double merit of gathering the works of a school of painting he admittedly didn't well understand, and then preventing their dispersal by making a magnificent gift to the Louvre with the greatest disinterestedness.

Dolikhos suspected Camondo of seeking some favor in return.*

By your shiny pate, oh Dolikhos, your error is grave. Someday you will recognize the noble sentiment that guided that donor, and draw a salutary lesson from it. You will keep your Cézannes, Gauguins, Renoirs, and Redons, even your Iturrinos, de Grouxes, and Mérys. You will remain the disinterested man that all the world knows, and make the gesture we all expect,

* Read in the *Mercure de France* of December 16, 1916, "Figures d'amateurs."

and donate your marvelous collection to the Louvre. Even Jarry's ghost will quiver with pleasure, and forgive you for the difficult trials you put it through.[13]

Dolikhos wrote about Cézanne and Renoir, little snatches of washerwoman gossip in the accent of a kangaroo from Bombala.[14] He stewed us in Ubu-isms of every flavor, and it was side-splitting. It was so funny that even Ubu cried, "This frater is overboarding much! Think we ought to whistle-plug him?"

Dolikhos's eyelids are getting heavy... Shhh! He's asleep...[15]

Having sketched a picture of these two merchants, I'll conclude with just this comment. A whole world separates the two men and their attitudes. In Mayer's shop, the walls were practically riddled with witticisms. "It was the last salon where people really talked," Marguerite Durand wrote in her society column. Dolikhos's shop was chilly and unwelcoming, perhaps by design. Camondo yawned there, and Dolikhos reproached him for it. (They say that Ubu had hysterics at Dolikhos's bons mots, laughing fit to bust a gut.)

Dolikhos owed a great deal—maybe his whole fortune—to Mayer, Pissarro, and Bauchy.

As for the painters, old and young, he owed them even more. The first for using their genius to overcome his disdain for gold; the second for using their youth to push away from his lips the chalice of bitterness that art offers only to its elect.

Acknowledgments

This book, it is safe to say, has been a labor of love on the part of many. Key has been Julie Saul, who introduced me to Berthe Weill and to Robert M. Parker, who happily joined our initial research efforts. Absolutely essential has been Marianne Le Morvan; this project would have been simply impossible without her participation and tireless efforts. William Rodarmor, as well, is owed an enormous debt of gratitude for having given a coherent, readable English voice to Berthe's idiosyncratic and quirky French. All named above would have not been engaged had this project not received crucial early support from Michele Tocci and the David Berg Foundation. Similarly, heartfelt thanks are owed to Mary Jane Jacob and Clayton Lewis for their generous subsidy from the Magdalena Abakanowicz Art and Culture Charitable Foundation to fund this translation. At the University of Chicago Press, Susan Bielstein, with the help of Dylan Montanari and James Toftness, along with copy editor Elizabeth Ellingboe, guided this manuscript of many moving parts to its logical, elegant realization. Marianne Le Morvan would like to thank Hervé Bourdon, Elsa Mazières, and Adam and Alice Orawski for their sustained early support. To the Grey Art Gallery staff, especially Allegra Favila and Ally Mintz, I greatly appreciate your patience and indispensable assistance. *Vive Berthe Weill!*

Lynn Gumpert

Chronology

NOVEMBER 20, 1865. Berthe Weill is born (Paris, 1st arrondisse-
ment)

1880S. Apprentices with the picture antique dealer Salvator Mayer
on rue Laffitte (Paris, 9th)

1897. Starts an antique shop with her brother Marcellin at 25 rue Vic-
tor Massé (Paris, 9th)

DECEMBER 1, 1901. Galerie B. Weill opens

DECEMBER 1916. Weill self-publishes *Dolikhos's Beginnings*, a thinly
disguised satire of Ambroise Vollard in response to his critical
portrait of Isaac de Camondo published that month in *Mercure de
France*

1917. Moves to 50 rue Taitbout (Paris, 9th)

DECEMBER 3, 1917. Amedeo Modigliani's solo show causes a scandal

SEPTEMBER 1919. Art bookstore launched at the Galerie B. Weill

1920. Moves to 46 rue Laffitte (Paris, 9th) and inaugurates the new
location on August 10

FEBRUARY 21, 1921. The gallery's one hundredth show is celebrated
with a preview and a puppet show, *La Petite revue des peintres*

NOVEMBER 1923. The gallery's first *Bulletin* is published

DECEMBER 20, 1926. Galerie B. Weill's silver anniversary and first
year-end themed retrospective exhibition

DECEMBER 1927. The gallery moves to 27 rue Saint Dominique
(Paris, 7th)

FEBRUARY 1933. Publication of Berthe Weill's memoir, *Pan! dans
l'œil!*

1935. The gallery's bulletin ceases publication

APRIL 1940. Last exhibition of paintings by Odette des Garets

1941. Galerie B. Weill closes

DECEMBER 12, 1946. Public auction of works donated by artists and
galleries as a fundraiser for Weill, in gratitude for her support

MARCH 20, 1948. Weill is named a chevalier of the Legion of Honor

174 CHRONOLOGY

APRIL 17, 1951. Berthe Weill dies

JUNE 13, 2007. Picasso's portrait of Berthe Weill is declared a national treasure by the Commission consultative des trésors nationaux

DECEMBER 1, 2011. The city honors Weill with a commemorative plaque at 25 rue Victor Massé on the 110th anniversary of Galerie B. Weill's inauguration and the 60th anniversary of its owner's death

MARCH 2020. The city of Paris inaugurates a pocket park named for Berthe Weill adjacent to the Musée Picasso

Glossary of Names

Below are the names of artists and major cultural figures mentioned in *Pow! Right in the Eye!* Unless stated otherwise, all are French. Years are indicated when known; some are approximations. Compiled by William Rodarmor with assistance from Marianne Le Morvan, Julie Saul, and Allegra Favila.

AGARD, CHARLES-JEAN (1866–1950): painter

AGUTTE, GEORGETTE (1867–1922): painter and collector

ALBERT-BIROT, PIERRE (1876–1967): avant-garde poet, dramatist, and theater manager who also worked for five decades as an art restorer; his friend Apollinaire called him "le Pyrogène" due to his fiery personality

ALIX, YVES (1890–1969): painter

ALLARD, ROGER (1885–1961): poet, writer, and critic

AMOS, MATHILDE (?–1967): cited by Weill as an attendee to the 1926 dinner honoring her and hosted by some fifty artists

ANGIBOULT, FRANÇOIS, pseudonym of Hélène d'Oettingen (1887–1950): a baroness who was a painter, poet, and novelist and who used a masculine alias

ANTIGNY, BLANCHE D' (1840–1874): singer, actress, and courtesan used by Émile Zola as the principal model for his novel *Nana*

ANTOINE, ANDRÉ (1858–1943): actor, director, manager, producer, and critic

APOLLINAIRE, GUILLAUME (1880–1918): poet, playwright, novelist, and art critic; impassioned defender of Cubism and Surrealism

ARCHIPENKO, ALEXANDER (1887–1964): Ukrainian-American sculptor

ARM: cited by Weill as a regular client of Salvator Mayer's shop in *Dolikhos*

ASSELIN, MAURICE (1882–1947): painter and engraver

176 GLOSSARY OF NAMES

AUDOUX, MARGUERITE, born Marguerite Donquichote (1863–1937): orphan who grew up extremely poor, eventually became part of the Parisian intelligentsia, and penned a best-selling memoir, along with several novels

AUGLAY, AUGUSTE (1853–1925): painter and poster artist

BAIGNIÈRES, PAUL (1869–1945): painter, illustrator, and decorator

BAIL, JOSEPH (1862–1921): academic Realist painter

BARAT-LEVRAUX, GEORGES (1878–1964): painter

BARRÈRE, ADRIEN (1874–1931): painter and sculptor; designed posters for Parisian cinemas and the Grand Guignol theater

BASHKIRTSEFF, MARIE (1858–1884): Russian artist who lived and worked in Paris

BASLER, ADOLPHE (1876–1951): Polish-born art critic, art historian, collector, and gallerist

BAUCHY, AUGUSTE (1858–1940): art collector who owned the Café des Variétés

BEAUFRÈRE, ADOLPHE (1876–1960): painter, illustrator, and engraver

BELLIER, ALPHONSE (1886–1980): Hôtel Drouot art auctioneer

BÉRALDI, HENRI (1849–1931): bibliophile and publisher who wrote on nineteenth-century French printmakers

BERGER, JEAN: son of the painter and postcard illustrator, Hans Berger; Weill exhibited Jean's work in February 1912

BERGON, FRANÇOIS: painter

BERNARD-LEMAIRE, LOUIS: painter who exhibited with Picasso in a 1902 show at Galerie B. Weill

BERNHARDT, SARAH (1844–1923): famous actress

BERNHEIM, ALEXANDRE (1839–1915): founded the Bernheim-Jeune gallery on Rue Laffitte, which he operated with his sons Josse and Gaston; the gallery held the first important exhibition of Van Gogh paintings in Paris

BERNHEIM, GEORGES (?–1935): art dealer and a cousin of Josse and Gaston Bernheim; opened a gallery at 9 rue Laffitte around 1898, and later moved it to 40 rue la Boétie

BERNHEIM-JEUNE, JOSSE (1870–1941) and GASTON (1870–1953): sons of Alexandre Bernheim born in the same year, but not twins, known as the Bernheim brothers and as the Bernheim-Jeune *frères*; in 1906, with Félix Fénéon as gallery director, they began

GLOSSARY OF NAMES 177

to exhibit emerging artists such as Kees van Dongen, Raoul Dufy, and Amedeo Modigliani

BERN-KLENE, HENDRICUS (1870–1930): Dutch painter

BERTRAND, CLAIRE (1890–1969): Expressionist painter; wife of Willy Eisenschitz

BÉTRIX or BÉTRIS: described by Weill as an emerging artist in the 1930s

BEURDELEY, ALFRED (1847–1919): art collector from a family of cabinetmakers and antique dealers

BIANCHINI: musician

BIETTE, JEAN (1876–1935): painter

BILLETTE, RAYMOND (1875–1942): painter

BISSIÈRE, ROGER (1886–1964): stained-glass artist

BLANCHE, JACQUES-ÉMILE (1861–1942): academic portrait painter

BLOT, EUGÈNE (1883–1976): interior decorator, draftsman, and landscape designer

BLOY, LÉON (1846–1917): novelist, essayist, pamphleteer, and poet; passionate defender of Catholicism

BOCQUET, PAUL (1868–1947): painter

BOLLIGER, RODOLPHE (1878–1952): Swiss painter

BONGARD, GERMAINE (1885–1971): painter who ran a couture house from 1911 to 1925

BONNARD, PIERRE (1867–1947): Postimpressionist painter, illustrator, and printmaker, known for the stylized decorative qualities of his paintings and bold use of color

BONNAT, LÉON (1833–1922): painter and teacher at the École des Beaux-Arts

BORGEAUD, MARIUS (1861–1924): Swiss Postimpressionist painter

BOSSHARD, RODOLPHE-THÉOPHILE (1889–1960): Swiss painter

BOTTINI, GEORGES (1874–1907): painter, draftsman, watercolorist, and engraver

BOUCHE, GEORGES (1874–1941): painter

BOUDIN, EUGÈNE (1824–1898): marine painter; one of the first French landscape artists to paint outdoors

BOUGUEREAU, WILLIAM-ADOLPHE (1825–1905): academic painter

BOUSSINGAULT, JEAN-LOUIS (1883–1943): painter, engraver, and illustrator

BRAILOWSKY, ALEXANDER (1896–1976): Ukrainian-born pianist who specialized in Chopin

178 GLOSSARY OF NAMES

BRAQUE, GEORGES (1882–1963): major painter, collagist, draftsman, printmaker, and sculptor

BRAUN, MAURICE (1877–1941): American Impressionist known for paintings of California's deserts, coast, and the Sierra Nevada

BRÉBANT, PAUL (1823–1892): chef and restaurateur

BRENOT, CLAUDINE: long-suffering girlfriend and model of Raoul Dufy, according to Weill; little other information is known about her

BRISSON, ADOLPHE (1860–1925): journalist and drama critic

BROUSSON, JEAN-JACQUES (1878–1958): journalist and writer

BUHOT, JEAN (1885–1952): painter, illustrator, and wood engraver

BURGSTHAL, RICHARD, born René Billa (1884–1944): musician and glass artist

BURTY, FRANK (1886–1971): Cubist painter and collector of African art

CÂMARA, TOMÁS LEAL DA (1876–1948): Portuguese painter and caricaturist

CAMOIN, CHARLES (1879–1965): Fauvist painter who won a 1925 case ruling that an artist retains intellectual property rights in the physical material of his artwork, even if he no longer possesses it

CAMONDO, COMTE ISAAC DE (1851–1911): banker and art collector with a special interest in Impressionist and Postimpressionist artists; his collection was bequeathed to the Louvre in 1908

CANALS, RICARD (1876–1931): Catalan Impressionist painter, illustrator, and engraver

CAPON, GEORGES (1890–1980): painter, engraver, lithographer, and poster artist

CAPPIELLO, LEONETTO (1875–1942): innovative Franco-Italian poster designer

CARAN D'ACHE, born Emmanuel Poiré (1858–1909): Russian-born draftsman and caricaturist

CARNOT FAMILY: descendants of Lazare Carnot (1753–1823), a notable mathematician, physicist, and political figure involved in the French Revolution

CARO-DELVAILLE, HENRI (1876–1928): painter and decorator

CAROLUS-DURAN, born Charles Durand (1837–19127): painter and art instructor

CARRÉ, RAOUL (1868–1933): painter

GLOSSARY OF NAMES 179

CASAGEMAS, CARLES (1880–1901): Catalan painter and poet, known for his complicated friendship with Picasso

CASSE, RAYMOND (?–1918): painter described by Weill as having a bright future—he died at the age of twenty-five; in her memoir, she calls him "Robert" by mistake

CELLI, ELMIRO (1870–1958): Italian painter

CÉZANNE, PAUL (1839–1906): major Postimpressionist painter

CHABAUD, AUGUSTE (1882–1955): painter and sculptor

CHAGALL, MARC (1887–1985): Russian-French modernist active in painting, drawing, illustration, stained glass, stage sets, ceramic tapestries, and fine art prints

CHAMPIGNOL: the lead character in *Champignol malgré lui*, a farce by Georges Feydeau and Maurice Desvallières

CHARENSOL, GEORGES (1899–1995): literature, art, and film critic

CHARMY, ÉMILIE (1878–1974): painter who worked closely with the Fauves and close friend of Weill

CHARRETON, VICTOR (1864–1936): Impressionist landscape painter

CHÉRAMY, J.-A. (1890–1920): painter

CHÉRET, JULES (1836–1932): painter, lithographer, and major poster artist

CHERNIAVSKY, CHARLES (1900–1976): Belarusian-born painter and engraver

CHÉRON, GEORGES (?–1931): Parisian dealer in modern art and owner of the Galerie des Indépendants, which opened in 1913

CHOCARNE-MOREAU, PAUL (1855–1931): painter

CLAIRIN, PIERRE-EUGÈNE (1897–1980): painter, illustrator, engraver, and *résistant*

CLARETIE, JULES (1840–1913): novelist, playwright, drama critic, historian, and the director of the Théâtre Français

CLEMENCEAU, GEORGES (1841–1929): statesman who led France through the end of World War I and served as prime minister twice (1906–1909 and 1917–1920)

COLETTE, SIDONIE-GABRIELLE (1873–1954): author, mime, actress, and journalist

COQUIOT, GUSTAVE (1865–1926): writer and art critic; Rodin's ex-secretary, he collected work by Utrillo

COROT, JEAN-BAPTISTE (1796–1875): famed landscape and portrait painter and printmaker

180 GLOSSARY OF NAMES

COTTEREAU, HENRI: bicycle manufacturer turned art dealer of Impressionists, especially Camille Pissarro

COUBINE, OTHON, born Otakar Kubín (1883–1969): French-Czech sculptor and engraver

COURBET, GUSTAVE (1819–1877): eminent painter and founder of Realism, which championed depictions of the everyday lives of the working class

COUSTURIER, LUCIE (1876–1925): writer and painter

COUTURIER, ÉDOUARD (1871–1903): artist and pro-Dreyfus caricaturist

CRAVAN, ARTHUR, born Fabian Lloyd (1887–1918): Swiss-British boxer, writer, and Dada-style provocateur

CYR, GEORGES (1880–1964): painter who left France to settle in Lebanon

CZÓBEL, BÉLA (1883–1976): painter who introduced Postimpressionism, Fauvism, Cubism, and Expressionism to his native Hungary

DAMIA, born Marie-Louise Damien (1889–1978): singer and actress

DARAGNÈS, JEAN-GABRIEL (1886–1950): painter and engraver

DAUMIER, HONORÉ (1808–1879): painter, draftsman, and caricaturist, especially of lawyers

DAVID, HERMINE (1886–1970): painter and engraver; wife of Jules Pascin

DAYOT, ARMAND (1851–1934): art critic, art historian, and leftist politician; founded the journal *L'Art et les artistes* and published numerous books on art, history, and politics ranging from medieval times to the present

DECOURCELLE, PIERRE (1856–1926): writer and playwright

DEGAS, EDGAR (1834–1917): painter, draftsman, and sculptor famous for depicting ballerinas

DELACROIX, EUGÈNE (1798–1863): leading painter of French Romanticism regarded for his evocative scenes and bold use of color

DELAROCHE, LÉON (1837–1897): a successful newspaper publisher, writer, and collector; owner of *Le Progrès de Lyon*, which he acquired in 1880

DELAUNAY, ROBERT (1885–1941): painter and cofounder of the Orphism movement; known for his many paintings of the Eiffel Tower

GLOSSARY OF NAMES 181

DELCOURT, MAURICE (1877–1916): painter, draftsman, and wood and linoleum engraver

DELMÉE, ADOLPHE (1820–1891): publisher, according to Weill, who partnered with Pierre Reverdy

DELTOMBE, PAUL (1878–1971): painter, decorator, and designer

DENIS, MAURICE (1870–1943): painter, decorative artist, and writer whose theories contributed to the foundations of Cubism, Fauvism, and abstract art

DEPAQUIT, JULES (1869–1924): illustrator and "mayor" of the "Free Commune of Montmartre"

DERAIN, ANDRÉ (1880–1954): painter, engraver, sculptor, and writer; a founder of Fauvism

DÉROULÈDE, PAUL (1846–1914): author and nationalist politician

DESJARDINS, DR. AND MME: indicated by Weill as collectors who attended the hundredth exhibition of her gallery on February 21, 1921

DESPIAU, CHARLES (1874–1946): sculptor

DESVALLIÈRES, GEORGE (1861–1950): painter who combined dark subjects and violent color with a dramatic conception of religion

DETAILLE, ÉDOUARD (1848–1912): academic painter and military artist

DEVILLE, HENRY WILFRID (1871–1939): architect and artist working primarily in etching

DIAGHILEV, SERGE (1872–1929): Russian art critic, patron, ballet impresario, and founder of the Ballets Russes

DIAZ DE SORIA, ROBERT (1883–1971): Spanish painter

DIÉTERLE, GEORGES (1881–1925): painter and small-town mayor

DIRIKS, EDVARD (1855–1930): Norwegian academic Realist painter

DOISTAU, FÉLIX (1846–1936): industrial manufacturer of liqueurs, art collector, and major donor of works of art to French public collections

DORIVAL, GEORGES, born Lemarchand (1871–1939): actor, painter, and collector

DORNY, THÉRÈSE (1891–1976): film and stage actress

DOUCET, JACQUES (1853–1929): fashion designer and art collector

DRUET, EUGÈNE (1867–1916): gallerist, art dealer, and photographer

DUBREUIL, PIERRE (1872–1944): photographer

DUFRÉNOY, GEORGES (1870–1943): Postimpressionist painter

182 GLOSSARY OF NAMES

DUFY, JEAN (1888–1964): painter of Parisian society, country scenes, and horse races

DUFY, RAOUL (1877–1953): Fauvist painter whose colorful, decorative style appeared on ceramics and textiles; also a draftsman, printmaker, book illustrator, scenic designer, furniture designer, and planner of public spaces

DUPARC, HENRI (1848–1933): troubled composer of the late Romantic period

DUPARQUE, PAUL (1879–?): Belgian designer who lived in the United States

DURAND, MARGUERITE (1864–1936): stage actress, journalist, and suffragette who founded her own newspaper, stood for election, and owned a pet lion

DURAND-RUEL, PAUL (1831–1922): art dealer who early supported Monet, Pissarro, and Renoir and modernized the art business

DURET, THÉODORE (1838–1927): writer, art critic and collector, and founder of the republican newspaper *La Tribune*

DUREY, RENÉ (1890–1959): painter

DURIO, PACO (1875–1940): goldsmith and ceramicist

DUSSUEIL, GEORGES (1848–1926): businessman and collector from Le Havre, where in 1906 he cofounded the Cercle de l'art moderne, which promoted avant-garde art, especially Fauvism

EBERL, FRANÇOIS ZDENEK (1887–1962): Czech-born painter who was friends with Picasso, Modigliani, and Vlaminck

EBSTEIN, JOSEPH (1881–1961): sculptor

EISENSCHITZ, WILLY (1889–1974): Austrian-born landscape painter, mostly depicting scenes of Provence and Drôme; husband of Claire Bertrand

ELLISSEN, ROBERT (1872–1957): an industrialist, art collector, and member of the Peau de l'ours collecting association

EPHRUSSI FAMILY: a wealthy Russian banking family; Charles Ephrussi (1849–1905) was a well-known art historian, collector, and editor who is reputed to have been one of Marcel Proust's models for the character of Charles Swann

ESMEIN, MAURICE (1888–1918): analytic Cubist painter

FAIVRE, ABEL (1867–1945): painter, illustrator, and cartoonist; created propaganda posters in World War I and comics for *Le Rire*, *L'Écho de Paris*, and *Le Figaro*

GLOSSARY OF NAMES 183

FANTIN-LATOUR, HENRI (1836–1904): painter and lithographer known for his paintings of flowers, artists, and writers

FARREY, PIERRE (1896–1987): painter and decorator

FAVORY, ANDRÉ (1889–1937): painter and illustrator

FELIXMÜLLER, CONRAD, born Conrad Felix Müller (1897–1977): German Expressionist painter and printmaker

FELS, FLORENT (1891–1977): journalist and art critic

FÉNÉON, FÉLIX (1861–1944): anarchist and art critic who coined the term Neo-impressionism

FINKELSTEIN, ALEX (Sacha) (1878–1919): Russian painter who eventually moved to the United States

FLANDRIN, JULES (1871–1947): painter, printer, and draftsman

FLEURET, FERNAND (1883–1945): writer and poet

FLORÈS, RICARDO (1878–1918): painter, illustrator, caricaturist, and draftsman

FORAIN, JEAN-LOUIS (1852–1931): Impressionist painter, lithographer, watercolorist, and anti-Dreyfus caricaturist

FOURNIER, GABRIEL (1893–1963): painter

FOURNIER, MARCEL (1869–1917): painter and sea captain; called up in World War I at age forty-nine and sketched the fighting on the Somme, where he was killed

FRANCE, ANATOLE (1844–1924): a major writer and literary critic

FRÉDUREAU, PAUL (?–1927): sculptor

FRÉLAUT, JEAN (1879–1954): painter, engraver, and illustrator

FRIESZ, OTHON (1879–1949): a Fauvist painter who grew up in Le Havre, like Dufy; later returned to a more traditional painting style

FURSY, HENRI, born Henri Dreyfus (1866–1929): cabaret singer, director, and lyricist

GAILLARD, MARCEL (1886–1947): painter, engraver, and illustrator

GALANIS, DEMETRIUS (1879–1966): popular Greek painter who exhibited alongside Picasso, Matisse, Braque, Gris, Dufy, and Chagall

GALIMBERTI, SÁNDOR (1883–1915): Hungarian painter; husband of Valéria Galimberti-Dénes

GALIMBERTI-DÉNES, VALÉRIA (1877–1915): early Hungarian Cubist painter; wife of Sándor Galimberti

GALLIENI, JOSEPH (1849–1916): colonial administrator

184 GLOSSARY OF NAMES

GALTIER-BOISSIÈRE, JEAN (1891–1966): writer and journalist; founded *Le Crapouillot* and wrote for *Le Canard enchaîné*

GARDELLE, CHARLOTTE (1879–1953): painter

GARETS, ODETTE DES (1891–1967): painter

GAUGUIN, PAUL (1848–1903): major figure in the Symbolist movement as a painter, sculptor, printmaker, ceramist, and writer

GEN-PAUL, born Eugène Paul (1895–1975): Expressionist painter, draftsman, engraver, and lithographer

GEORGE, WALDEMAR, born Jarocinsky (1893–1970): Polish art historian, critic, and collector, with anti-imperial republican sentiments

GERNEZ, PAUL-ÉLIE (1888–1948): painter, watercolorist, engraver, and illustrator

GIGNOUX: cited by Weill as a member of Sanary's summer vacationers

GILLIARD, MARGUERITE (1888–1918): painter whose parents, sister, and husband were also painters; exhibited with Weill when she was sixteen

GIMMI, CÉCILE ABRANSKI (1886–1954): Russian-born sculptor; wife of Wilhelm Gimmi

GIMMI, WILHELM (1886–1965): Swiss painter, draftsman, and lithographer; husband of Cécile Gimmi

GIRAN-MAX, LÉON (1867–1927): painter and poster artist

GIRARDIN, MAURICE (1884–1951): dentist and art collector; founded the Galerie La Licorne

GIRIEUD, PIERRE (1876–1948): self-taught Fauvist painter

GLEIZES, ALBERT (1881–1953): artist, philosopher, and self-proclaimed founder of Cubism

GOERG, ÉDOUARD (1893–1969): Australian-born Expressionist painter, engraver, and illustrator

GONCOURT, EDMOND DE (1822–1896): writer, literary and art critic, and publisher; founder of the Académie Goncourt, which awards the prestigious Prix Goncourt

GOSÉ, XAVIER (1876–1915): Catalan Art Nouveau and Art Deco painter and illustrator

GOTTLOB, ADOLPH (1873–1935): graphic artist and caricaturist who contributed to humorous magazines and *L'Estampe moderne*

GRASSET, EUGÈNE (1845–1917): Swiss-born Art Nouveau decorative artist

GLOSSARY OF NAMES 185

GRASS-MICK, AUGUSTIN (1873–1963): painter, art critic, and historian; promoted Provençal artists

GRILLON, ROGER (1881–1938): painter, illustrator, and wood engraver

GRIS, JUAN (1887–1927): famed Spanish Cubist painter

GROMAIRE, MARCEL (1892–1971): painter often associated with Social Realism

GROULT, CAMILLE (1832–1908): flour and grain businessman and major collector, especially of late nineteenth-century British art

GROUX, HENRY DE (1866–1930): Belgian Symbolist painter, sculptor, and lithographer, noted for his 1889 painting *Christ Attacked by a Mob*

GRÜN, JULES (1868–1938): painter, illustrator, and poster artist; painted *Un Vendredi au salon des artistes français* (1911)

GUÉRIN, CHARLES (1875–1939): Postimpressionist painter who studied with Gustave Moreau

GUILLAUME, PAUL (1861–1934): early modern art dealer

GUINIER, HENRI (1867–1927): portrait and landscape painter

GUYS, CONSTANTIN (1802–1892): Dutch-born war correspondent, watercolor painter, and newspaper illustrator

HALICKA, ALICE (1894–1975): Polish-born painter, illustrator, collagist, and theater artist

HALOU, ALFRED (1875–1939): sculptor

HARDY: theater manager who directed Weill's *Petite revue des peintres*, the puppet show she produced to celebrate her gallery's hundredth exhibition

HARRISON, CARTER (1860–1953): American newspaper publisher and five-term Democratic mayor of Chicago

HAYDEN, HENRI (1883–1970): Polish-born Cubist painter

HECHT, JÓZEF (1891–1951): Polish-born painter and printmaker

HELLEU, PAUL (1859–1927): painter, pastel artist, drypoint etcher, and designer, known for his portraits of society women; conceived the starry ceiling of New York's Grand Central Terminal

HENNER, JEAN-JACQUES (1829–1905): painter noted for his use of sfumato and chiaroscuro in his nudes, religious subjects, and portraits

HENSEL, MAURICE (1880–1958): painter and watercolorist

HERBIN, AUGUSTE (1882–1960): painter best known for his Cubist and abstract paintings consisting of colorful geometric figures

186 GLOSSARY OF NAMES

HERMANN-PAUL, RENÉ (1864–1940): artist and illustrator of newspapers and periodicals

HERVIEU, LOUISE (1878–1954): writer, artist, painter, draftsman, and lithographer

HESSEL, JOS or JOSEPH (1859–1942): Belgian art dealer, collector, and historian

HEUZÉ, EDMOND, born Amédée-Honoré Letrouvé (1884–1967): painter, draftsman, engraver, illustrator, and writer

HIVER, MARCEL: identified by Weill as associated with Les Veilleurs and an editor of the journal *CAP*

HODEBERT, LÉON AUGUSTE CÉSAR (1852–1914): painter

HOGG, PAUL (1892–1985): Swiss painter

HOUDON, JEAN-ANTOINE (1741–1828): a Neoclassical sculptor famous for his portrait busts and statues of philosophers, inventors, and political figures of the Enlightenment

HUC, ARTHUR (1854–1932): politician, journalist, and art critic who noticed neglected artists like Toulouse-Lautrec

HUYOT, ALBERT (1872–1968): painter and draftsman

IBELS, HENRI-GABRIEL (1867–1936): illustrator, printmaker, painter, and author; collaborated with Toulouse-Lautrec and became involved in avant-garde theater

INGRES, JEAN-AUGUSTE-DOMINIQUE (1780–1867): renowned Neoclassical painter famous for his portraits

ITURRINO, FRANCISCO (1864–1924): Spanish Basque Postimpressionist painter

JACOB, MAX (1876–1944): Jewish poet, painter, writer, and critic, and one of the first Paris friends of Pablo Picasso, who put Jacob in his painting *Three Musicians* along with himself and Apollinaire; died of pneumonia at Drancy before he would have been deported to Auschwitz

JARRY, ALFRED (1873–1907): Symbolist writer best known for his provocative 1896 play *Ubu Roi*

JAURÈS, JEAN (1859–1914): socialist leader assassinated at the outbreak of World War I

JEANNE, PAUL: puppet maker, performer, and the author of *Les Théâtres d'ombres à Montmartre de 1887 à 1923* (1937)

JONGKIND, JOHAN BARTHOLD (1819–1891): Dutch marine painter and forerunner of Impressionism

GLOSSARY OF NAMES 187

JOSSOT, GUSTAVE-HENRI (1866–1951): poster designer and orientalist painter

JOURDAIN, FRANTZ (1847–1935): Belgian architect; launched the Salon d'Automne and designed La Samaritaine department store

JOUVENCEL, HENRI DE (1877–1960): lawyer and public finance administrator

JOYANT, MAURICE (1864–1930): manager of the Paris branch of Galerie Boussod, Valadon & Cie and lifelong friend of Toulouse-Lautrec and nephew of the painter Jules-Romain Joyant

JUSTE, RENÉ (1868–1954): landscape painter fond of rain and snow scenes

KAHNWEILER, DANIEL-HENRY (1884–1979): major German-born art dealer and early champion of Cubism; long associated with Picasso

KAPFERER, MARCEL (1872–1966): inventor, aviation pioneer, and art collector, like his brother Henri Kapferer (1870–1958)

KARS, GEORGES, born Karpeles (1880–1945): Czech-born painter

KAYSER, EDMOND CHARLES (1882–1965): watercolorist, engraver, and lithographer

KISLING, MOÏSE (1891–1953): Polish-born painter

KROHG, PER (1899–1965): Norwegian painter, illustrator, and draftsman known for his UN Security Council mural

KRUGLIKOVA, ELIZAVETA (1865–1941): Russian-Soviet painter, etcher, silhouettist, and monotypist

KUBITZKY, ALEXANDER (1881–1936): Russian opera singer

LA CLAIRON, stage name of Clair Leris (1723–1803): classical stage actress at the Comédie-Française

LACOSTE, CHARLES (1870–1959): painter of foggy or snowy landscapes

LA FRESNAYE, ROGER DE (1885–1925): Cubist painter and sculptor

LAGLENNE, JEAN-FRANÇOIS (1899–1962): painter and theater artist

LAGUT, IRÈNE (1893–1994): painter and student of Picasso

LAPRADE, PIERRE (1875–1931): painter, engraver, and book illustrator; exhibited at the 1913 Armory Show

LARGYS: couple cited as attendees at 1926 banquet honoring Weill

LA ROCHA, LUIS DE (1886–1968): Spanish-born artist who exhibited at Weill's gallery in 1919

LARRONDE, CARLOS (1888–1940): poet, journalist, and playwright

188 GLOSSARY OF NAMES

LASSOUCHE, stage name of Pierre-Louis-Ange Bouquin de La Souche (1828–1915): actor

LAUNAY, FABIEN (1877–1904): painter, draftsman, engraver, and caricaturist

LAURENCIN, MARIE (1883–1956): Cubist painter and printmaker; had romantic relationships with both men and women

LAURENS, HENRI (1885–1954): Cubist sculptor and illustrator

LAURENS, MARTHE (1886–1957): painter and ceramicist

LÉANDRE, CHARLES (1862–1934): painter and caricaturist who contributed to *L'Assiette au beurre*, *Le Rire*, and *Le Figaro*

LEBASQUE, HENRI (1865–1937): Postimpressionist painter who exhibited at the inaugural Salon d'Automne with Matisse in 1903

LE BEAU, ALCIDE (1873–1943): Impressionist painter

LEBLOND, MARIUS-ARY: joint pen name of two journalists and art critics, Aimé Merlo (1880–1958) and Georges Athénas (1877–1953), who together won the 1909 Goncourt Prize for their novel *En France*

LECOMTE, GEORGES (1867–1958): novelist and playwright

LÉGER, FERNAND (1881–1955): painter, ceramicist, sculptor, draftsman, illustrator, and tapestry and stained-glass designer

LEGRAND, EDY, born Édouard Warschawsky (1892–1970): painter and illustrator

LEGRAND, LOUIS (1863–1951): artist known for rendering Parisian social life, including bar scenes with dancers and sex workers

LEHMANN, LÉON (1873–1953): painter

LEJEUNE, HENRI-PIERRE (1881–1961): landscape painter

LEMPEREUR, EDMOND (1876–1909): painter, draftsman, engraver, and shadow puppeteer

LEPOUTRE, CONSTANT (?–1929): frame maker, art dealer, and the subject of a Modigliani portrait

LEPRIN, MARCEL (1891–1933): painter

LERIS, CLAIR (1723–1803): classical stage actress known as La Clairon

LESIEUTRE, MAURICE (1879–1975): poet and songwriter

LEVEL, ANDRÉ (1863–1947): businessman and early collector of modern art; helped launch the careers of many emerging painters with his Peau de l'ours group purchases

LÉVY, LÉOPOLD (1882–1966): painter and engraver; illustrated the 1934 edition of *De rerum natura*

GLOSSARY OF NAMES 189

LÉVY, SIMON (1886–1973): painter, influenced by Cézanne

LEWITSKA, SONIA (1880–1937): Russo-Polish painter and printmaker; wife of Jean Marchand

LHOTE, ANDRÉ (1885–1962): Cubist painter, teacher, and writer on art

LIBAUDE, LOUIS (1869–1922): painter, writer, and art dealer

LOBEL-RICHE, ALMÉRY (1877–1950): painter, engraver, and illustrator known for his erotic nudes

LOMBARD, ALFRED (1884–1973): painter

LOMBARD, JEAN (1895–1983): painter

LOTIRON, ROBERT (1886–1966): painter and engraver

LUCE, MAXIMILIEN (1858–1941): Neo-impressionist and Pointillist painter, engraver, poster artist, and illustrator; also, a militant libertarian

LUGNÉ-POE, born Aurélien-Marie Lugné (1869–1940): actor, theater director, and scenic designer

LURÇAT, JEAN (1892–1966): painter, ceramicist, and tapestry artist

MAC ORLAN, PIERRE, born Pierre Dumarchey (1882–1970): novelist and songwriter

MAILLOL, ARISTIDE (1861–1944): sculptor, painter, and printmaker

MAINSSIEUX, LUCIEN (1885–1958): painter

MAKOWSKI, TADEUSZ (1882–1932): Polish-born painter, musician, art critic, and collector

MALPEL, CHARLES (1874–1926): lawyer, vintner, art collector, and patron of the Parisian avant-garde; organized the first retrospective of Toulouse-Lautrec in 1907

MAÑACH, PEDRO "PÈRE" (1870–1940): Catalan industrial locksmith, art collector, and agent who moved to Paris as a young man to promote Spanish and Catalan painters and was Picasso's first dealer and patron

MANGUIN, HENRI (1874–1949): Fauvist painter and student of Gustave Moreau along with Matisse and Camoin

MANOLO, born Manuel Hugué (1872–1945): Catalan sculptor, painter, and engraver; friends with Picasso and Carles Casagemas and was at the dinner when the latter shot himself

MANZI, MICHEL (1849–1915): font designer and publisher who created the Galerie Manzi-Joyant

MARCHAND, JEAN (1883–1940): Cubist painter, printmaker, and illustrator; husband of Sonia Lewitska

MARCOUSSIS, LOUIS (1878–1941): Polish-born painter and engraver

190 GLOSSARY OF NAMES

MARQUE, ALBERT (1872–1939): sculptor and doll maker, often confused with Albert Marquet, who was born three years later

MARQUET, ALBERT (1875–1947): painter associated with the Fauves

MARTIN, JACQUES (1844–1919): painter

MARTINIE, BERTHE (1883–1958): sculptor

MARVAL, JACQUELINE, pseudonym of Marie Josephine Vallet (1866–1932): painter, lithographer, and sculptor with a modern, edgy style

MARX, ROGER (1859–1913): art critic and man of letters

MATHAN, RAOUL DE (1874–1938): painter and World War I camouflage artist

MATISSE, HENRI (1869–1954): famous painter, draftsman, printmaker, and sculptor best known for his use of color and his fluid and original draftsmanship who, with Picasso, helped define the revolutionary developments in the visual arts in the early twentieth century

MAYER, SALVATOR (1847–1896): painting, prints, and antique dealer on rue Laffitte in Paris, the shop where Weill apprenticed and worked

MEISSONIER, ERNEST (1815–1891): genre and military history painter

MENDÈS-FRANCE, RENÉ (1888–1985): painter

MÉPHISTO: the role played by Antonin Alexander, the master of ceremonies at the famous Cabaret de l'Enfer, who was very popular with the Surrealist artists

MÉRY, ALFRED-EMILE (1824–1896): painter known for his images of animals, including birds, insects, and monkeys

METZINGER, JEAN (1883–1956): painter, theorist, writer, critic, and poet, who along with Albert Gleizes wrote the first theoretical work on Cubism

MILCENDEAU, CHARLES (1872–1919): painter

MINARTZ, TONY (1870–1944): painter, draftsman, illustrator, and engraver of Paris by night

MIRANDE, HENRY (1877–1955): painter and illustrator for *Le Rire*, *L'Assiette au beurre*, and *La Grisette*

MITA, GEORGES (1871–1904): painter

MODIGLIANI, AMEDEO (1884–1920): famed Italian Jewish painter and sculptor

GLOSSARY OF NAMES 191

MOLINE, LÉONCE: dealer cited with Druet and Vollard in Paul
Reboux's preface

MONET, CLAUDE (1840–1926): major plein air painter, founder of
French Impressionism

MONTICELLI, ADOLPHE (1824–1886): painter

MONZIE, ANATOLE DE (1876–1947): administrator, encyclopedist,
political figure, and scholar

MOREAU, GUSTAVE (1826–1898): Symbolist painter, engraver, drafts-
man, and sculptor

MOREAU, LOUIS-AUGUSTE (1855–1919): Art Nouveau and Art Deco
sculptor

MOREAU, LUC-ALBERT (1882–1948): painter, engraver, lithographer,
and illustrator

MOREAU-NÉLATON, ÉTIENNE (1859–1927): painter from a wealthy
family who is better known as a prominent collector and patron

MORICE, CHARLES (1860–1919): writer, poet, and essayist

MORTIER, ROBERT (1878–1940): artist exhibited at Weill's gallery in
the 1920s

MOUILLOT, MARCEL (1889–1972): sea captain and painter

MUCHA, ALPHONSE (1860–1939): Czech painter, illustrator, and
graphic artist known for his theater posters

MÜLLER: artist who exhibited at Weill's gallery in 1903

NONELL, ISIDRE (1872–1911): Spanish painter of socially marginal-
ized individuals in late nineteenth-century Barcelona

NUITTER, CHARLES (1828–1899): translator, playwright, and librar-
ian who wrote or cowrote some five hundred librettos, mainly
vaudevilles, opéras comiques, opéras bouffes, operettas, and bal-
lets

ORTIZ DE ZÁRATE, MANUEL (1887–1946): Chilean painter who knew
Modigliani and Apollinaire

OTTMANN, HENRY (1877–1927): painter and printmaker

OZENFANT, AMÉDÉE (1886–1966): painter

PACQUEMENT, CHARLES (1871–1950): art collector

PARENT, ARMAND (1863–1934): Belgian violinist and composer

PARTURIER, MARCEL (1901–1976): painter

PASCIN, JULES, born Julius Pincas (1885–1930): Bulgarian artist
known for his drawings and paintings, especially of women; hus-
band of Hermine David

192 GLOSSARY OF NAMES

PATORNI-CASADESUS, RÉGINA (1886–1961): harpsichordist, member of the Casadesus musical dynasty

PAUWELS, LUCIE VALORE (1878–1965): painter and engraver; wife of Robert Pauwels and Maurice Utrillo, after Robert's death

PAUWELS, ROBERT (?–1933): collector from a wealthy Belgian banking family; husband of Lucie Valore Pauwels

PAVIOT, LOUIS-CLAUDE (1872–1943): painter of landscapes, cityscapes, nudes, and floral still lifes

PESSON, ANDRÉ: cited by Weill as associating with Coquiot and working with a group of artists to open a gallery that, eventually, he asked Weill to take over

PETITJEAN, HIPPOLYTE (1854–1929): Postimpressionist Pointillist painter

PICABIA, FRANCIS (1879–1953): painter, draftsman, and writer, close to the Dada and Surrealist movements

PICASSO, PABLO (1881–1973): Spanish painter, printmaker, ceramicist, and theater designer; one of the twentieth century's most influential artists

PICHOT, RAMON (1871–1925): Catalan Spanish Impressionist; a friend of Picasso's and mentor to young Salvador Dalí

PICON: cited by Weill as a retired bailiff and collector who also sold artworks; died by suicide in 1906

PIET, FERNAND (1869–1942): painter and engraver of scenes in Brittany, Holland, and the South of France, as well as many nudes

PILLE, HENRI (1844–1897): painter and illustrator best known for his humorous pen drawings of historical and genre scenes

PIOT, RENÉ (1866–1934): painter and theater decorator

PISSARRO, CAMILLE (1830–1903): Danish-French Impressionist and Neo-impressionist painter

PLUMET, JEAN (1871–1939): painter and draftsman

POIRET, PAUL (1879–1944): fashion designer and master couturier

PONIATOWSKI FAMILY: prominent Polish family with some members who lived in Paris; Weill cites one as a regular client of Salvator Mayer's shop in *Dolikhos*

PORTAL, HENRY (1890–1982): painter

PRAX, VALENTINE (1897–1981): painter; wife of Ossip Zadkine

PRINCET, MAURICE (1875–1973): mathematician and actuary who introduced the Cubists to the concept of the "fourth dimension"

GLOSSARY OF NAMES 193

PUY, JEAN (1876–1960): Fauvist painter

QUELVÉE, FRANÇOIS (1884–1967): painter, engraver, and illustrator

RAMEY, HENRY (1890–1978): painter

RANFT, RICHARD (1862–1931): Swiss Postimpressionist portrait and landscape painter, engraver, illustrator, and poster artist

RANSON, PAUL-ÉLIE (1861–1909): painter, engraver, and promoter of Art Nouveau

REDON, ODILON (1840–1916): Symbolist painter, printmaker, draftsman, and pastelist

REINACH, THÉODORE (1860–1928): archaeologist, mathematician, lawyer, papyrologist, philologist, historian, numismatist, musicologist, and politician

RÉJANE, GABRIELLE (1856–1920): popular actress

RENO, IRÈNE, born Rena Hassenberg (1884–1953): Polish-born painter and lithographer

RENOIR, EDMOND (1849–1944): journalist and art critic; Pierre-Auguste Renoir's youngest brother

RENOIR, PIERRE-AUGUSTE (1841–1919): famed Impressionist painter

RETH, ALFRED (1884–1966): Hungarian-born painter

REVERDY, PIERRE (1889–1960): poet associated with Cubism and Surrealism

REY, ROBERT, born Robert Herfray-Rey (1888–1964): art critic, art historian, writer, museum curator, and *résistant*

RIBEMONT-DESSAIGNES, GEORGES (1884–1974): poet, dramatist, and painter who was a precursor of Dada with Duchamp and Picabia

RIOU, LOUIS (1893–1958): painter

RIVERA, DIEGO (1886–1957): famed Mexican painter and muralist

ROBBE, MANUEL (1872–1936): painter and aquatint engraver

ROBERT, THÉOPHILE (1879–1954): Swiss painter, draftsman, engraver, and stained-glass artist

ROCHEFORT, VICTOR (1831–1913): politician and writer of vaudevilles

RODIN, AUGUSTE (1840–1917): sculptor, generally considered the founder of modern sculpture

RODRIGUE (Ramiro): cited by Weill as a regular client of Salvator Mayer's shop in *Dolikhos*

194 GLOSSARY OF NAMES

ROEDERSTEIN, OTTILIE (1859–1937): Swiss portrait painter, especially of women

ROPS, FÉLICIEN (1833–1898): Belgian artist noted for erotic and Satanic drawings; a pioneer of Belgian comics

ROQUES, HIPPOLYTE-JULES (1850–1909): publisher who founded *Le Courrier français*

ROSENBERG, LÉONCE (1879–1947): collector, publisher, and major dealer of modern art

ROSOY, JEANNE, pseudonym of Charlotte Alix (1897–1987): painter and decorator who exhibited with Weill and contributed to *Le Crapouillot*

ROUART, STANISLAS-HENRI (1833–1912): businessman, collector, and painter; his son Ernest married Julie Manet

ROUAULT, GEORGES (1871–1958): painter, draftsman, and print artist often associated with Fauvism and Expressionism

ROUBILLE, AUGUSTE (1872–1955): painter, draftsman, poster designer, and caricaturist

ROUCHÉ, JACQUES (1862–1957): art and music patron who owned the journal *La Grande revue* and managed the Théâtre des Arts and the Opéra

ROUSSEAU, HENRI, called Le Douanier (1844–1910): Postimpressionist painter in the naive or primitive manner

ROUSTAN, ÉMILE (1877–1959): painter

ROUVEYRE, ANDRÉ (1879–1962): writer, journalist, caricaturist, and lifelong friend of Matisse; the two men exchanged 1,182 letters

ROYBET, FERDINAND (1840–1920): painter and engraver

RUSSELL, MORGAN (1886–1953): American painter and founder of Synchronism

SABBAGH-SABERT, GEORGES (1887–1951): Egyptian-born painter

SAGOT, CLOVIS (1854–1913): one of Picasso's first dealers

SAINSÈRE, OLIVIER (1852–1923): prominent politician and art patron who supported many emerging painters, including Picasso and the Fauves

SALMON, ANDRÉ (1881–1969): poet, novelist, journalist, and art critic

SAMUEL, FERDINAND, born Adolphe-Amédée Louveau (1862–1914): theater director of the Théâtre des Variétés from 1892 to 1914, earning a reputation as "Samuel le Magnifique"

SANCHA Y LENGO, FRANCISCO (1847–1930): Spanish painter, draftsman, and caricaturist

GLOSSARY OF NAMES 195

SÁNCHEZ-SOLÁ, EDUARDO (1869–1949): Spanish painter

SARDOU, VICTORIEN (1831–1908): dramatist

SARRAUT, ALBERT (1872–1962): art collector and politician who was twice prime minister of the Third Republic

SAVIN, MAURICE (1894–1973): painter, ceramicist, and tapestry maker

SCHNERB, JACQUES (1879–1915): painter, engraver, and art critic

SECTION D'OR: a collective of painters, sculptors, poets, and critics associated with Cubism and Orphism

SEGONZAC, ANDRÉ DUNOYER DE (1884–1974): painter and graphic artist

SEM, born Georges Goursat (1863–1934): well-known Belle Époque caricaturist

SEMBAT, MARCEL (1862–1922): socialist politician

SEURAT, GEORGES (1859–1891): Postimpressionist painter and draftsman who invented Pointillism; famous for *A Sunday Afternoon on the Island of La Grande Jatte* (1884–1886)

SEVERINI, GINO (1883–1966): painter and leading member of the Futurist movement

SICARDI, LOUIS MARIE (1743–1825): a painter favored by Louis XVI for miniature presentation portraits

SIMÉON, FERNAND (1884–1928): painter, engraver, and illustrator

SIMON, HENRI (1874–1926): businessman and Radical-Socialist politician

SIMON, HUGHES: art collector described by Weill as a swindler

SISLEY, ALFRED (1839–1899): Impressionist painter committed to plein air landscape painting

SMITH, FRANCIS (1881–1961): Portuguese painter of British descent

SOMM, HENRY, born François Sommier (1844–1907): painter, engraver, and caricaturist

SOUTINE, CHAÏM (1893–1943): Russian Expressionist painter

STEIN, GERTRUDE (1874–1946): American novelist, poet, playwright, and art collector

STEIN, LEO (1872–1947): American art collector and critic; older brother of Gertrude Stein

STEINLEN, THÉOPHILE (1859–1923): Swiss-born Art Nouveau painter and printmaker known for depicting Montmartre and cats

SUNYER, JOAQUIM (1874–1956): Neo-impressionist Catalan painter

SURVAGE, LÉOPOLD (1879–1968): Moscow-born painter

TABARANT, ADOLPHE (1863–1950): journalist and art historian

196 GLOSSARY OF NAMES

TAILHADE, LAURENT (1854–1919): satirical poet, anarchist polemicist, essayist, translator, and opium devotee

TANGUY, JULIEN-FRANÇOIS "PÈRE" (1825–1894): owner of a paint supply shop and an early collector of works by Picasso, Van Gogh, and Cézanne

TARKHOFF, NICOLAS (1871–1930): Russian painter

TEN CATE, SIEBE (1858–1908): Dutch-Frisian Impressionist painter who spent most of his working life in France

THÉVENET, JACQUES (1891–1989): painter, engraver, and illustrator

THIÉBAULT-SISSON, FRANÇOIS (1856–1944): art critic at *Le Temps*

THIESSON, GASTON (1882–1920): painter influenced by Sisley, Pissarro, and Cézanne

TOBEEN, pseudonym of Félix Bonnet (1880–1938): painter and woodcarver

TORENI, EVELIO (1876–1940): Catalan modernist painter and draftsman

TOULOUSE-LAUTREC, HENRI DE (1864–1901): famed painter, printmaker, draftsman, caricaturist, and illustrator of Paris's colorful night life in the late nineteenth century

TZANCK, DANIEL (1874–1964): dentist to and major collector of modern artists, including Braque, Léger, Vlaminck, and Duchamp (who once paid a dental bill with a meticulously forged Dada check for $115)

UHDE, WILHELM (1874–1947): German art collector, dealer, and critic who wrote about Henri Rousseau

UTRILLO, MAURICE (1883–1955): painter who specialized in cityscapes, especially of Montmartre, where he was born; son of Suzanne Valadon and later husband of Lucie Valore Pauwels

UTTER, ANDRÉ (1886–1948): painter; Suzanne Valadon's husband and manager

VALADON, SUZANNE (1865–1938): painter and artists' model who in 1894 became the first woman painter admitted to the Société nationale des Beaux-Arts; mother of Maurice Utrillo, wife of André Utter, and the lover of, inter alia, Toulouse-Lautrec, Satie, Renoir, and Degas

VALLOTTON, FÉLIX (1865–1925): Swiss-French painter, printmaker, and an important figure in the development of the modern woodcut

GLOSSARY OF NAMES 197

VAN COPPENOLLE, JACQUES (1878–1915): painter

VANDERPYL, FRITZ-RENÉ (1876–1965): Dutch-born journalist, poet, art and food critic, and anti-Semite

VAN DONGEN, KEES (1877–1968): Dutch-French painter and a leading Fauve

VAN GOGH, VINCENT (1853–1890): Dutch Postimpressionist painter who is among the most influential figures in the history of Western art

VAN REES, OTTO (1884–1957): Dutch painter and muralist

VAUXCELLES, LOUIS (1870–1943): influential conservative art critic, credited with coining the terms Fauvism (1905) and Cubism (1908)

VÉBER, JEAN (1864–1928): painter and caricaturist

VERGÉ-SARRAT, HENRI (1880–1966): Belgian-born painter and engraver; husband of Rolande Vergé-Sarrat

VERGÉ-SARRAT, ROLANDE (1898–1977): landscape painter; wife of Henri Vergé-Sarrat

VERHOEVEN, JAN (1870–1941): Dutch painter

VIAU, GEORGE (1855–1939): dentist and prominent art collector of Impressionist works; Claude Monet was one of his patients

VIBERT, JEHAN (1840–1902): academic painter

VILDRAC, CHARLES, born Charles Messager (1882–1971): playwright, poet, and author of perhaps the first modern children's novel, *L'Île rose* (1924)

VILLETTE, CHARLES: painter and assistant to Weill and Clovis Sagot

VILLON, JACQUES, born Gaston Duchamp (1875–1963): Cubist and abstract painter and printmaker; older brother of Marcel Duchamp

VLAMINCK, MAURICE DE (1876–1958): painter, ceramicist, engraver, and writer; a major figure in the Fauve and Cubist movements

VOGLER, PAUL (1853–1904): self-taught Impressionist landscape painter

VOLLARD, AMBROISE (1866–1939): major early twentieth-century art dealer referred to by Weill with the pseudonym "Dolikhos" in her satirical broadside

WALDECK-ROUSSEAU, RENÉ (1846–1904): twenty-ninth prime minister of France

WARNOD, ANDRÉ (1885–1960): writer, art critic, and draftsman

198 GLOSSARY OF NAMES

WAROQUIER, HENRY DE (1881–1970): painter, sculptor, draftsman, and engraver

WARRICK FULLER, META VAUX (1877–1968): Black American poet, painter, and sculptor at the fore of the Harlem Renaissance who studied with Auguste Rodin

WEILUC, LUCIEN-HENRI (1873–1947): illustrator, poster artist, and satirical draftsman

WÉLY, JACQUES (1873–1910): painter, draftsman, caricaturist, and illustrator

WIDHOPFF, DAVID (1867–1933): Odessa-born painter, caricaturist, and poster artist

WILLETTE, LÉON (1857–1926): caricaturist and lithographer; designed the Moulin Rouge cabaret

ZADKINE, OSSIP (1888–1967): Belarusian-born sculptor, painter, and lithographer; husband of Valentine Prax

ZAMARON, LÉON (1872–1955): police official, art collector, and patron

ZAMOYSKI, AUGUSTE (1893–1970): Polish-born sculptor

ZÁRRAGA, ÁNGEL (1886–1946): Mexican painter who moved to France in 1911

ZBOROWSKI, LÉOPOLD (1889–1932): Polish poet, writer, and art dealer; Modigliani's primary dealer and friend during his final years

ZOLA, ÉMILE (1840–1902): novelist, journalist, and playwright known as the primary practitioner of Naturalism; a great advocate of Dreyfus, Zola devoted his later years to supporting him through writing and action

Notes

William Rodarmor and Marianne Le Morvan, along with Julie Saul and Lynn Gumpert, all contributed to the notes and annotations to the text of *Pow! Right in the Eye!*, with Rodarmor writing the lion's share.

FOREWORD

1 Michael C. FitzGerald, *Making Modernism: Picasso and the Creation of the Market for Twentieth-Century Art* (Berkeley: University of California Press, 1995), 23–24. See also Marianne Le Morvan, *Berthe Weill 1865–1951: La Petite galeriste des grands artistes* (Paris: L'Écarlate, 2011).

INTRODUCTION

1 The full French title is *Pan !... dans l'œil !... ou trente ans dans les coulisses de la peinture contemporaine 1900–1930*. The initial printing was modest: five copies on Japan paper numbered I to V, twenty-five copies on Dutch Van Gelder paper numbered VI to XXX, and five hundred copies on Marais vellum numbered from 1 to 500. In 2009, it was published in an incomplete, now out-of-print version by L'Échelle de Jacob, Paris, with an introduction by François Roussier. Also, it should be noted that the Weill family pronounced their name as "vay," as opposed to "vile," which reflects the name's German origins and wouldn't have been popular in France following the Franco-Prussian War. Both pronunciations are still used.

2 *Les Jeunes* literally translates as "the young," i.e., the younger generation. With her use of a capital *J*, Weill identifies them as an ever-evolving group of emerging artists.

3 *The Shock of the New* was a popular documentary television series written and presented by the art critic Robert Hughes for the BBC in association with Time Life Films. It covered modern art start-

NOTES TO PAGES XXIII–XXVII

ing with the Impressionists and also appeared as a book.

4 See Rebecca A. Rabinow, Douglas W. Druick, Ann Dumas, Gloria Groom, Anne Roquebert, and Gary Tinterow, eds., *Cézanne to Picasso: Ambroise Vollard, Patron of the Avant-Garde* (New York: Metropolitan Museum of Art; New Haven, CT: Yale University Press, 2007).

5 Vollard published his profile of Isaac de Camondo—a scion of the Sephardic-Jewish banking family that had moved from Istanbul to France—as "Portrait of an Amateur" on December 16, 1916, in *Mercure de France* after Camondo's collection of Impressionist paintings had been donated to the Louvre in 1908. Ambroise Vollard, "Figures d'amateurs," *Mercure de France*, no. 444 (December 16, 1916): 592–99. Weill, as she recounts in her avant-propos translated here, had approached *Mercure de France* to write a rebuttal to Vollard's critical portrayal of Camondo but wasn't permitted due to potential libel charges, so she self-published the thinly disguised tract as *Les Débuts de Dolikhos ou la traite des arts par un papou* in 1916.

6 In this volume, *Dolikhos* appears in the back, following Weill's memoir rather than at the beginning. Ambroise Vollard (1866–1939) wrote his own lively but uneven autobiography, which was first published in English two years after Weill published hers, as *Recollections of a Picture Dealer*, trans. Violet Macdonald (1936; repr., Boston: Little, Brown, 1978), then in France as *Souvenirs d'un marchand de tableaux* (1937; repr., Paris: Albin Michel, 2007).

7 *Les Nouvelles littéraires, artistiques et scientifiques*, October 29, 1931, p. 2. Unless otherwise noted, all translations from French in the explanatory matter are our own.

8 Gustave and Léon Bollag founded the Salon Bollag, one of the first art galleries in Switzerland, in 1912. It was also probably the first in Switzerland to hold auctions. Lucy, their sister, became friendly with Weill and introduced the family to a number of artists she promoted, including Picasso. Successive family members continued this tradition, and it operated for many years as Bollag Galleries.

9 Invitation to the "11 Sculpteurs," May 18 to June 3, 1939, at Galerie B. Weill, 27 rue Saint Dominique, Paris, 7th arrondissement.

10 J. T. Martin, "Peints par eux-mêmes" (In their own words), *Le Cahier jaune*, no. 12 (January 1943): 6–7. Among Weill's family, her brother Nephtali's daughter and his wife, also named Berthe, were deported to Drancy but, luckily, released thanks to the efforts of his son-in-law, who was a Breton political activist.

11 André Warnod, *Les Berceaux de la jeune peinture* (The cradles of young painters) (Paris: Albin Michel, 1923), 271–72.

CHAPTER 1

1 Salvator Mayer operated an antique shop where he also sold prints and paintings. Weill began her apprenticeship there probably in her early teens, since public education for girls ended at the age of ten. What is known is that Mayer's customers included many artists and intellectuals of the day. Ambroise Vollard offers the following description: "One of the most picturesque figures in the second-hand trade was Salvator Mayer. . . . Small and plump, with a Greek fez on his head and fireside slippers on his feet, Salvator trotted to and fro among his clients in his shop, talking all the time. While paying careful attention to the 'serious' clients, he did not despise the customer who had only ten francs to spend. He was very accommodating, too. 'Goods are meant to circulate,' was one of his favorite sayings." Ambroise Vollard, *Recollections of a Picture Dealer*, trans. Violet Macdonald (Boston: Little, Brown, 1936), 74–75.

2 A sou is one-twentieth of a franc, or 5 centimes. In the late 1890s, the franc was worth about $1.80, so one hundred sous would be about nine dollars.

3 The judge's name was Boucard. For a photo of him, view https://www.europeana.eu/en/item/9200518/ark__12148_btv1b90315072.

4 It is important to note that gallerists, at this point, were called *marchands de tableaux* in French.

CHAPTER 2

1 The Dreyfus affair was a major political scandal in France during the 1890s and early 1900s. It involved the wrongful conviction for treason of Captain Alfred Dreyfus (1859–1935), a Jewish artillery officer. Dreyfus was sentenced to life in prison on Devil's Island. He was later pardoned, retried, and resentenced, but finally exon-

202 NOTES TO PAGES 8–17

erated. He resumed his military career, retiring as a lieutenant colonel.

2 Edgar Degas's studio was located at 37 rue Victor Massé, down the street from Weill's gallery toward rue des Martyrs in the 9th arrondissement.

CHAPTER 3

1 Weill's mother loved the theater and spent her afternoons at the Comédie-Française, thus generally neglecting her children's education.

CHAPTER 4

1 Saint-Germain-en-Laye is a small town fifteen miles due west of Paris.

2 Born Meta Vaux Warrick, this precocious Black artist grew up in a prosperous Philadelphian family. After one of her high school art projects was included in the 1893 World's Columbian Exposition in Chicago, Warrick received a scholarship to the Pennsylvania Museum and School of Industrial Art (now the University of the Arts). After graduation, she received a teacher's certificate and moved to Paris, where she was taken under the wing of the Black painter Henry Ossawa Tanner and met W. E. B. Du Bois. She furthered her studies at the Académie Colarossi and the École des Beaux-Arts and took inspiration from the work of Auguste Rodin. In 1902, she became the *maître*'s protégée. After moving back to Philadelphia, she married Dr. Solomon Fuller, a prominent physician. Tragically, most of her early work was destroyed in a studio fire in 1910. She would go on to play a prominent role in the Harlem Renaissance not only as an artist but as a poet and theater designer. A 1988 exhibition at the Crocker Art Museum triggered renewed interest in the imaginative artist and polymath and resulted in a retrospective at the Danforth Art Museum in Framingham, MA, in 2014.

3 Research by Franck Joubain, as yet unpublished, conducted under the supervision of Marianne Le Morvan, has established that Maillol's participation in the exhibitions organized by Pedro Mañach at the Galerie B. Weill took place some months before the solo show that Ambroise Vollard gave the painter and sculptor in June or July 1902.

NOTES TO PAGES 20–29 203

4 The art critic Louis Vauxcelles is usually credited as the origina-
tor of the term "Fauves," which he used in describing the boldly
colored canvases of Henri Matisse, André Derain, Albert Marquet,
Maurice de Vlaminck, Kees van Dongen, Charles Camoin, and
Jean Puy at the 1905 Salon d'Automne.

5 Paul Ranson (1861–1909), who had himself studied at the
Académie Julian, founded his own school in 1908. When Ranson
died a year later, his wife Marie-France Ranson took over. The
school eventually moved to Montparnasse, where it counted Mau-
rice Denis and Paul Sérusier among its instructors.

CHAPTER 5

1 Clovis Sagot (1854–1913), reputed to have been a clown in the
Cirque Medrano, is also known as one of the earliest promoters of
Cubism. Following in the footsteps of Salvator Mayer, he opened
an antique shop on rue Laffitte, after having first worked with his
brother Edmond Sagot, a renowned print dealer. Leo Stein bought
his first work by Picasso from Sagot.

CHAPTER 6

1 In those days, "starving artist" wasn't just a metaphor. Here is
Pierre Mac Orlan talking to the writer and photographer Brassaï
in 1945:

> Montmartre, the Butte, the Bateau-Lavoir, Le Lapin Agile,
> what does all that mean to me? Memories of the "bohemian
> life"? That's all bullshit! It reminds me of the hotel owners who
> took my room key because I was late with the rent. A horrible
> time, to tell you the truth, of hardship, poverty, humiliation.
> There is nothing so terrible as such a youth. In Montmartre—
> fortunately I lived there only a year—I didn't have enough cash
> to pay for a hotel room, a suit, a real meal. I was literally starv-
> ing to death. If I went to see my friends, it was to hit them up.
> But most of the time, they were as broke as I was.

Brassaï, *Conversations with Picasso*, trans. Jane Marie Todd (Chi-
cago: University of Chicago Press, 1999), 227–28.

2 The Salon d'Automne is an annual art exhibition held in Paris.
It was launched in 1903 at the initiative of Belgian architect and

art collector Frantz Jourdain and quickly became a showpiece for innovations in twentieth-century painting, drawing, sculpture, prints, architecture, and decorative arts.

3 Damia, born Marie-Louise Damien (1889–1978), was a popular French singer and actress, known for her sad songs and tragic roles.

CHAPTER 7

1 Galerie Danthon, 29 rue la Boétie, specialized in sculpture, with major shows of Rodin and Antoine Bourdelle in the 1920s.

2 The value of French money in 1903: "In those days a workingman's daily wage was 4.15 francs, a good cook earned 65 francs a month, and a judge of the Court of Appeal, 1,000. A copious dinner with wine in a moderately good restaurant cost 2.50; a common eating-house would feed one for 1 franc, with bread and wine thrown in; and one could go from one end of Paris to the other on the bus for 15 centimes." From Patrick O'Brian, *Pablo Ruiz Picasso: A Biography* (New York: G. P. Putnam's Sons, 1976), 89.

3 Jeanne Granier (1853–1939) and Lucien Guitry (1860–1925) played the leads in *Les Amants* (1895), a play by Maurice Donnay (1859–1945).

4 Josse (1870–1941) and Gaston (1870–1953) Bernheim-Jeune worked with their father Alexandre, who opened Bernheim-Jeune et Cie. in 1863 on rue Laffitte, not far from Salvator Mayer's shop. It is best known for first promoting Barbizon school artists and, starting in 1874, the Impressionists. The Bernheim-Jeunes also organized Vincent van Gogh's first important painting exhibition. The art critic Félix Fénéon served as director from 1906 to 1925, bringing many younger artists into their stable. Interestingly, in 1922, he organized an exhibition that included many of the artists that Berthe Weill had supported or shown such as Alice Halicka, Auguste Herbin, Marie Laurencin, and Henri Lebasque.

5 Eugène Druet (1867–1916) became a gallerist almost by accident. He had a café that Rodin patronized, and the sculptor encouraged him take up photography. Druet became Rodin's semiofficial photographer and went on to open a gallery where he sold both paintings and photographs.

NOTES TO PAGES 41–58 205

CHAPTER 8

1 Here and elsewhere, Weill notes that she often scouted for les Jeunes at the various juried salons. A lifelong friend of Weill, Émilie Charmy remains under known. In the June 1, 1951, issue of *Aux Ecoutes*, a weekly journal founded by Paul Lévy in 1918, an uncredited article notes: "It's hard to understand why Charmy, who is so respected in artistic circles, isn't better known. Her portrait of Aristide Briand is a masterpiece. And she painted plenty of others, notably one of the amazing Berthe Weill, who kept discovering so many great painters of our day. The one we called the little 'mère Weill' always had a Charmy hanging in her shop on rue Laffitte. She would say: 'It's barely dry, but it will age well.'"

2 Marlotte is a small town ten miles south of Fontainebleau, visited in the late nineteenth century by Sisley, Renoir, and Cézanne.

3 Weill may mean that she felt she was in the service of a movement greater than herself, in this case, Jeune painters and their revolutionary art.

CHAPTER 9

1 Weill's remark is a mystery. By "Chinese," she could be referring to the color in Chinese export porcelain that was popular at the time.

CHAPTER 10

1 The unnamed artist was probably Henri Guinier (1867–1927), a portrait and landscape painter who won the second prize at the Prix de Rome in 1896. He lived at 6 avenue Frochot, across the street from Weill's gallery.

2 The Cercle Volney was an artistic and literary group that met at 7 rue Volney, near the Opéra.

3 Carpentras is a small town in the Vaucluse, thirty miles east of Avignon.

4 Gertrude and the Stein brothers were not clients of Weill, buying their Picassos and Matisses from other dealers. Interestingly, Gertrude published *The Autobiography of Alice B. Toklas* in 1933, the same year Weill's *Pan!* appeared. In it, Stein describes the Parisian art scene of the early 1900s: "Vollard was a huge dark man who lisped a little. His shop was on the Rue Laffitte not far from the Boulevard. Further along this short street was Durand-

Ruel and still further on . . . was Sagot the ex-clown. Higher up in Montmartre on the rue Victor-Massé was Mademoiselle Weill who sold a mixture of pictures, books and bric-a-brac and in entirely another part of Paris on the rue Faubourg-Saint-Honoré was the ex-café keeper and photographer Druet." Gertrude Stein, *The Autobiography of Alice B. Toklas* (New York: Vintage Book Editions, 1990), 29.

5 Hôtel Drouot is a large auction house in Paris known for fine art, antiques, and antiquities. It consists of sixteen halls hosting seventy independent auction firms, which operate under the Drouot umbrella.

6 Druet was Rodin's photographer of choice until they fell out around Rodin's 1900 retrospective at the Exposition Universelle, where Druet exhibited seventy-one images of the sculptor's work.

7 Beaufort-sur-Gervanne is a small town in Drôme in southeastern France.

8 Weill sent the paintings to the firm of J. & S. Goldschmidt, which was opened by two brothers, Jacob and Selig, in 1863 and which sold art and antiques.

CHAPTER 12

1 Weill made no secret of the fact that she was Jewish, but she wasn't observant. Carter Harrison, a former mayor of Chicago and a collector of works from the gallery, noted:

It was the Jew in him [Modigliani], quite as much as his undoubted artistry, that had excited Berthe Weill's admiration and affection. Unlike her fellow Jewess, Gertrude Stein, who as far as I have managed to read her effusions never once made reference to her race, Berthe far from being ashamed of it glories in her Hebrew blood. Once I had commented on the number of younger Jews who have reached eminence in modern art, Pascin, Modigliani, Soutine, Zadkine, Chagall, Kisling—her sole answer was: "*Pourquoi pas? Ils sont d'élite.*" (Why not? They are elite.) A pretty play on the word, a suggestion both of the elite in art and the biblical "elect" or God's chosen people!

Carter Harrison, Review of "Pan! Dans l'Oeil!, an Autobiography

by Berthe Weill" (manuscript), n.d., box 14, folder 699, pp. 14–15, Carter H. Harrison IV Papers, The Newberry, Chicago.

2 In the eighteenth and nineteenth centuries, buildings were taxed according to the number of their windows. In France, the window tax was repealed in 1926.

3 Victor Charreton (1864–1936) was named a chevalier of the Legion of Honor in 1914.

4 During the late nineteenth century and into the early years of the twentieth century, rue Laffitte and lower Montmartre served as the hub for *les marchands de tableaux*, with Durand-Ruel as the anchor. Eventually, however, galleries began moving to the 8th arrondissement and, in particular, to the rue la Boétie, which stretches from the avenue des Champs-Élysées to the place Saint-Augustin. Later in the twentieth century, a parallel neighborhood for galleries developed in the 6th arrondissement, with rue de Seine as a main artery.

CHAPTER 13

1 La Closerie des Lilas is a classic Montparnasse brasserie, frequented in their day by such artists and writers as Verlaine, Picasso, and Hemingway.

2 Cagnes is a town on the French Riviera where Renoir lived from 1907 until his death in 1919.

3 Le Crotoy is a seaside town north of Paris, famous in early twentieth-century aviation as the site of the Caudron brothers' flying school.

4 Roland Garros (1888–1918) was a pioneering aviator and a fighter pilot in World War I. The tennis center near Paris is named for him.

5 No information about this mysterious dealer could be located.

6 Located at 109 rue Faubourg Sant-Honoré, Galerie Barbazanges operated as a contemporary exhibition space from 1911 to 1928. The building was owned by the Parisian fashion designer Paul Poiret, whose atelier abutted the gallery. André Salmon and Poiret collaborated on the programming, showing works by Chagall, Dufy, Gauguin, Matisse, Picasso, and Modigliani, among others.

7 In 1908, Wilhelm Uhde married painter Sonia Terk (1885–1979) in a marriage of convenience that masked his homosexuality.

NOTES TO PAGES 78–83

She divorced him in August 1910 and wed Robert Delaunay three months later.

8 Vivid though it is, Weill's description only partly portrays the many facets of Edmond Heuzé (1884–1967), who reportedly held seventeen jobs in a thirty-year period. He tap-danced at Maxim's and traveled the world with the Moulin Rouge troupe; he was a salesman, repairman, and street vendor; he managed a traveling circus. The adopted son of a tailor, he handled uniforms for the army and worked in a menswear store. Before World War I, he was the curator of enamels for Russia's Grand Duke Nicholas Mikhailovich. From 1918 on, he worked at Clovis Sagot's shop on rue Laffitte, selling paintings by Utrillo, Valadon, and Rouault along with his own.

9 The Section d'Or, also known as the Groupe de Puteaux, was a collective of painters, sculptors, poets, and critics associated with Cubism and Orphism who were most active between 1912 and 1914. Notable among its members were Alexander Archipenko, Constantin Brancusi, Robert Delaunay, Marcel Duchamp, Juan Gris, František Kupka, Fernand Léger, Francis Picabia, and Jacques Villon.

10 Located in Montparnasse, Théâtre Bobino started off as a dance hall in 1800, became a theater in 1873, and was converted back to a music hall in 1926. It still operates today.

11 Henri Fursy (1866–1929), whose real name was Henri Dreyfus, was a French cabaret singer, director, and lyricist. Among several cafés he owned or managed was the legendary Le Chat Noir.

12 Louise Hervieu (1878–1954) was a French writer, artist, painter, and lithographer. Despite Weill's description, she was syphilitic at birth, and her health was very fragile. She exhibited her paintings only once before focusing exclusively on drawing and lithography. She wrote several acclaimed novels and actively advocated on behalf of syphilitics. Rue Louise Hervieu in the 12th arrondissement is named after her.

CHAPTER 14

1 Marius-Ary Leblond was a joint pseudonym adopted by two art critics and journalists from Réunion who were cousins (not brothers, as Weill wrote).

NOTES TO PAGES 83-84 209

2 Henri Duparc (1848–1933) was a composer of the late Romantic period diagnosed with "neurasthenia," who went blind and destroyed many of his compositions.

3 The group's name derives from the saying "Ne vends pas la peau de l'ours avant de l'avoir tué"—the equivalent of "Don't count your chickens before they hatch"—which comes from a fable by Jean de La Fontaine. The first private investment fund, La Peau de l'ours was headed by Level, who worked with eleven Parisian businessmen. Each investor contributed 250 francs annually to the fund to buy contemporary art. Over a period of years the eleven partners assembled a collection of approximately 145 works of contemporary art. Apparently, after ten years, the collection was to be sold with investors receiving 3.5 percent interest a year. Any profits beyond that would be split among the artists (20 percent) and Level (20 percent), with the rest (60 percent) going to the investors.

4 Guillaume Apollinaire, reviewing the exhibition, noted: "At Galerie B. Weill, 25 rue Victor Massé, Monsieur Diego Rivera is exhibiting studies and drawings that reveal to what extent this young painter has been touched by modern art; in fact, the sensitivity of just a few of the drawings would have justified the show. A person who signed their name 'B.' wrote a preface for the catalog that claims that the exhibitor presenting the work has in some way been harmed; we believe this is the first time such a thing has ever happened." Guillaume Apollinaire, *Chronique d'art (1902–1918)* (Paris: Gallimard, 1993), 455–56. In her preface to the show's catalog, which took place from April 21 to May 6, 1914, and which she signed only with her first initial, Weill observed:

> To collectors of les Jeunes we hereby present the Mexican Diego H. Rivera, who has tried his hand at Cubism. We don't want to risk overpraising this young artist. Let's let him evolve, and some critic or well-intentioned flack knocking at doors that are already open is sure to discover him someday. We have ample evidence of the danger of praising artists too soon. One artist who shows talent is pushed and encouraged. A bit of luck brings him some notoriety. Suddenly, he becomes bourgeois. He wants to earn lots of money, starts to fly very high. Like a certain high-

fashion patron of the arts, he sees himself as the direct descendent of the great Louis, his genius equaled only by that of the Bastille. But what about his current work? From time to time he gives birth to a mouse. Forgetting his lineage, he lingers in the antechambers, but the tapestries on the walls have found an innovator. Hooray!

Another artist may have said all he has to say, but reigns as a master while his court, gathered at his feet, squabbles over scraps. Smirking and satisfied, he contemplates the spoils. Though he is Spanish, his genius has not grown.

Still others (eunuchs, the keepers of the harem) stand guard around the safe: the Jeunes are forbidden from entering. But let's bring some youth to the leadership ranks. It smells moldy in here! Let's have some fresh air! But the guardians are tough, and the buggers resist fiercely. How many more of them still exist only in their imagination? And all this in the name of art? Poor art! *Servum pecus!* Come see the free and independent Jeunes, and you will find, among many false starts, the springtime charm of youth. In making no attempt to please, they will please you.

Berthe Weill, preface to *Exposition particulière de peintures, aquarelles et dessins par M. Diego H. Rivera*, April 21–May 6, 1914 (Paris: Galerie B. Weill, 1914).

5 On September 6–7, 1914, General Joseph Gallieni mobilized some 1,100 Parisian taxis and a few buses to transport soldiers to reinforce French troops in the First Battle of the Marne. Their meters ran during the round trip, and the treasury paid the companies at the end, like any other customer. The famous "Taxis of the Marne" had little military impact, but galvanized the French population.

6 *Poilu* ("hairy one") is an informal term for the typical French World War I infantryman with his bushy beard and mustache. It is still used as a term of endearment for those soldiers.

7 Mobilized as an artillery captain, Berthe Weill's older brother Nephtali was named to the Legion of Honor and awarded the Croix de Guerre for heroism under fire.

NOTES TO PAGES 88–103 211

CHAPTER 15

1 General Joseph Joffre (1852–1931) commanded French forces on the western front from the start of World War I to the end of 1916.

2 *Le Mot*, an art, literary, and satirical journal, was founded by Jean Cocteau and Paul Iribe in 1914, just after France declared war on Germany. Cocteau, along with Raoul Dufy, Albert Gleizes, and André Lhote, contributed text and illustrations. Although graphically stunning, it ceased publication in 1915 after twenty issues.

3 Amédée Ozenfant collaborated with Max Jacob and Guillaume Apollinaire to found the journal *L'Élan*. He edited the magazine until 1916, when his interest in Purism intensified. He would later work with Le Corbusier (Charles-Édouard Jeanneret) on the journal *L'Esprit nouveau*, which was active from 1920 to 1925.

4 Weill is making a Franco-German joke: Weill + *lèche* + *kopf* = Weill licks head, or in other words, roughly, "Weill the ass-kisser."

5 Pierre Albert-Birot (1876–1967), a French poet, painter, sculptor, typographer, and theatrical producer, founded the review *Sic* (1916–1919), which was a mouthpiece for the Futurists and Cubists. He maintained an antagonistic relationship with the Surrealists, although it was he and Apollinaire who apparently coined the term.

6 *Parade* is a one-act ballet with music by Erik Satie, scenario by Jean Cocteau, and designs by Pablo Picasso.

CHAPTER 16

1 Here and elsewhere in the original, Weill mistakenly calls Raymond Casse "Robert," which has been corrected in the translation.

2 *Nord-Sud*, edited by Pierre Reverdy, was published in Paris for a total of fourteen issues between March 1917 and October 1918. Addressing multiple aspects of the avant-garde, the magazine commissioned contributions from Guillaume Apollinaire, Louis Aragon, André Breton, Max Jacob, and Tristan Tzara, among others.

3 Weill incorrectly gives the date as October 3 in the original.

4 Hellebore is a family of plants, many of them toxic. In Greek legend, Hercules's madness was cured with hellebore.

5 On March 15, 1918, an explosion at a hand grenade factory in La

Courneuve north of Paris killed fourteen people and wounded fifteen hundred.

6 Modigliani died on January 24, 1920, twenty-five months after the exhibition closed, not "eight or ten months," as Weill writes in the original.

7 This mysterious group, it seems, was composed of writers, businessmen, and artists who wanted to be patrons, and it appears to have branched off from the French Theosophical Society. For more, see Emmanuel Dufour-Kowalski, *La Fraternité des veilleurs: Une Société secrete au XXe siècle (1917–1921)* (Editions Arché, 2017).

8 Bièvre is a town about twenty miles southwest of Paris.

CHAPTER 17

1 Félix Fénéon (1861–1944) was a French art civil servant, critic, gallery director, anarchist, and collector. After working for fourteen years at the war office, and a stint at the newspaper *Le Matin*, he directed the Bernheim-Jeune gallery from 1906 to 1925. He promoted contemporary art as well as African sculpture and collected examples of both.

2 The article mentioned is F.-M. Bergon, "Exposition: Galerie Weill, 25, rue Victor-Massé," *Soi-même* 1, no. 2 (March 1917): 6–7.

3 "Big Bertha" was the nickname given to a type of long-range German siege gun used to bombard Paris during World War I. By barrel length and diameter, it was one of the largest artillery pieces ever fielded.

4 La Baule is a seaside resort town in Brittany, 280 miles west of Paris.

5 Weill rarely mentions personal matters, but here she is unusually cryptic about her brother's trouble. Depression, alcoholism, suicide attempt? Who knows?

6 This was Captain Nephtali's widow, who was also named Berthe Weill.

7 *Les Lettres parisiennes* appears to be a literary journal that lasted only two years, from 1918 to 1920.

8 Paul Guillaume (1891–1934), a collector and dealer, introduced African sculpture through a series of exhibitions. Apollinaire subsequently introduced Guillaume to contemporary artists, includ-

ing Soutine and Modigliani. Following Guillaume's untimely death, his widow sold his collection and acquired works by the Impressionists, which she later donated to the French state and which became the basis of the Musée de l'Orangerie's collection.

9 *Le Crapouillot* was a satirical French magazine founded by Jean Galtier-Boissière during World War I. The name comes from *le petit crapaud*, French army slang for a small trench mortar.

CHAPTER 18

1 Rena Hassenberg was Polish and exhibited with Weill in 1921, although Weill incorrectly says in the original that she was Russian and that the show was held in 1922.

2 Léonce Rosenberg (1879–1947) was an art collector, writer, publisher, and one of the most influential French art dealers of the twentieth century. Having worked in the family antique business, he parted with his brother Paul and struck out on his own as a dealer in 1910. As a collector, he had purchased a lot of Cubist work from Daniel-Henry Kahnweiler and was able to take over much of the latter's stable after World War I. In 1918, he rebranded as Galerie de L'Effort Moderne, where he mainly showed artists affiliated with Cubism.

3 Anatole France (1844–1924) was a major writer and Nobel Prize winner. Jean-Jacques Brousson's book was *Anatole France en pantoufles* (Anatole France in slippers) (Paris: Crès et Cie, 1924).

4 This version of *Ubu Roi* at the Théâtre de l'Œuvre was a revival of the original production of the nihilistic farce that had premiered in 1896. Aurélien Lugné-Poe had taken over the theater in 1919 as artistic director.

CHAPTER 19

1 *Faridondaine* and *faridondon* are onomatopoeia that occur in the chorus of popular French songs. (English uses "derry derry down" and "alive, alive-o" the same way.) Because "Zamaron" rhymes with "faridondon," it is likely that Weill's party worked the drunken policeman's name into a song.

2 Each volume of the *Bulletin* series was numbered and used the same cover color as the show in a given season. Contrary to the accusations claiming that Berthe Weill haphazardly hung up

whatever works came her way, the *Bulletin* instead reveals a search for diversity in her offerings as a way of increasing the chances of attracting collectors. They seem to indicate Weill's interest in keeping Montmartre relevant at a time when Montparnasse was becoming the new playground of the avant-garde.

3 Daniel Tzanck (1874–1964) was a dentist and art collector. Though not wealthy, he collected early works by Braque, Léger, and Vlaminck and would accept artwork in lieu of payment, including a now-famous piece by Marcel Duchamp. To pay for dental services in 1919, Duchamp created a meticulously forged check for $115 drawn on the "Teeth's Loan & Trust Company, Consolidated."

4 This section is full of made-up "French" words whose meaning we can only guess at.

5 Jules Moy (1862–1938) was a popular stage and film actor with no obvious connection to teeth.

6 *Bousilleur* is an unusually versatile word. It means "bungler," "tattooist," "killer," and "builder of mud walls." Weill may have wanted to suggest something that makes a mess. *Le Bousilleur* was also the French title of a 1935 movie starring James Cagney called *Devil Dogs of the Air*.

7 To understand the darts Weill throws in the mock interview, it's worth knowing these facts about Vlaminck: he was of Belgian descent and grew up in northern France, was a bicycle racer and lifelong friends with André Derain, wrote a couple of pornographic books that Derain illustrated, had five daughters by two wives, published a tirade against Picasso and Cubism in the periodical *Comœdia* in June 1942, and was an early collector of African art.

8 Champignol is the main character in *Champignol malgré lui* (Champignol in spite of himself), an 1892 farce by Georges Feydeau and Maurice Desvallières. Weill is probably mocking the journalist and critic Georges Charensol.

9 In chapter 11, Weill tells how she once gave an Odilon Redon picture to Vlaminck, who turned around and sold it the next day.

10 L'Obèse, L'Aztèque, Le Prolifère, and Le Microbiol are made-up names that may refer to specific writers.

11 A collaborative undertaking, *Philosophie* brought to together Georges Politzer, Pierre Morhange, Norbert Guterman, Georges Friedmann, and Henri Lefebvre, who had all worked previously

NOTES TO PAGES 137–138 215

on another journal, *Clarté*. For more on the many journals that emerged in the first half of twentieth century, see Yves Chevrefils Desbiolles, *Les Revues d'art à Paris, 1905–1940* (Aix-en-Provence: Presses Universitaires de Provence, 2014).

CHAPTER 20

1 "Vive la Pologne, monsieur!" was allegedly shouted by Charles Floquet to Czar Alexander II at the 1867 Paris World's Fair. Or maybe not; the tale has several variants. In Weill's account, she may be mocking Waldemar George, who was Polish, by having him cry defiance to the world.

2 The subtitle for *CAP* was "Critique, Art, Philosophie." A monthly periodical, it was published between 1924 and 1928, for a total of nine issues.

3 André Salmon (1881–1969) was a French poet, art critic, and writer and one of the early supporters of Cubism, along with Apollinaire, Maurice Raynal, and Weill. He lived at the Bateau-Lavoir, as did Picasso, Apollinaire, and Max Jacob. In July 1916, he organized the exhibition *L'Art moderne en France*, where Picasso's *Les Demoiselles d'Avignon* was shown for the first time. His book, *L'Art vivant* (Paris: Georges Crès, 1920), was not published by Larousse, as Weill writes. The journal of the same name lasted much longer than other art periodicals, from 1925 to 1939, and appeared with various subtitles and was published by *Nouvelles littéraires*.

4 Rey notes: "Mlle B. Weill has noticed, apparently with some bitterness, that *Le Crapouillot* rarely mentions her gallery. She ascribes this to the fact that she doesn't announce her exhibitions in its advertising pages. I deeply respect Mlle Weill, but her stated claim stems from either oozing bad faith or boundless stupidity. I have never received the slightest suggestion with a similar basis from Galerie Boissière. And even if it were true, I think Galerie Boissière would be considerate enough not to make it." Robert Rey, "Le Poil et la Plume" column, *Le Crapouillot*, February 16, 1925, 8–9. Weill responded tersely: "Monsieur: As he knows full well, I have neither a husband nor a son to go slap M. Robert Rey in the face. I will not dignify him with a response, and I won't try to ascertain what responsibility you bear as the editor for publishing such garbage. Asserting my rights under the law, I simply ask that you insert these few lines in the same place as the offending article

216 NOTES TO PAGES 138–143

that appeared in the February 15, 1925 [*sic*] issue of the *Crapouillot*." *Le Crapouillot*, March 16, 1925, 33, Cote INHA: Mfilm 321.1 ISBN 0751-5553, Spool "Le Crapouillot 1924–1925," Institut d'Histoire de l'Art, Paris, France.

5 In describing a success, Weill uses an unusual word, *critérium*. In sport, it means a qualifying heat or a bicycle rally.

6 As Weill notes, the journal *L'Amour de l'art* seems to have been the most tenacious of the periodicals, lasting from 1922 until 1938, but, again as she mentions, changed editors frequently.

7 For a sense of how pervasive misogyny was in the period's cultural milieu, here is the painter Gustave Moreau in an undated letter, likely in response to the publication of Marie Bashkirtseff's letters in 1891: "The serious intrusion of women in art would be a disaster without remedy. What will happen when beings whose state of mind is so positive and down to earth compared to men, when beings so deprived of true imaginative gifts, bring their horribly pedestrian artistic judgment, supported by their pretensions? That Marie [Bashkirtseff] . . . gives one goose bumps. . . . Poor passionate idiot, poor overexcited concierge. . . . It's enough to make you flee art and everything connected with it forever, never to return." Gustave Moreau, *L'Assembleur de rêves, écrits complets* (Paris: Fata Morgana, 1984), 207.

CHAPTER 21

1 The pun is better in French: "Mer Méditerranée, mère Weill."

2 Weill is being sarcastic. The Grand Palais always seems gloomy, but she feels that the 1925 exhibition space layout was worse than usual.

3 The critic André Warnod noted: "If all the painters who had exhibited their works under Mlle Weill's auspices came to a dinner in her honor, the main room at Dagorno's wouldn't be big enough; it would have to be held at the Grand Palais. But the dinner two evenings ago wasn't a banquet. It was an intimate dinner, even with some sixty guests, because they all just came to dine with their friends." See André Warnod, "Le diner de Mlle. Weill," *Comœdia*, January 21, 1926, 3.

4 La Villette was the site of a famous slaughterhouse. Like Les Halles, it was also known for having good restaurants.

NOTES TO PAGES 158–164 217

APPENDIX A

1 *Pan dans l'œil* is a children's toy, which dates from the turn of the twentieth century. The aim of the game is to make a spring land exactly on the eye in a picture. *Pan!* is the French onomatopoeic equivalent of "Bang!"

APPENDIX B

1 Ambroise Vollard, "Figures d'amateurs," *Mercure de France*, no. 444, December 16, 1916, 592–99.

2 Berthe Weill, *Les Débuts de Dolikhos ou la traite des arts par un papou* [Dolikhos's beginnings, or a Papuan in the art business], three hundred copies; one is at the library of the National Gallery of Art, Washington, DC.

APPENDIX C

1 Victorien Sardou (1831–1908) was a dramatist whose many plays include *Madame Sans-Gêne* and *La Tosca*, on which Puccini based his opera.

2 Sarah Bernhardt (1844–1923), the famous actress, was performing at the Théâtre du Châtelet. Before entering the theater, she would often stop at the café at 2 place du Châtelet.

3 Gabrielle Réjane (1856–1920) was a popular actress, famous for playing the title role in *Madame Sans-Gêne*, a comedy-drama by Victorien Sardou and Émile Moreau about an outspoken eighteenth-century laundress who becomes the Duchess of Danzig.

4 *Germinie Lacerteux* is a grim, anti-Romantic play based on a novel by Edmond and Jules de Goncourt. It was produced at the Odéon in 1889.

5 It remains unclear why Weill used the name "Dolikhos" in reference to Ambroise Vollard, one of the most notable art dealers of the twentieth century. It has been suggested that the word means "the crafty one" in Greek. Another clue lies in the etymology of the term *dolikhos*, or *dolichos*. The latter spelling refers to the lablab species of black bean, which grows in the tropics, including in, we can assume, Réunion, where Vollard was born. It is also the Greek root for words that mean "long." In fact, the word "dolichocephalic" was popularized in the mid-nineteenth century using this root; the term was used to describe people who have relatively long

skulls. It is conceivable, then, that Weill's appropriation of the term was a statement on Vollard's appearance—he was described by his peers as a gruff-looking man with downcast eyes and a large forehead. Marianne Le Morvan suggests that, in Greek, *dolikhos* also translates to "lying down," and Weill's use of this name is a pun referring to the dark-skinned dealer's narcolepsy.

6 Vollard was born on the island of Réunion, but Weill portrays him as a "primitive" from Papua New Guinea.

7 Julien-François Tanguy (1825–1894) was a plasterer, butcher, and railroad worker before he opened a paint supply shop. "Père Tanguy" loved his Impressionist friends and by accepting paintings in lieu of cash, he accumulated a collection of Picassos, Van Goghs, and Cézannes, among others.

8 Paul Durand-Ruel (1831–1922) was a renowned art dealer associated with the Impressionists and the Barbizon school and one of the first modern dealers to support his painters with stipends and solo exhibitions.

9 See Vollard, "Figures d'amateurs."

10 Frantz Jourdain (1847–1935) was a Belgian architect and author, known for launching the Salon d'Automne and designing La Samaritaine, an Art Nouveau department store in the 1st arrondissement of Paris.

11 In ancient Greek religion, Ananke is the personification of inevitability, compulsion, and necessity. She is usually shown holding a spindle.

12 In the Christian liturgy, the *Sursum Corda* (Latin for "Lift up your hearts") is the opening dialogue to the preface of the Eucharistic prayer.

13 Alfred Jarry (1873–1907) was a Symbolist writer best known for his 1896 play *Ubu Roi*, a "pataphysical" work that attacks the mediocrity of the bourgeoisie. The play is infamous for Ubu's opening line, "Merdre!" ("Sheee-yit!"). Vollard was a close friend of Jarry's and published a number of his short Ubu books with sketches by Pierre Bonnat: *Le Père Ubu à l'hôpital* (1917), *Le Père Ubu à l'aviation* (1918), etc.

14 Bombala is a small town on the southeast coast of Australia.

15 Vollard was a narcoleptic.

Contributors

LYNN GUMPERT is director of New York University's Grey Art Gallery. Previously she was an independent curator, consultant, and writer; from 1980 to 1988 she served as curator at the New Museum of Contemporary Art, New York. She authored the first major monograph on the French artist Christian Boltanski (Paris: Flammarion, 1992).

MARIANNE LE MORVAN is the author of *Berthe Weill 1865–1951: La Petite galeriste des grands artistes* (The great artists' little gallerist; Paris: L'Écarlate, 2011) and is the founder of the Archives Berthe Weill in Paris.

PAUL REBOUX (1877–1963) was a French editor and literary critic who wrote novels, biographies, travel stories, and children's books.

WILLIAM RODARMOR has translated some forty-five books and screenplays from French and been honored by the American Translators Association and the Northern California Book Awards. He translated Claudine Cohen's *The Fate of the Mammoth* for the University of Chicago Press in 2002. He lives in Berkeley, California.

JULIE SAUL owned and directed the Julie Saul Gallery from 1986 to 2019, specializing in contemporary photo-based art. She subsequently founded Julie Saul Projects to consult, organize pop-up shows, and execute special commissions. Saul received an MA and a certificate in museum training from the Institute of Fine Arts, New York University, in 1982.

Index

PAGE NUMBERS IN ITALIC REFER TO FIGURES.

Abin, César, *"Leurs figures," xxi*
Abranski, Mme, 143
abstract painting, xxvi
academic painting and painters, 51,
 61, 112, 151–52
Action, 113, 137
Agard, Charles-Jean, 31
Agutte, Georgette, 103
Albert-Birot, Pierre, 25, 92, 123,
 211n5 (chap. 15)
Alix, Yves, 137, 143
Allard, Roger, 111, 124, 128
Alsace, xvi, 55
Amos, Mathilde, 143
Amour de l'art, L', 139, 216n6
Angiboult, François, 116
Antigny, Blanche d', 162
antiques, sales at Galerie B. Weill: ad-
 vantages, 55; Dufy on, 56; end of,
 115; income from, 29, 30, 37, 42,
 45, 52, 57, 62, 105; recommended
 by Mme Mayer, 16, 63; weapons
 and china, 61
antiques shops: of H. sisters, 73, 76,
 88; of Mayer, xvi–xvii, 49, 201n1;
 of Weill and brother, xvii, 4
anti-Semitism, xx, xxvii, 8, 67. *See
 also* Jewishness
Antoine, André, 79
Apollinaire, Guillaume: artists and,
 25, 43, 49, 79, 212–13n8; *The
 Breasts of Tiresias*, 92; on Cub-

ism, 81; death, 107; Fauves and,
 20, 43; journals involved with,
 83, 211n3 (chap. 15), 211n2 (chap.
 16); review of Rivera exhibit,
 209n4; Surrealism and, 211n5
 (chap. 15)
Aragon, Louis, 211n2 (chap. 16)
Archipenko, Alexander, 116, 208n9
art market: auction houses, xvi, 51,
 59, 83–84, 142, 149–50, 206n5;
 neighborhoods of galleries, xvi,
 205–6n4, 207n4 (chap. 12); in
 1920s, 142–43, 149; in 1930s, xxv–
 xxvi, 149–50; prices, 44; scandals,
 149–50; speculation, 138, 139,
 142, 144, 146; during World War I,
 93. *See also* collectors; dealers
Art vivant, L' (journal), 137, 215n3
Asselin, Maurice, 106, 109
Assiette au beurre, L', 4, 31
auction houses. *See* Hôtel des Ventes;
 Hôtel Drouot
Audoux, Marguerite, 157
Auglay, Auguste, 29
Auvergne, 82–83, 85, 93
avant-garde artists, 147. *See also*
 Jeunes, les

Baignières, Paul, 52
Bail, Joseph, 61
Ballets Russes, 92
banquets and dinners: of critics, 145;

222 INDEX

banquets and dinners (*cont.*)
 for gallery anniversaries, xxv,
 143, 216n3; for Pascin, 142; for
 Valadon, *xxvi*
Barat-Levraux, Georges, 120, 136, 143
Barrère, Adrien, 12
Bashkirtseff, Marie, 216n7
Basler, Adolphe, 93–95, 113, 118, 123,
 127
Bateau-Lavoir, 25–26, 215n3
Bauchy, Auguste, 110, 166–67, 171
Beaufort-sur-Gervanne, 59, 60, 63,
 65–68, 206n7
Beaufrère, Adolphe, 40
Bellier, Alphonse, 141
Beothy, Étienne, xxvi
Béraldi, Henri, 163
Berger, Jean, 73
Bergon, François, 106
Bernard-Lemaire, Louis, 19
Bernhardt, Sarah, 161, 217n2 (app. C)
Bernheim, Alexandre, 204n4
Bernheim, Georges, 74, 77
Bernheim-Jeune, Gaston, 37, 163,
 204n4
Bernheim-Jeune, Josse, 37, 204n4
Bernheim-Jeune et Cie., 204n4. *See
 also* Galerie Bernheim-Jeune
Bern-Klene, Hendricus, 63
*Berthe Weill: Indomitable Art Dealer
 of the Parisian Avant-Garde* (ex-
 hibition), vii–viii
Bertrand, Claire, 134, 163
Bétrix (or Bétris) (artist), 29
Beurdeley, Alfred, 162
Bianchini (musician), 83
Biette, Jean, 46–47
Bièvre, 104, 110, 212n8 (chap. 16)
Big Bertha, 106, 212n3
Billette, Raymond, 126
Bissière, Roger, 112, 118, 122, 127

Blanche, Jacques-Émile, 112
Blot, Eugène, 12, 14, 74
Bloy, Léon, 7–8
Blum-Lazarus, Sophie, xxvii
Bocquet, Paul, 17
Bollag, Gustave, 200n8
Bollag, Léon, 200n8
Bollag, Lucy, 200n8
Bolliger, Rodolphe, 64, 84
Bongard, Germaine, 100
Bonnard, Pierre, 91, 153
Bonnat, Léon, 51, 163, 218n13
book sales: advantages, 116; art
 books, 110; challenges, 75;
 dealers, 82; enjoyment of books,
 110; income from, 63, 79, 83, 91,
 117, 122; personal library, 52, 75;
 purchases for, 75, 110, 113
Borgeaud, Marius, 97
Bosshard, Rodolphe-Théophile, 135
Bottini, Georges, 5, 14, 24, 26
Boucard (judge), 6–7, 201n3
Bouche, Georges, 41, 42, 82, 109
Boudin, Eugène, 40
Bouguereau, William-Adolphe, 153
Bourdelle, Antoine, 204n1
Bousilleur, Le, 129, 214n6
Boussingault, Jean-Louis, 75
Brailowsky, Alexander, 134
Brancusi, Constantin, 208n9
Braque, Georges: caricature, *xxi*;
 collectors, 214n3; Cubist works,
 58; exhibitions at Galerie B. Weill,
 xix, 61; sales, 70; Weill and, 69–70
Brassaï, 203n1 (chap. 6)
Braun, Maurice, 19
Breasts of Tiresias, The (Apolli-
 naire), 92
Brébant, Paul, 163
Brenot, Claudine, 26–28, 29, 47–48, 54
Breton, André, 211n2 (chap. 16)

Briand, Aristide, 205n1 (chap. 8)
Brisson, Adolphe, 14
Brousson, Jean-Jacques, 119–20, 213n3
Buhot, Jean, 84
Bulletin de la Galerie B. Weill: contributors, xxiii–xxiv; as exhibition catalogs, 213–14n2; issue 1, *xxiv*, 127–28; issue 3, 129; issue 5, 132; number of issues, xxvi; Weill's writing in, 132, 138, 145
Burgsthal, Richard, 64
Burty, Frank, 120
business and financial decisions: borrowing from family members, 60, 98, 108; business practices, xxi–xxii; consequences, xxi–xxii, 51; postcard sales, 87–88, 91, 142; refusal to take advantage of artists, 89; uses of income, 9–10, 25, 26, 39, 48, 63. *See also* antiques, sales at Galerie B. Weill; book sales

Cahier jaune, Le, xxvii
Câmara, Tomás Leal da, 19
Camoin, Charles: exhibitions at Galerie B. Weill, 30, 41, 42, 57, 61, 81; as Fauve, 203n4; paintings, 53; parties, 118; Renoir painting and, 73–74; sales, 40
Camondo, Isaac de, xxiii, 160, 165, 168–69, 170, 171, 200n5
Canals, Ricard, 13, 14, 21
CAP, 137, 215n2
Capon, Georges, 138, 145
Cappiello, Leonetto, 4–5, 17
Caran d'Ache, 4
Carnot family, 80
Caro-Delvaille, Henri, 61
Carolus-Duran, 61, 84

Carré, Raoul, 39
Casadesus, Mlle (violinist), 147–48
Casagemas, Carles, 13, 25
Casse, Raymond, 100, 107
Celli, Elmiro, 104, 108
Cendrars, Blaise, xxiii
Cercle Volney, 57, 205n2 (chap. 10)
Cézanne, Paul, 152, 166, 167–68, 171
Chabaud, Auguste, 108, 124
Chagall, Marc, *xxi*, xxvii, 90, 143, 206n1, 207n6
Champignol, 129
Charensol, Georges, 143, 145, 214n8
Charivari, 10
Charmy, Émilie: appendectomy, 74; career, 139; dinners, 136; exhibitions, 69, 109; exhibitions at Galerie B. Weill, xxi, 41, 43, 52, 62, 81, 82, 83, 108, 127; friendship with Weill, 41, 71–72, 77; Galerie Pesson and, 109–10; Heuzé and, 92; illness, 106; paintings, 205n1 (chap. 8); parties, 118, 143; sales, 41, 82, 91, 96, 109; vacations, 71–72, 81, 85, 93; during World War I, 90
Charreton, Victor, 70–71, 207n3 (chap. 12)
Chéramy, J.-A., 162
Chéret, Jules, 5, 18, 24, 29, 30
Cherniavsky, Charles, 144
Chéron, Georges, 12
Chocarne-Moreau, Paul, 153
Clairin, Pierre-Eugène, 112, 118, 119
Claretie, Jules, 161
Clemenceau, Georges, 86
Closerie des Lilas, 73, 207n1
Coco. *See* Laurencin, Marie
Cocteau, Jean, 211n2 (chap. 15), 211n6
Colette, Sidonie-Gabrielle, 140

collectors: bad experiences with, 111–12, 125–26, 134–35; of Cubists, 213n2 (chap. 18); Derain and, 129; of Dufy, 134; of engravings, 49–51; expectations, 119; German, 94, 95; H., 70–71; of les Jeunes, 62, 75–76, 77, 83–84, 90–91, 119, 128; of Lautrec, 36–37; of modern art, 12; in Montmartre, 124–25; Peau de l'ours group, 209n3; of Picasso, 14, 15, 16; of Redon, 59; Tzanck, 128, 214n3. *See also* Picon (retired bailiff); Veilleurs, Les

Compagnie de l'Ouest, 22–23, 25, 26

Conservatoire Maubel, 92

Coquiot, Gustave, 17, 97, 118

Corot, Jean-Baptiste, 123, 163

Cottereau, Henri, 133

Coubine, Othon, 110, 113, 127

Courbet, Gustave, 163, 167

Courrier français, Le, 4

Cousturier, Lucie, 81

Couturier, Édouard, 8

Crapouillot, Le, 113, 138, 145, 213n9, 215–16n4

Cravan, Arthur, 78–79

critics: banquets, 145; catch phrases, 128–29; Cravan, 78–79; duel, 135; interviews by, 141; Thiébault-Sisson, 122

Crotti, Jean-Joseph, xiii

Cubisme, 81

Cubists: collectors, 213n2 (chap. 18); exhibitions, xix, 81, 84–85, 100, 122; Favory, 93; galleries, 213n2 (chap. 18); Gris, 124; journals, 211n5 (chap. 15); Princet, 58; sculptors, 97; Section d'Or, 79, 208n9; Zárraga, 105. *See also* Braque, Georges; Marcoussis,

Louis; Metzinger, Jean; Picasso, Pablo

Cyr, Georges, 147

Czóbel, Béla, 58, 62, 83

Dagorno's restaurant, 142, 143, 148, 216n3

Damia (Marie-Louise Damien), 31, 140, 204n3 (chap. 6)

Danthon (dealer), 35–36

Daragnès, Jean-Gabriel, 109

Daumier, Honoré, xix–xx, 10, 11–12, 65, 163

David, Hermine, *xxvi*, 126–27, 135, 136

Dayot, Armand, 12, 163

dealers: in antiques, 4, 10, 12; in books, 82; crooked, 5–6, 13, 82; for Cubists, 213n2 (chap. 18); exclusivity agreements, 35–36; interviews of, 141; treatment of artists, 134; during World War I, 93–95, 97. *See also* Basler, Adolphe; Libaude, Louis; Rosenberg, Léonce; Vollard, Ambroise

decorative art, 110–11

decorators, 93, 133, 144

Decourcelle, Pierre, 163

Degas, Edgar, 8, 46, 152, 163, 165, 202n2 (chap. 2)

Delacroix, Eugène, 163

Delaroche, Léon, 12

Delaunay, Robert, 52, 77, 78, 79, 207–8n7, 208n9

Delcourt, Maurice, 27–28

Delmée, Adolphe, 100

Deltombe, Pierre, 29, 39

Denis, Maurice, 18, 38, 203n5

dentists, 128, 214n3

Depaquit, Jules, 19, 87–88

Derain, André: Ballets Russes and,

92; caricature, *xxi*; collectors, 129; drawings, 106, 110, 113; exhibitions at Galerie B. Weill, xix, 42, 57, 61, 64, 110; as Fauve, 203n4; in Le Havre, 64; personality, 42–43; sales, 53, 91; Vlaminck and, 129, 214n7; watercolors, 113; wife, 106; during World War I, 106

Déroulède, Paul, 12

Desjardins, Dr. and Mme, 118

Despiau, Charles, 126, 136

Desvallières, George, 52

Detaille, Édouard, 61, 84

Deville, Henry Wilfrid, 64

Diaghilev, Serge, 92

Diaz de Soria, Robert, 112

Diéterle, Georges, 74

Dinard, 28, 35, 71

dinners. *See* banquets and dinners

Diriks, Edvard, 62

Doistau, Félix, 163

dolikhos (or *dolichos*), term, 217–18n5

Dolikhos's Beginnings (Weill), viii, xxiii, 160, 161–71, 200n5

Donnay, Maurice, 36, 204n3 (chap. 7)

Dorival, Georges, 117, 118

Dorny, Thérèse, 140

Doucet, Jacques, 162

Dreyfus affair, xx, 7–8, 67, 201–2n1

Druet, Eugène, 43, 59, 69, 153, 204n5, 205–6n4, 206n6

Dubreuil, Pierre, 125, 126, 132–33, 137, 143

Duchamp, Marcel, xiii, 208n9, 214n3

Dufrénoy, Georges, 30, 41, 43, 118, 143

Dufy, Jean, 83, 112, 116, 118, 119, 135

Dufy, Raoul: career, 53; *Chevaux de course* (Horse race), 27; contributions to *Le Mot*, 211n2 (chap.

15); donation to auction supporting Weill, xxvii; exhibitions, 51, 207n6; exhibitions at Galerie B. Weill, xix, 24, 29, 35, 40, 41, 42, 43, 61, 81, 110, 116, 127, 135, 139; Fauves and, 43; Friesz and, 40, 43, 55–56; girlfriend, 26–28, 47–48, 54; in Le Havre, 32, 33, 47–48, 54; letter from, 55–57; in Marseille, 55–56; paintings, 111, 153; personality, 40; postcards, 87–88; prices, 134; *La Rue de Norvins*, 23; sales, 62, 101, 111; watercolors, 134; Weill and, 40, 143; during World War I, 87–88, 90

Duparc, Henri, 83, 209n2

Duparque, Paul, 29

Durand, Marguerite, 171

Durand-Ruel, Paul, vii, 14, 46, 167, 205n4, 207n4 (chap. 12), 218n8

Duret, Théodore, 163

Durey, René, 108

Durio, Paco, 17

Dussueil, Georges, 43

Eberl, François Zdenek, 125–26, 136, 142

Ebstein, Joseph, 118

Edward (prince of Wales), 12

Eisenschitz, Willy, 126, 134

Élan, L', 89

Ellissen, Robert, 12

engravings: antique, 12–13, 63; color, 14, 48; eighteenth-century, 48, 49–51; sales, 4, 16, 29

Ephrussi family, 163

Esmein, Maurice, 84

Estampe originale, L', 14

exhibition catalogs, *xx*, xxiii, xxv, 29, 84, 209–10n4. See also *Bulletin de la Galerie B. Weill*

exhibitions. *See* themed exhibitions; *and individual artists*

Exposition des peintures et des dessins de Modigliani (exhibition catalog), *xx*

Exposition Universelle (1900), 11, 13

Faivre, Abel, 5, 14, 17, 24, 26, 29, 30
Falaise, 47–48
Fantin-Latour, Henri, 44
Farrey, Pierre, 112, 119
Fauves, xix, 20, 42–43, 53, 56, 203n4. *See also* Derain, André; Matisse, Henri; Vlaminck, Maurice de
Favory, André, 93, 112, 118, 119, 125, 127, 128, 143
Fels, Florent, 113, 137–38, 143
Fénéon, Félix, 105, 204n4, 212n1
finances. *See* business and financial decisions
Finkelstein, Alex (Sacha), 64
FitzGerald, Michael C., vii
Flandrin, Jules, 18, 20, 57, 118
Fleuret, Fernand, 25
Florès, Ricardo, 31, 37
Forain, Jean-Louis, 4, 8, 12, 24, 29
forgeries, 5–7, 12, 97
fortune teller, 10–11
Fournier, Gabriel, 112, 119
Fournier, Marcel, 31
France, Anatole, 119–20, 213n3
Frankfurt am Main, 55, 59
Frédureau, Paul, 120
Frélaut, Jean, 126
Freundlich, Otto, xxvi, xxvii
friends and neighbors: H. sisters, 73, 76, 88; Kars, 120; Mlles P., 32, 38, 48–49, 59, 63, 66–69; parties, *xxvi*, 118, 126–27, 143, 145–46; potential husband, 24; subtenant at rue Victor Massé, 65, 69, 70, 72,

97–98; V., 26, 48, 52, 54, 55, 58, 80; visit to old friend (1924), 135–36. *See also* banquets and dinners; Charmy, Émilie
Friesz, Othon: career, 53; Dufy and, 40, 43, 55–56; exhibitions at Galerie B. Weill, xix, 41, 43, 110; girlfriend, 27; paintings, 56, 153; painting style, 40, 43; parties, 118; sales, 62; Salon Folie Dentaire and, 128
Fursy, Henri, 79–80, 208n11
Futurists, 101, 211n5 (chap. 15)

Gaillard, Marcel, 121
Galanis, Demetrius, 37, 110, 112, 118
Galerie Barbazanges, 207n6
Galerie Bernheim-Jeune, vii, 100–101, 127, 212n1. *See also* Bernheim-Jeune et Cie.
Galerie B. Weill: assistants, 116, 121, 123–24; closing (1941), xxvii; competition, 18–19, 37, 38; name of gallery, xix; opening, xv, xvii, 3–4, 17; promotional card, *xviii*; rue Laffitte location, 114–15, 118, 142; rue Saint Dominique location, xxvi; rue Taitbout location, 98–99, 114–15, 142; rue Victor Massé location, 3, 16, 26, 28, 57, 58, 60, 72, 97–98, 121; Stein on, 205–6n4; thirtieth anniversary, xxv, 149; twenty-fifth anniversary, 143, 147–48, 216n3. *See also* business and financial decisions; exhibition catalogs; themed exhibitions
Galerie Danthon, 204n1
Galerie de L'Effort Moderne, 213n2 (chap. 18)
Galerie Druet, 38, 118, 134

INDEX 227

Galerie Malpel, 90–91
Galerie Pesson, 108–10, 114–15
Galimberti, Sándor, 84
Galimberti-Dénes, Valéria, 84
Gallieni, Joseph, 86, 210n5
Galtier-Boissière, Jean, 145, 213n9
Gardelle, Charlotte, 92–93
Garets, Odette des, xxvii, 132, 143
Garros, Roland, 75, 207n4 (chap. 13)
Gauguin, Paul, 17, 73, 110, 166, 167,
 168, 207n6
Gen-Paul (Eugène Pal), 143
George, Waldemar, 137, 139, 143,
 215n1
Germany: Big Bertha, 106, 212n3;
 Frankfurt gallery, 59, 206n8;
 Matisse in, 58; vacations, 55. *See
 also* World War I
Gernez, Paul-Élie, 112, 116, 127
Ghist, Mme (singing teacher), 75
Gignoux (vacationer), 140
Gilliard, Marguerite, 41
Gimmi, Wilhelm: collectors, 133;
 exhibitions at Galerie B. Weill,
 116, 120, 125, 127; paintings, 113,
 122; parties, 118, 143
Giran-Max, Léon, 97
Girardin, Maurice, 132–33
Girieud, Pierre: exhibitions at
 Galerie B. Weill, 17, 23, 35, 43, 62,
 64, 81, 137, 143; parties, 118, 143;
 sales, 62
Gleizes, Albert, xix, 81, 116, 211n2
 (chap. 15)
Goerg, Édouard, 136, 137, 138, 144
Goncourt, Edmond de, 162, 217n4
 (app. C)
Goncourt, Jules de, 217n4 (app. C)
González, Julio, xxvi
Gosé, Xavier, 13, 17
Gottlob, Adolph, 19, 21

Grass-Mick, Augustin, 37, 70, 88
Grillon, Roger, 133, 145
Gris, Juan, 124, 208n9
Gromaire, Marcel, 132–33, 137, 143,
 144
Groult, Camille, 161–62
Groupe de Puteaux. *See* Section d'Or
Groux, Henry de, 7–8, 20, 63
Grün, Jules, 19, 21
Guérin, Charles, 36–37, 44, 52
Guillaume, Paul, 113, 118, 140, 212–
 13n8
Guinier, Henri, 205n1 (chap. 10)
Guys, Constantin, 44

Halicka, Alice, xxi, 113, 116, 125,
 204n4
Halou, Alfred, 52
Hardy (theater manager), 117–18
Harrison, Carter, 206–7n1
Hassenberg, Rena. *See* Reno, Irène
Hayden, Henri, 123
Hecht, József, 146
Helleu, Paul, 5, 7, 24, 26, 30
Henner, Jean-Jacques, 51, 153
Hensel, Maurice, 106
Herbin, Auguste, 58, 100, 123, 204n4
Hermann-Paul, René, 4, 17
Hervieu, Louise, 80, 208n12
Hessel, Jos (Joseph), 95
Heuzé, Edmond, 77–78, 91–92, 97,
 108–9, 114–15, 208n8
Hiver, Marcel, 104, 137
Hodebert, Léon Auguste César, 77
Hogg, Paul, 121
Homme libre, L', 86
Hôtel Biron, 76
Hôtel des Ventes, 51, 59
Hôtel Drouot, xvi, 59, 83–84, 141,
 149, 206n5
Houdon, Jean-Antoine, 12

228 INDEX

Huc, Arthur, 12, 15, 30
Hughes, Robert, xvi
Huyot, Albert, 144–45

Ibels, Henri-Gabriel, xix–xx, 8
Impressionists, xviii, 35, 36, 152, 163, 167, 204n4, 212–13n8
Ingres, Jean-Auguste-Dominique, 163
Iribe, Paul, 211n2 (chap. 15)
Iturrino, Francisco, 13, 16

Jacob, Max: drawings, 43–44; gatherings at Bateau-Lavoir, 25; journals involved with, 211n3 (chap. 15), 211n2 (chap. 16); Picasso and, 24; reaction to war casualties, 89
J. & S. Goldschmidt, 206n8
Jarry, Alfred: *Ubu Roi*, 122, 213n4, 218n13; Vollard and, 171, 218n13
Jaurès, Jean, 85
Jeanne, Paul, 118
Jeunes, les: auction to support Weill (1946), xxvii; collectors, 61, 75–76, 77, 83–84, 90–91, 119, 128; critics of, 112; Galerie Malpel, 90–91; impact, 53–54; introduced by Weill, xviii–xix, xxii; Peau de l'ours group, 83–84; use of name, 17, 199n2; Weill's commitment to, viii, xv, xxviii, 56. *See also* themed exhibitions
Jewishness: anti-Semitism, xx, xxvii, 8, 67; of Weill, xvi, 67, 206n1
Jongkind, Johann Barthold, 71
Jossot, Gustave-Henri, 12
Jourdain, Frantz, 18, 169, 203–4n2, 218n10
Jouvencel, Henri de, 118
Joyant, Maurice, 12
Juste, René, 29

Kahnweiler, Daniel-Henry, xv, 213n2 (chap. 18)
Kapferer, Marcel, 14, 109–10, 111, 125
Kars, Georges: exhibitions at Galerie B. Weill, 116, 120, 125; friendship with Weill, 120; parties, 143; *Portrait of Berthe Weill, xiv*
Kayser, Edmond Charles, 123, 126, 129, 133, 138, 143
Kisling, Moïse, 125, 135, 206n1
Krohg, Lucy, *xxvi*
Krohg, Per, 126, 132–34, 137, 143, 144
Kruglikova, Elizaveta, 18, 19
Kubitzky, Alexander, 140
Kupka, František, 208n9

La Baule, 106, 212n4
La Clairon (Clair Leris), 161
Lacoste, Charles, 47, 65, 81, 83
La Courneuve, 103, 211–12n5
La Fresnaye, Roger de, 124
Laglenne, Jean-François, 139
Lagut, Irène, 123
Laprade, Pierre, 44, 52, 81, 106, 118
Largys (banquet attendees), 143
La Rocha, Luis de, 104, 112, 118, 143
La Rocha, Mme de, 104, 110, 118, 143
Larronde, Carlos, 103–4, 116
Lassouche (Pierre-Louis-Ange Bouquin de La Souche), 162–63
Launay, Fabien, 17, 21, 23
Laurencin, Marie, 48–49, 57, 78, 79, 93, 204n4
Laurens, Henri, 97
Laurens, Marthe, 97, 105
Léandre, Charles, 19, 21, 37
Lebasque, Henri, 31, 81, 204n4
Le Beau, Alcide, 23
Leblond, Marius-Ary, 82–83, 208n1
Lecomte, Georges, 12

INDEX 229

Le Corbusier (Charles-Édouard Jean-
neret), 211n3 (chap. 15)
Le Crotoy, 75, 207n3 (chap. 13)
Léger, Fernand, xix, *xxi*, 81, 208n9,
214n3
Legion of Honor, xxvii, 71, 207n3
(chap. 12)
Legrand, Edy, 122, 127
Legrand, Louis, 12
Le Havre: businessmen from, 104;
Derain in, 64; Dufy in, 27, 28, 32,
47–48, 54; vacations, 21–22
Lehmann, Léon, 57, 59, 60, 63, 66,
68–69, 84
Lejeune, Henri-Pierre, 24
Le Morvan, Marianne, vii, xii
Lempereur, Edmond, 31
Lepoutre, Constant, 121
Leprin, Marcel, 137
Leris, Clair (La Clairon), 161
Lesieutre, Maurice, 25
Lettres parisiennes, Les, 111, 212n7
(chap. 17)
Level, André, 12, 70, 79, 84, 87–88,
209n3
Levy, Adrienne (sister), xvi, *xvii*,
15, 16
Lévy, Léopold, 126, 133, 134, 143
Lévy, Simon, 127, 140, 141, 143
Lewitska, Sonia: exhibitions at Gal-
erie B. Weill, xxi, 81, 83, 116, 136;
as Marchand's wife, 76; paintings,
76; parties, 118, 143; visit with, 90
Lhote, André: contributions to *Le
Mot*, 211n2 (chap. 15); donation to
auction supporting Weill, xxvii;
exhibitions at Galerie B. Weill,
xix, 65, 81, 83, 112, 116, 127, 138;
parties, 118; visits to Galerie B.
Weill, 64–65; during World War
I, 91

Libaude, Louis, 51, 79, 90, 103
Lloyd's insurance company, 114, 115
Lobel-Riche, Alméry, 17
Lombard, Alfred, xi
Lombard, Jean, xi, 143
Lotiron, Robert, 112, 118
Louvre, Camondo legacy, 160, 170,
200n5
Luce, Maximilien, 20, 65, 81, 84,
87–88
Lugné-Poe (Aurélien-Marie Lugné),
64, 213n4
Lurçat, Jean, 133–34, 135, 139

Mac Orlan, Pierre, 25, 203n1 (chap.
6)
Maillol, Aristide, xviii, 17, 18–19,
202n3
Mainssieux, Lucien, 108, 109, 118
Maintenant, 78, 79
Makowski, Tadeusz, 132–33, 137, 144
Malpel, Charles, 61, 78, 90–91, 92,
101, 108
Mañach, Pedro "Père," xvii, 11, 13–14,
16–17, 19, 21, 202n3
Manet, Édouard, 165, 166
Manguin, Henri, xix, 30, 40, 118
Manolo (Manuel Hugué), 13, 14, 25
Manzi, Michel, 12, 165
Marchand, Jean, 75–76
Marcoussis, Louis, 113, 116, 135, 139
Marlotte, 42, 205n2 (chap. 8)
Marque, Albert, 46
Marquet, Albert: donation to auction
supporting Weill, xxvii; exhibi-
tions, 18, 30; exhibitions at Gal-
erie B. Weill, xix, 41, 42, 43, 61,
110; as Fauve, 203n4; paintings,
30–31, 108, 153; prices, 96; sales,
19, 40, 53, 62, 101
Marseille, 55–56, 140–41

230 INDEX

Marseille (dealer), 75–76

Martin, Jacques, 71–72

Martinie, Berthe, 139

Marval, Jacqueline, xxi, 18, 44, 57, 81, 153

Marx, Roger, xxiii, 12, 163

Mathan, Raoul de, 17, 30, 57, 64

Matisse, Amélie, 118

Matisse, Henri: Ballets Russes and, 92; Biette and, 46–47; career, 20, 53; collectors, 58–59; Dufy and, 43; exhibitions, 18, 45–46, 207n6; exhibitions at Galerie B. Weill, xv, xix, 20, 30, 42, 81, 110; as Fauve, 42, 43, 203n4; friends, 30–31; in Germany, 58; at Hôtel Biron, 76; influence, 31, 58; *The Joy of Life*, 45–46; paintings, 20, 31, 56, 58–59, 153; Paris apartment, 20; prices, 20; sales, 40, 58–59, 101; students, 58; wife, 20

Mayer, Mme: antique sales encouraged by, 16, 63; art collection, 10, 30, 48; death, 93; support for Weill's business, xxii, 3, 4, 9

Mayer, Salvator: death, xvii, xxiii, 3; gallery, xvi–xvii, 49, 161–65, 171, 201n1

Meissonier, Ernest, 61, 84

Mendès-France, René, 116, 117, 118

Méphisto, 79, 80

Mercure de France, 160, 200n5

Méry, Alfred-Emile, 164

Metzinger, Jean: Cubist works, xix, 58, 81, 93; donation to auction supporting Weill, xxvii; exhibitions at Galerie B. Weill, xix, 24–25, 29, 43, 52–53, 62, 81, 84–85, 123; paintings, 52–53; parties, 118; during World War I, 91

Milcendeau, Charles, 20

Minartz, Tony, 41–42

Mirande, Henry, 19

Mita, Georges, 36

modern art, vii, 10, 11, 12, 112–13. *See also* Jeunes, les

Modigliani, Amedeo: death, xix, 103, 212n6 (chap. 16); drawings, 103; drunken visit, 89; exhibition catalog, *xx*; exhibitions, 207n6; exhibitions at Galerie B. Weill, xix, *xx*, 101–3; Guillaume and, 212–13n8; Jewishness, 206n1; nudes, 102–3; paintings, 101; Zborowski and, 89, 101

Monet, Claude, 152, 167

Monticelli, Adolphe, 65

Montmartre: artists, 25–26, 203n1 (chap. 6); Bateau-Lavoir, 25–26, 215n3; clubs, 79–80; collectors, 124–25; galleries, 207n4 (chap. 12), 213–14n2; place du Tertre, 118

Montparnasse, 73, 79, 207n1, 208n10

Montreal Museum of Fine Arts, viii

Mont-Saint-Michel, 34, 35

Monzie, Anatole de, 145

Moreau, Gustave, 20, 30, 44, 216n7

Moreau, Louis-Auguste, 75, 110, 118, 140

Moreau-Nélaton, Étienne, 163

Morice, Charles, 73

Mortier, Robert, 116, 120, 137

Mot, Le, 89, 211n2 (chap. 15)

Mouillot, Marcel, xix, 127, 140, 141

Moy, Jules, xiii, 128, 214n5

Müller (artist), 14, 29

Musée de Lyon, 71

Musée des Arts Décoratifs, 139

Nabis, xviii

Nantes, 15

INDEX 231

neighbors. *See* friends and neighbors

New York University, Grey Art Gallery, vii–viii

Nonell, Isidre, 11, 13

Nord-Sud, 100, 211n2 (chap. 16)

Nouveau spectateur, Le, 111

nudes, xix, 44, 102–3, 113, 117

Nuitter, Charles, 163

occultism, 68, 116

Ortiz de Zárate, Manuel, 108

Ottmann, Henry, 44, 52

Ozenfant, Amédée, 89, 100, 211n3 (chap. 15)

Pacquement, Charles, 134

Parent, Armand, 75–76

Partisans, 134

Pascin, Jules: birthday dinner, 142; death, 150; donation to auction supporting Weill, xxvii; drawings, 93; exhibitions at Galerie B. Weill, 63–64, 126, 132–33, 137, 144; Jewishness, 206n1; paintings, 124; parties, 126–27, 145; personality, 150; photograph of, *xxvi*

Patorni-Casadesus, Régina, 147–48

Pauwels, Lucie-Valore and Robert, 118, 119, 120

Paviot, Louis-Claude, 31, 42, 65, 118, 133

Peau de l'ours group, 83–84, 209n3

Pesson, André, 97, 108–10, 114–15

Petite revue des peintres (puppet show), 117

Petitjean, Hippolyte, 18

Petit parisien, 116

Philosophie, 133, 214–15n11

Picabia, Francis, xix, xxvii, 35, 36, 140, 208n9

Picasso, Pablo: Apollinaire and, 43;

caricature, *xxi*; collectors, 14, 15, 16; *Composition, 2*; Cubism, 58; *Les Demoiselles d'Avignon*, 215n3; donation to auction supporting Weill, xxvii; drawings, 23–24, 25, 37, 100, 105, 110, 111–12; exhibitions, 19, 207n6; exhibitions at Galerie B. Weill, xv, xviii, 23, 35, 81, 110; *Family of Saltimbanques*, 84; French language ability, 24; letters to, xxvii; *Le Moulin de la Galette*, 15; *On the Upper Deck*, 19; paintings, 13–14, 15, 16, 19, 23–24, 25, 108, 153; *Portrait of Berthe Weill, vi*, 174; prices, 14, 15, 16, 19, 59, 84; Rivera and, 84; Sagot gallery and, 25; sales, xviii, 62, 84, 111–12; sets for Ballets Russes, 92, 211n6; *Soirées de Paris* issue dedicated to, 83; studios, 13, 14, 25–26; on Villette, 100; watercolors, 105; Weill and, 24, 69–70

Pichot, Ramon, 13, 16, 21, 23

Picon (retired bailiff), 30, 36, 40, 47, 48

Piet, Fernand, 31

Pille, Henri, 4, 5–7, 12

Piot, René, 44

Piot, Stéphane, 44

Pissarro, Camille, 152, 163, 166, 167, 171

Plumet, Jean, 65

Pointillism, 24–25, 52, 84

Poiret, Paul, 140, 207n6

police commissaire, xix, 102–3

Portal, Henry, 112, 119, 125

postcards, 87–88, 91, 142

posters, 5, 16

Postimpressionists, xviii. *See also individual artists*

Prax, Valentine, 129

232 INDEX

Princet, Maurice, 58
puppet show, 117–18
Puy, Jean, 30, 62, 110, 203n4

Quelvée, François, 143

Ramey, Henry, 136
Ranft, Richard, 14
Ranson, Marie-France, 203n5
Ranson, Paul-Élie, 21, 41, 203n5
Reboux, Paul, preface by, viii, 151–59
Redon, Odilon: Burgsthal and, 64; collectors, 59; drawings, 10, 18, 169; exhibitions at Galerie B. Weill, 18, 81; personality, 18; sales, 62 63, 71, 77, trade with, 65; Verhoeven and, 61; Vollard and, 18, 164, 169; wife, 37
Reinach, Théodore, 12
Réjane, Gabrielle, 13, 33, 161, 217n3
religious discussions, 67–69. *See also* Jewishness
Reno, Irène (Rena Hassenberg), 116, 117, 213n1 (chap. 18)
Renoir, Edmond, xi, 94–95
Renoir, Pierre-Auguste: in Cagnes, 207n2 (chap. 13); collectors, 110; paintings, 19, 73–74, 94–95, 152, 167, 169–70; Vollard and, 166
Reth, Alfred, xix, xxvi, 83
Reverdy, Pierre, 100, 211n2 (chap. 16)
Rey, Robert, 138, 215–16n4
Ribemont-Dessaignes, Georges, 64, 83
Riou, Louis, 112, 119
Rivera, Diego, xix, 84, 91, 209–10n4
Robbe, Manuel, 14
Robert, Théophile, 134
Rochefort, Victor, 12
Rodin, Auguste, xviii, 136, 202n2 (chap. 4), 204n1, 204n5, 206n6
Rodrigue (Ramiro), 163

Rops, Félicien, 12
Roques, Hippolyte-Jules, 4
Rosenberg, Léonce, vii, 116, 123, 124, 213n2 (chap. 18)
Rosoy, Jeanne (Charlotte Alix), 137, 143
Rouart, Stanislas-Henri, 163
Rouault, Georges: exhibitions at Galerie B. Weill, 44, 52, 64, 81; Lehmann and, 60; Moreau and, 44; paintings, 153, 208n8; public reactions to work, 44; sales, 61, 101; watercolors, 62, 124
Roubille, Auguste, 5, 17, 29, 37
Rouché, Jacques, 92
Rousseau, Henri (Le Douanier), 64, 77, 79; *Liberty Inviting Artists to Take Part in the 22nd Exhibition of the Indépendants*, 46
Rousselot (police commissaire), 102–3
Roustan, Émile, 47
Rouveyre, André, 19
Roybet, Ferdinand, 61
Russell, Morgan, 100, 101

Sabbagh-Sabert, Georges, 125, 128
Sagot, Clovis: death, 100; gallery, vii, 25, 100, 114–15, 203n1 (chap. 5), 205–6n4, 208n8; life, 203n1 (chap. 5)
Sagot, Edmond, 203n1 (chap. 5)
Sagot, Mme, 100, 105, 108, 124
Sainsère, Olivier, 12, 14, 15, 36, 46, 90
Saint-Malo, 34–35
Saint-Nom-la-Bretèche, 90
Saint-Tropez, 140–41
Salmon, André, xxiv, 25, 137, 207n6, 215n3
Salon Bollag, xxvi, 200n8
Salon d'Automne: of 1903, 29, 203n4,

203–4n2; of 1905, xix; of 1922, 126; of 1925, 141, 216n2; of 1926, 144

Salon des Indépendants: of 1904, 36; of 1905, 40–41; of 1906, 44, 45–46; of 1908, 58; of 1911, 70; of 1913, 78; of 1924, 129; of 1926, 144; Metzinger's paintings, 53

Salon des Peintres Français, 121

Salon Folie Dentaire, xii, 128

Sanary, *xxv*, 140

Sancha y Lengo, Francisco, 13, 17, 21

Sánchez-Solá, Eduardo, 91

Sardou, Victorien, 161, 217n1 (app. C), 217n3

Sarraut, Albert, 12

Satie, Erik, 211n6

Savin, Maurice, 136, 144

Schnerb, Jacques, 63

Section d'Or, 79, 208n9

Segonzac, André Dunoyer de, 75, 140

Sem (Georges Goursat), xix–xx, 4, 17, 24

Sembat, Marcel, 103

Sérusier, Paul, 203n5

Seurat, Georges, 40

Severini, Gino, 123

Sic, 92, 211n5 (chap. 15)

Sicardi, Louis Marie, 13

Sifflet, Le, 8

Siméon, Fernand, 146

Simon, Henri, 103

Simon, Hughes, 134

singing lessons, 38

Sisley, Alfred, 35, 167

Smith, Francis, 121–22, 134, 136, 140

Société des amateurs d'art et des collectionneurs, xxvii

Soi-même, 96, 106

Soirées de Paris, Les, 83

Somm, Henry, 70

Soutine, Chaïm, 206n1, 212–13n8

Spanish artists, 11, 13, 16, 29–30, 91. *See also* Picasso, Pablo

Spanish flu, 107

Stein, Gertrude, 58–59, 205–6n4, 206n1

Stein, Leo, 58–59, 203n1 (chap. 5), 205n4

Steinlen, Théophile, 5, 24, 26, 30

Stravinsky, Igor, 92

Sunyer, Joaquim, 11, 13, 21

Surrealists, 147, 211n5 (chap. 15)

Survage, Léopold, 116, 123

Symbolists, 73

Synchronism, 100

Tabarant, Adolphe, 80, 143

Tailhade, Laurent, 29–30

Tanguy, Julien-François "Père," 167, 218n7

Tanner, Henry Ossawa, 202n2 (chap. 4)

Tarkhoff, Nicolas, 62, 64

taxes, 45, 142, 146, 148, 207n2 (chap. 12)

Temps, Le, 122

ten Cate, Siebe, 14

Terk, Sonia, 207–8n7

Théâtre Bobino, 79, 208n10

Théâtre de l'Œuvre, 122, 213n4

Théâtre des Arts, 92

themed exhibitions: "Animated Flowers," 141; decorative art, 110–11; emerging artists as focus, xxiii, xxviii, 16–17, 51; end-of-year, 136, 141, 147–48; of female artists, xxi; final (1940), xxvii; "The Flower," 136; "Flowered Windows," 147–48; hundredth, 117–18

234 INDEX

Thévenet, Jacques, 128
Thiébault-Sisson, François, 122
Thiesson, Gaston, 35, 36
Tobeen (Félix Bonnet), 120, 126
Torent, Evelio, 13, 21, 24, 29–30, 39, 62
Toulouse-Lautrec, Henri de: collectors, 36–37, 165; exhibitions at Galerie B. Weill, 30, 40; sales, 11–12, 36, 40, 47, 51–52, 101
train accident, 22–23
Trouville, 33
Tzanck, Daniel, 128, 214n3
Tzara, Tristan, 211n2 (chap. 16)

Ubu Roi (Jarry), 122, 213n4, 218n13
Uhde, Wilhelm, 77, 207–8n7
Utrillo, Maurice: Coquiot and, 97; critics on, 137; exhibitions, 121; exhibitions at Galerie B. Weill, 99, 121, 123, 124–25, 127; life, xii; paintings, 113, 153, 208n8; parties, 126; pastels, 92; prices, 90, 92, 99, 121, 124–25; Salon Folie Dentaire and, 128; sketches, 93; *Snow Scene*, 89; success, 121
Utter, André: Coquiot and, 97; exhibitions at Galerie B. Weill, 83, 89–90, 110, 112, 119, 125; *The Harlequin*, 97; Heuzé and, 78; parties, 118, 126, 143; Salon Folie Dentaire and, 128

Valadon, Suzanne: career, 139; Coquiot and, 97; Cravan's criticism of, 78; exhibitions at Galerie B. Weill, xxi, 83, 99, 110, 121, 122, 123; Heuzé and, 78; paintings, 113, 208n8; parties, *xxvi*, 118, 126, 143; photograph of, *xxvi*; prices, 99; Salon Folie Dentaire and, 128;

Utter and, 89–90
Vallotton, Félix, 5, 29, 53
van Coppenolle, Jacques, 64
Vanderpyl, Fritz-René, 116, 117
van Dongen, Kees: exhibitions at Galerie B. Weill, xix, 39, 40, 41, 64, 81, 110; as Fauve, 203n4; gatherings at Bateau-Lavoir, 25; paintings, 116–17, 153; sales, 101
van Gogh, Vincent: collectors, 110; exhibitions, xxiii, 40, 204n4; paintings, 74, 152, 166, 167; prices, 61
van Rees, Otto, 63, 65, 84
Vauxcelles, Louis, 23, 139, 145, 203n4
Véber, Jean, 5, 24, 26, 29, 30
Veilleurs, Les, 103–4, 108, 110, 112, 116, 212n7 (chap. 16)
Vergé-Sarrat, Henri, 126, 133, 138, 143, 144
Verhoeven, Jan, 61, 63, 88–89, 110
Viau, George, 163
Vibert, Jehan, 51, 153
Victoria, Queen, 12
Vildrac, Charles, 75, 140
Villette, Charles, 100, 101, 106
Villon, Jacques, 14, 19, 208n9
Vlaminck, Maurice de: collectors, 214n3; critic's interview of, xiii, 129–32; Derain and, 214n7; exhibitions at Galerie B. Weill, xix, 42, 110; as Fauve, 203n4; life, 214n7; paintings, 108, 153; personality, 42–43; sales, 53; trade for Redon study, 62–63
Vogler, Paul, 14
Vollard, Ambroise: autobiography, xxiii, 200n6; background, xxii, 218n6; comparison to Weill, xxii–xxiii; *Dolikhos's Beginnings* (Weill), viii, xxiii, 160, 161–71,

200n5; "Figures d'amateurs," 160, 200n5; gallery, vii, xxii–xxiii, 18–19; influence, 153; Maillol exhibition, 202n3; on Mayer, 201n1; Picasso exhibition, 19; Redon and, 18, 164; Spanish artists and, 16; Stein on, 205n4; success, 150

Waldeck-Rousseau, René, 12
Warnod, André, xxviii, 145, 216n3
Waroquier, Henry de, 118, 143
Warrick Fuller, Meta Vaux, xviii, 17, 202n2 (chap. 4)
Weill, Andrée (sister-in-law), 85–86
Weill, Berthe: achievements, viii, xv; "Avant-propos," 160; caricature, *xxi*; death, xxvii–xxviii; family, xvi, *xvii*, xxii, 8–9, 15; as feminist, 78; influence, xx, xxviii, 154–55; Jewishness, xvi, 67, 206n1; language lessons, 37; life, xvi–xviii, xxii, xxvii–xxviii, 38–39, 173–74; memoir, xxiv–xxv, 148, 149, 157–59; as model, ix; personal art collection, viii, xxvi, 91; personality, xv, xxviii, 38–39, 54, 95, 96, 149, 154–55, 156; personal library, viii, 52, 75; photographs of, *xvii, xxv, xxvi*; physical appearance, xv, 155–56; piano lessons, 76; political views, xix–xx, xxii; portraits, *vi, xiv*, 174, 205n1 (chap. 8); relationships

with men, 24, 26. *See also* Galerie B. Weill
Weill, Berthe (sister-in-law), *xvii*, 108, 201n10
Weill, Jenny Levy (mother): death, 119; dowry given to Berthe, xxii, 9; family, xvi; inheritance, 8–9; loans, 60; love of theater, 202n1 (chap. 3); pressure for marriage, 13, 16; during World War I, 106
Weill, Marcellin (brother), xvii, 4, 5, 13, 15
Weill, Nephtali (brother), *xvii*, 15, 85, 87, 201n10, 210n7
Weill, Salomon (father), xvi, 9, 15
Weiluc, Lucien-Henri, 19
Wély, Jacques, 19, 21, 26, 30, 60
Widhopff, David, 5, 127
Willette, Léon, 4, 12, 19, 23, 30
women: artists, xxi, 18, 41, 78, 80, 139; feminism, 78; fortune teller, 10–11; members of Les Veilleurs, 104; misogyny, 139, 142, 216n7
World War I, 85–101, 105–8, 142, 210nn5–7, 212n3
World War II, xxvi–xxvii, 201n10

Zadkine, Ossip, 122, 206n1
Zamaron, Léon, 126
Zamoyski, Auguste, 135
Zárraga, Ángel, 105
Zborowski, Léopold, 89, 101, 103, 118
Zola, Émile, 7–8, 12